The Life & Love of Cats

Lewis Blackwell

The Life & Love of Cats

Abrams, New York
in association with PQ Blackwell

CONTENTS

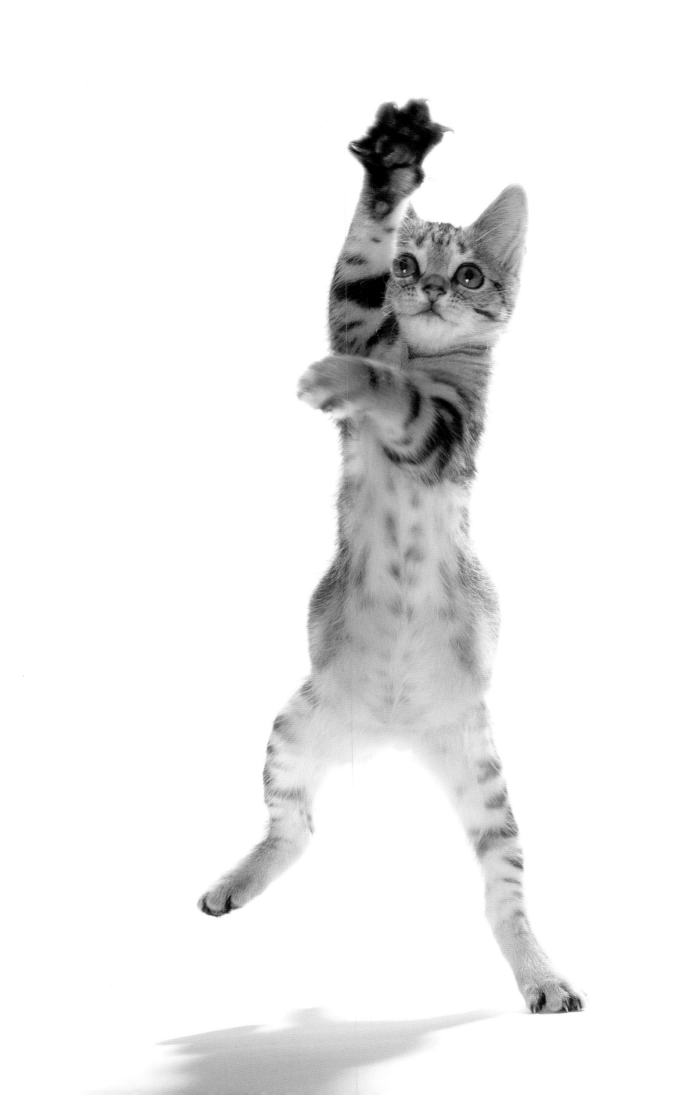

Cats have nine lives:
For the first three, they play.

For the next three, they stray.

And for the last three, they stay.

Introduction

This is a book for cat lovers. You deserve it.

Being a cat lover is hard. There is always a little area of doubt in your mind as to whether your cat really, truly, deeply, madly loves you quite as much as you do in your own uncompromising devotion.

Well, it does. I am sure. Just in its own way.

The thing is that the very mystery of the cat, the magic that makes it so wonderful, brings a joy to our lives, but also raises a question that teases us endlessly: What does the cat think of us?

In the nine chapters of this book we look for answers to that question, but let's be clear from the start—it is a mistake to assume that a cat thinks at all. That's just our favorite habit of assuming that the creatures we love live like us. We impose on them our notion that they think and feel in hand-me-down human ways, whereas their motives may be very different, the processes behind them quite unlike ours. It is one of the attractions and frustrations of living with cats that they so obviously work well alongside us and yet adhere to a different logic. They exist within and without the world that we occupy. At times this leaves us bemused, confused, and even maligning them. Indeed, in many eras this has been a problem for cats, who have been dragged into *our* half-baked ideas of witchcraft and other superstitions.

Now, of course, the nine chapters in this book were carefully chosen for a reason. Yes, nine because of the mythical nine lives that a cat enjoys. The precise reason for this number of lives is lost in the mists of the Nile, back in ancient Egypt, around the beginnings of cat domestication and veneration. But nine is a good number for our purpose because, while there is an almost-infinite range of fascinating things to say about cats, a book's pages are finite. Fittingly, therefore, we build our story and understanding around nine key topics.

The almost-infinite number does sort of work for the internet, though, and there it tells us something interesting. In a fraction of a second, a search answers one of those familiar nagging questions about cats: Just how popular are they? *Very* is the answer. You might find a dog lover wanting to challenge you on this, but just remember that a search for "dogs" brings up a mere 130 million results in Google, while "cats" cruises in with 546 million results. At least those are the numbers I have today and it is at least tomorrow for you, so add another naught if you wish. Whatever the number, it is a convincing victory for cat-loving over dog-loving and that's not going to change any time soon. Or ever.

So this is a book for people who love cats. Unashamedly, victoriously, and wonderfully so!

But if you don't love cats, and don't even know somebody who does (which is highly unlikely—do think again), then please look away. Indeed, go and do something else. Go and walk the dog, or play with your pet mice, feed the parakeet, or do whatever it is that can explain why you might not love cats.

Here, there are almost no boundaries to our indulgence of, and affection for, all things feline. Be warned, or indeed, persuaded. We will sail close to the shores of Sentimentality, drink deep from a well filled with the fine words of cat fanciers, and wander through thousands of years in order to appreciate our subject. And all the while, between and around the words, you will see a lot of cats doing a lot of cat things.

Now, most of what cats do is a little mysterious—some of it thoroughly baffling. Other activities seem normal until we realize we really don't understand the cat's motivation, but are just interpreting it with our own inadequate cat sensibility. (Always inadequate because we are not cats.)

For example, cats spend a lot of time sleeping. Most of the day, in fact. Do they sleep like us? Not really—for one thing, they look like they're enjoying it so much more than we do. It probably comes with practice, which they get plenty of. They look so relaxed and they are always ready for another nap. Their days seem to be largely filled with snoozing, broken up by a couple of active spells when food is on their minds or perhaps entertainment from humans is available. But we really don't know what they are thinking for up to three-quarters of the day, when they are asleep. There are signs they dream . . . so is being awake just a break from the larger and more fulfilling part of their lives?

Now, we are digging into their *thoughts*. As I said at the start, we impose much onto the inscrutable appearance of their bewhiskered faces and cool-eyed stares. But when you hear somebody talking about what their cat is thinking, this is usually an invitation to doubt their sanity, if only momentarily. Until the next time and the next time. At some point, you will need to change the conversation—or perhaps tell them about what *your* cat is thinking.

The truth is that we have little idea of what a cat thinks, or how a cat thinks, or if a cat thinks very much at all. And as we ponder on this, it eats away at us until we begin to doubt our own grip on things. Back in 1592, Michel de Montaigne put this best when he wrote, "When I play with my cat, who knows whether she is not amusing herself with me more than I with her."

What this is not: This is not a book for cats. It would be if it could. But I have yet to meet a cat who is interested in reading. (Oh yes, go on, tell me that you have a cat that does . . . I just know some of you out there do have a treasured pet or two that likes nothing more than perusing the pages of a book.) The thing is, the cats I meet seem to have a very full life without reading, surfing the internet, or taking much interest in television. They seem to have a grip on pretty much everything they need to know about having a good time, and no book is going to improve this.

Whereas we humans—we have a lot of reasons to read books. We struggle to make sense of our own lives, we have all sorts of issues to contend with and conflicts to deal with, and we never get to the bottom of the questions that trouble us. And we are certainly left baffled from time to time by the creature that we most commonly invite into our homes: the cat. So there is room for a little meditation on what it is about the cat-human/human-cat relationship that has proven so potent for us over many thousands of years and is, if anything, growing stronger today as more people find occasion to bring a cat into their lives.

So this is, failing curious cat readers, a book for people who might like to celebrate the magical contact we have with cats. Behind my own interest in felines, I have realized, is a mystery that I have cherished. As Montaigne philosophized more than 400 years ago, we don't know who is playing with whom . . . but what we do know today is that we like it that way.

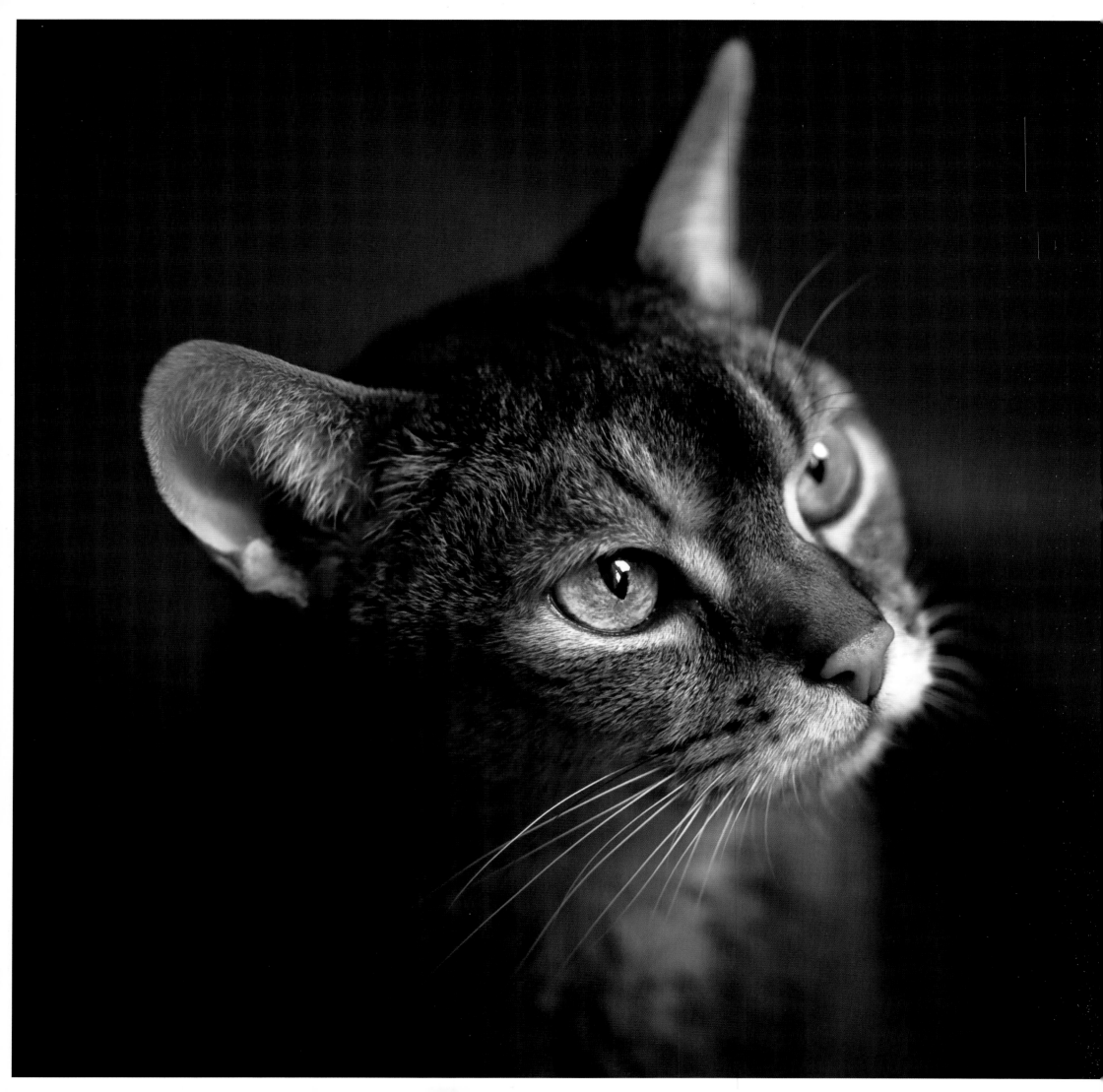

We like the not-knowingness of loving our cats. They perhaps reciprocate, and then again, perhaps not. Are they just being entirely selfish or do they have something that might pass for love for us? We don't know, and we don't really want to know. We want to tell ourselves how good our relationships with our cats are, and their politeness (or lack of any interest) allows us to build this perception. In a world where we might accept that we can't explain every phenomenon, somehow the cat is the creature that captures this ambiguous nature of things. It is at once a simple part of our lives, highly undemanding—viewed one way. And yet it also celebrates the uncertainties we face, is a doorway into the dark, giving us an inscrutable stare that seems to assert: "You really don't know, do you?"

Our cats provide a very commonplace doorway into the world of mysteries. We have more than 600 million cats out there worldwide (pets and strays), and we spend more on them than on poorer humans in some cases. In the United States alone, $4 billion is spent on cat food per year, a billion more than is spent on baby food. Cats lie around our homes, almost certainly spending more time napping in our homes than we ever do. In some ways, they become a part of our home, even more so than we might. (Many a divorce has featured a fight over who gets the cat.) Every day, while soaking up affection and occasionally giving a little back, they still manage to preserve their other-ness: unlike our dogs' attentive reassurance- and instruction-seeking behavior, our cats seem altogether more centered—they don't need approval from us, but they will allow us to show it.

When we look at a cat, there are things unsaid, thoughts beyond words. We sense more than a feeling, but it is outside the familiar forms of our languages. And so the cat's stare leaves us meditating on the mystery behind its eyes, provokes us to reach out and try to connect with this life that is not human yet seems so near that our emotions yearn to bond with it. It is easy then to see why cats have figured so often in and around matters of religion, spirituality, and superstition. We circle our thoughts around the feline existence, resolving only on the one thing we know for sure—that for us, there is a life that loves cats. We love them not for loving us, but for seeming to love themselves in such an untroubled and even profound way, and for allowing us into this pleasure just a little.

So there is inevitably something missing from this book. It is the voice, the tonality, the thoughts of . . . the cat. Rather, the cats. The unknown billions of them that have lived on our planet and helped shape our society in subtle ways. We are so inclined to interpret and invest the behaviors of cats with near-human motives, but it is perhaps our behavior in response to their existence that is the more perverse. We are always lacking the insight that really matters—what is going on behind those intense eyes?—but we are never short of opinions and cat-fawning behaviors. We think it is all about us—not them, or indeed anything else. We can't get outside of ourselves, but neither can the cat (or at least, we think that is the case). We look at cats and they look at us and we speculate on the universe we find ourselves in.

You can tell a lot about people by looking at the pets they choose to live with, and how they share their lives. The indications can show us in a good or bad light but are rarely less than entertaining, provocative, and even, occasionally, shocking. Versions of "Have you seen how she dotes on those cats? I do believe she cares more for them than any people she knows—the rest of the family included!" are played out in many an observation. My eyes grew wide in a conversation with a man in charge of marketing cat food for a big supermarket chain, as he explained that his colleagues regularly tasted their products because the cat food buyers were also important consumers. Some people sacrifice their own needs in budgetary distress, he said, in order to ensure a good food supply for their cat. They then share its food . . . even loyally continuing to buy it after the cat's death. This insight had been fully exploited by said supermarket: they knew they could charge a much higher price for low-quality meat products when supplied as cat food than they could ever hope to achieve if the same produce was sold for human consumption. The lesson of this, perhaps: greater love hath no man, or woman, than their cats.

But that said, we humans also have a great tradition of cruelty to cats. It is a reflection of our inadequacies that we have killed cats by the millions for every reason from their being passports to a happy afterlife in ancient Egypt, to witches in disguise in medieval Europe, to useful aids in medical research or exotic dishes for the menu in more recent times.

So cats need their mythical nine lives, because we put them on our altars as both little gods, and as sacrifices. Nine is an excellent number for dividing the contents of this book: we will range from how cats came to be domestic animals to how they simultaneously continue to be wild at heart; we will work across to the contrasting associations of cuteness and dark powers; we'll take in remarkable stories of healing and the other spiritual associations that seem to have gathered around cats through the generations. Faced with so much ground to cover, we'll use a handy structure of nine key areas to herd the cats into this book, allowing us to approach the feline from every direction.

And before we head off to see what that brings, there is one key thought that is worth remembering about cats: you couldn't, and probably wouldn't, invent them. They don't fit any specification that we set. They just are. Cats are perfect as partners through our lives because we did not breed them to work for us and fit in; instead they somehow worked it out for themselves. We are their solution to a problem.

In ancient times cats were worshipped as gods.

They have not forgotten this.

Evolution

When we think of a cat, we think of a fur-covered animal that is below knee height to an adult human. It is a creature that is usually comfortable with our presence but, unless we live with it, is a little wary of us. It sleeps a lot and is known for quite a few other distinguishing characteristics. There are exceptions to these commonalities, but they rather go to point out the general consistency of traits among cats. And this is pretty much how they have been for a long time. In this they differ from many other domesticated species that we have bred to achieve large variations in appearance (particularly in size) and behavior.

Perhaps the most compelling reason cats lack the diversity of breed and type that we see in other cherished domestic species, such as dogs or even horses (species that have evolved and been deliberately bred to serve a range of different purposes), lies with us rather than them. The fact is, we have never found that much variation in purpose for our relationship with cats. And so we haven't encouraged that much variety in domestic cats. But in the long evolution of this relationship, there is much still to be understood and much lost in the pea soup of ancient time.

Cats appear to have initiated contact with humans by demonstrating to our forefathers an interest in the previously unadvertised position of vermin hunter. The theory goes that wildcats were drawn in by the easy pickings of mice and rats to be found near our early farming ancestors' harvest stores or in the waste tips on the outskirts of early human settlements. Research published in the journal *Science* in 2007 suggests that this innovation arose in the very early agricultural settlements of the Fertile Crescent, the term given to a prehistoric swath of territory that runs through the Middle East. This first partnership may go back 10,000 years, to the very birth of farming practices. As some wildcats found accommodation with our needs, and we with theirs, so these cats were inclined to mate with each other. Thus, over a few generations, they strengthened their difference from their more wild cousins, who were having nothing to do with humans. Those that were most able to operate alongside humans, benefiting from the leftovers and easy hunting, will have thrived the most. As these cats were the best fed and least exposed to the dangers of the wild, they were most likely to survive, thrive, and breed some more—a virtuous circle that quickly evolved the basics of our tame house cats today. They retain the hunting instinct, while also having a strong sense of association with humans and an appreciation of home comforts. They both fit in with, and stand apart from, us.

But back to those ancient times. Our ancestors will have been inclined to tolerate, and indeed encourage, these neighbors. Life was hard enough without vermin and snakes creeping around the home, eating your food and occasionally killing you or your babies. In exchange for a little help with such terrible problems, the pick of the waste tip and the right to eat your catch will have seemed quite a modest wage to pay.

From hanging around on the outskirts, the move right into communities, then finally into stores and even homes to finish off the job of vermin extermination will have been a fairly obvious outcome. And so those cats that were most friendly, trusting, and appealing to humans were the ones that flourished in this environment. It is thought that humans may well have practiced an early form of genetic selection by further encouraging the most appealing in appearance. Imagine: early humans encountering kittens. They could either kill them, ignore them, or help nurture them. As kittens are not very edible, are no great trouble, and have an appealing defenselessness a bit like human babies . . . well, the nurturing instinct would take over. Especially as cats earned their keep, even our rugged and smelly early ancestors must have been inclined to favor such cute creatures. In so doing, they further encouraged the shaping of cats with cute appearances and tame ways.

This theorized development process would explain why domestic cats are all genetically closest to the African wildcat (*Felis silvestris*). There are other wildcat subspecies throughout the world—from Scotland to South Africa, through Asia to China—but these do not share the domestic cat genes and were never close to humans (although now crossbreeding with the dominant domestic strains is threatening the pure blood of wildcat subspecies around the world). Genetically, only *Felis silvestris* had the carefully honed skills to maintain the role of mouser and pet. As this variant was much more attuned to partnership opportunities with humans, so there was no opportunity for local wildcat varieties to develop into the role. The post was taken and has been ever since.

As farming spread, so did the early domestic cat, and *Felis silvestris* is now clearly the ancestor of every house cat the world over. The DNA evidence can even be pinned down to as few as five original mothers, "mitochondrial Eves," being the source of the domestic cat. Even without knowing the hard science, however, the casual observer can note the similarities between the markings of the average tabby and the African wildcat.

Once in from the cold, it was a quick step to attaining a more favored status. It seems that by as far back as 7500 BCE the cat had moved beyond being just a tolerated and useful parasite; instead, it had evolved into an important companion, and was earning a special place in our hearts. This date comes from a French archaeological discovery on the Mediterranean island of Cyprus. A dig reported in 2004 found a young cat's skeleton carefully, and very similarly, buried alongside a human grave. That someone went to the trouble of burying a cat in this way suggests a relationship that was valued and personal: not the result of some feral cats hanging around in the background, but an indication of a cat that was a highly treasured part of society. Although cats do not rival the ancient connection dogs have with humans (dogs having worked with the earlier hunter-gatherers), the evidence from Cyprus is a fresh challenge to our understanding of how early "pet" relationships developed between humans and cats.

It might seem that going from the wild, to helping on the farm, to fitting in as a pet, was achievement enough. But the cat went beyond the practical and moved into the souls of our ancestors; it became a goddess. In Egypt, around the third millennium BCE, the cult of the goddess Bastet formed and she bore feline form. Initially, this was drawn from the lion, but over time it migrated closer to the shape of the house cat. Elegant sculptures and other

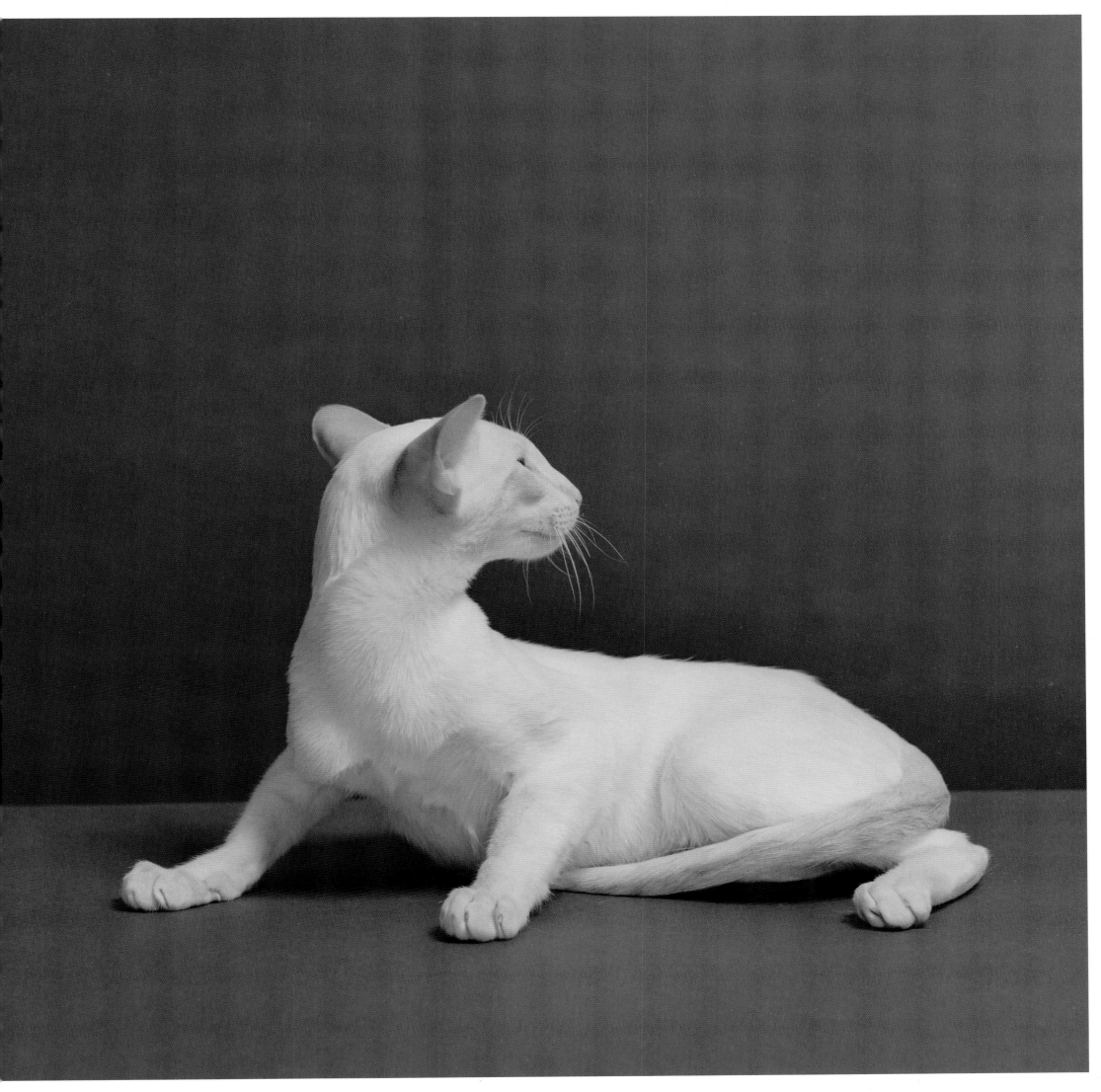

works survive to show how she was depicted as a cat and how enormously popular the cult was: Herodotus, in about 500 BCE, described a gathering of 700,000 people for a key celebration of Bastet in the ancient city of Bubastis.

The cat's elevated position can also be seen in some surviving painted works, where it is depicted as a key member of Egyptian households. The attributes of the cat crossed over with those ascribed to the goddess: women who hoped for children wore Bastet charms because of the cat's strong mothering instincts.

However, one unfortunate side effect of becoming central to religious devotions was being required for sacrifice from time to time. Cats were killed and mummified, in both their own honor and that of the goddess—and in huge numbers. In 1888, a tomb with a vast compression of animal mummies, mostly cats, numbering many hundreds of thousands, was found. Even a humble everyday house cat was apparently mummified, with extra special treatment for more noble cats. Over time, the veneration of cats appears to have changed from custom mummification of cherished animals, to industrial-scale breeding of cats to meet the needs of Egyptians wanting to sacrifice a cat. There is evidence in the last centuries of the ancient Egyptian civilization, before the Romans took control, that vast numbers of cats were being bred and deliberately killed to meet the needs of temple pilgrims keen to symbolize their devotion and lay a marker for the here-after. Mummifying cats must have been a good business, to judge by the vast burial tombs of animal corpses, in which the cat is usually the main subject. Unfortunately, once discovered, these tombs were brutally raided with most of the contents sold off. There is a record of twenty tons of mummies auctioned off at Liverpool dockside in February 1890, then almost entirely ground up to make fertilizer. The contents of more than twenty massive cat-dominated tombs have been lost. While these nineteenth-century events may have seemed the final insult to Bastet followers, more recently the internet seems to have spawned a modest revival, with a website (catreligion.org) dedicated to reigniting enthusiasm for the faith.

In the fifth century BCE, the Egyptian cat goddess also became associated with the Greek goddess Artemis, being seen as the Egyptian version of the same deity. Through this interpretation, Bastet became more associated with the moon than the sun, in line with the attributes of Artemis. Greeks began to speak of the cult of the Egyptian Ailuros (*cat* in Ancient Greek) and this word remains in use: an ailurophile being a cat lover in English, and an ailurophobe being the opposite. From the heights of godhead, however, by 320 BCE,

the Bastet cult declined and was banned. As the cat's role in Egyptian and wider society diminished from the sacred back to a more practical level, so the diffusion of the domestic cat widened as the Roman Empire spread the practice of keeping cats.

With the advent of Christianity, cats no longer had a place in the prevailing mythology, but the drop in status came with the benefit of an end to animal sacrifices. Later, the arrival of Islam saw a more protected status for the cat, perhaps owing to the legend of Mohammed and his favorite cat, Muezza. It is said that one day while getting ready for prayer, he preferred to cut his robe rather than awake the sleeping cat that was lying on him. Cats certainly have benefited from the general kindness to animals preached by Islam.

Trade routes, over land and by ship, also spread the animals as far east as China. They remained petted and welcomed in the home, in wide use as vermin hunters, and also most likely became established in feral communities around human settlements. By around 1000 CE, around the beginning of the Song Dynasty period in China, the cat was a much favored part of society. The concept of pampering cats with luxuries emerged, with special gifts evidently for sale in markets, and special fish foods developed solely for cats.

At some point in the Middle Ages, however, the previously un-blemished reputation of the cat began to acquire negative overtones, becoming associated in Christian cultures with satanic practices such as witchcraft. The invention, seeking out, and persecution of witches was accompanied by a taste for torturing and killing cats. It has been suggested by some historians that the severity of this persecution so depressed the cat population that it encouraged the spread of the Black Death epidemic. The disease was carried by rats, and, as these proliferated owing to a shortage of cats, the epidemic spread across fourteenth-century Europe, killing up to 50 percent of the population.

The remarkable superstitions around cats—both positive and negative—will be revisited later, but this emergence of negative perceptions is clearly a reflection of the growing tensions in human societies rather than any change in cat behavior. Fears of religious control, and the need to direct and manage hatred of an enemy, led to the picking of cats as useful victims. The same can be said for the "great cat massacre" that occurred in Paris in the early eighteenth century—only here cats were killed as a workers' protest against poor pay and poor working conditions. Apprentice printers in the 1730s turned on the cats they saw being given better treatment by their masters' families: gathering up the defenseless creatures, and holding them accountable for the injustices, they slaughtered them.

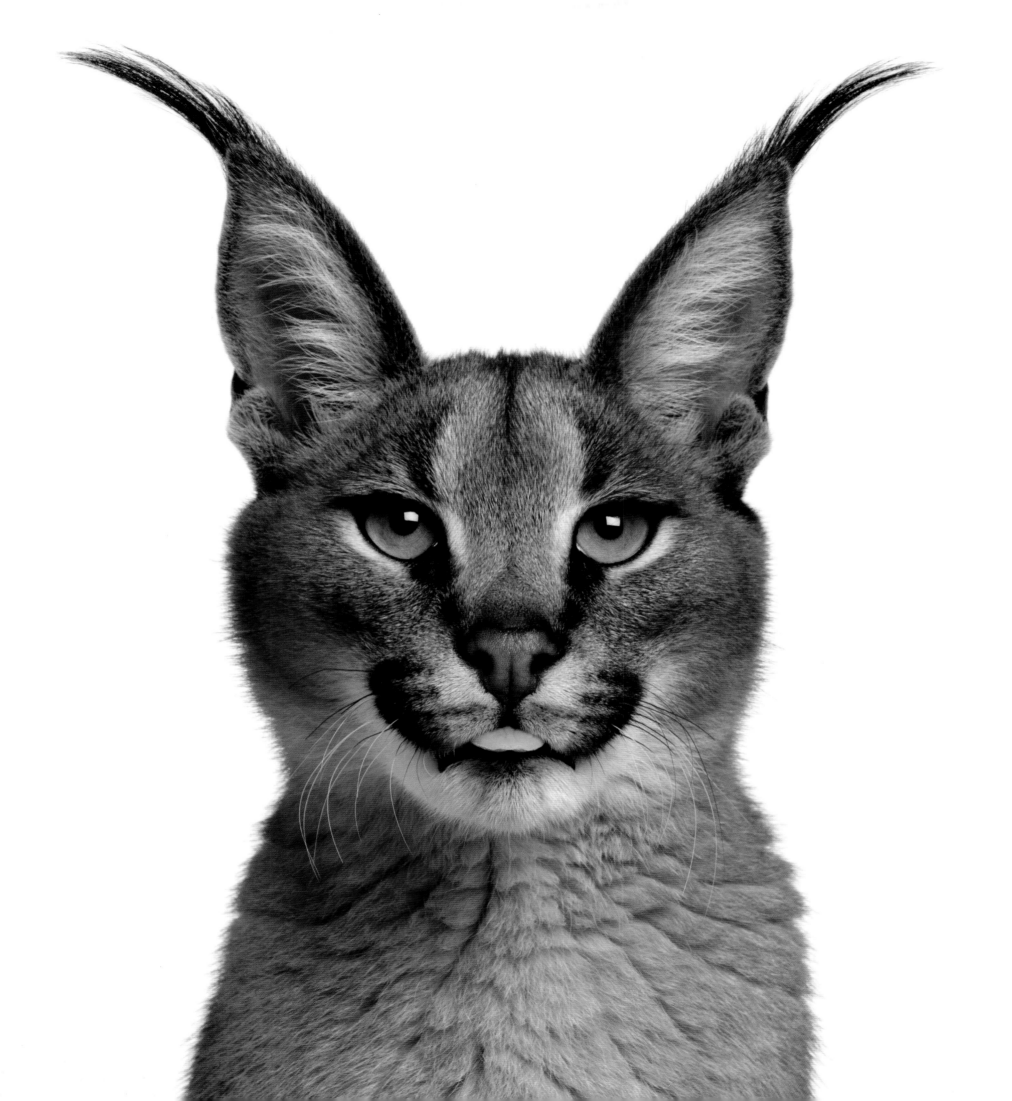

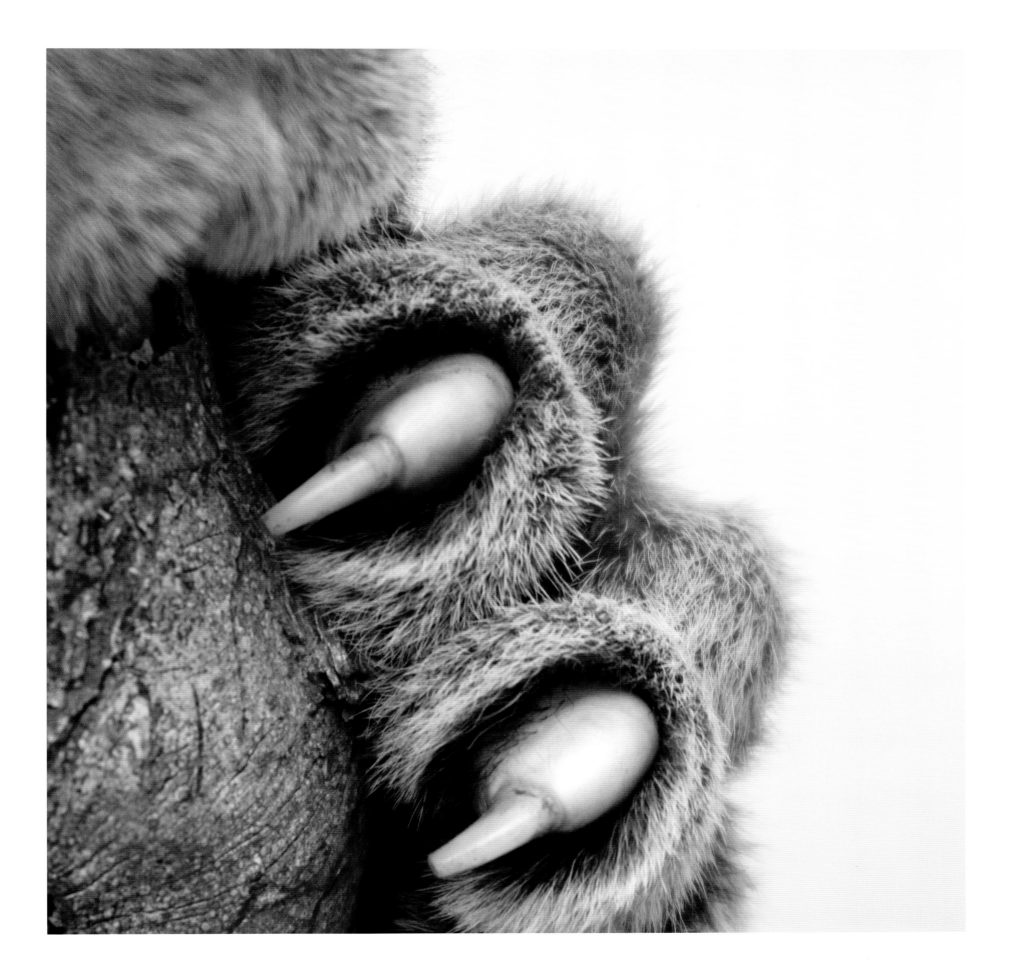

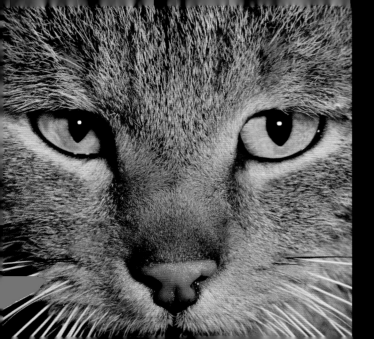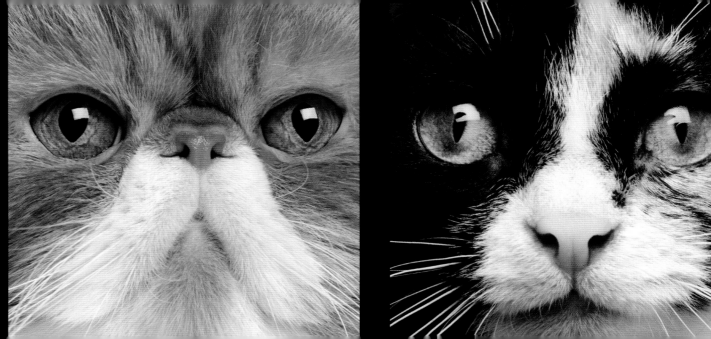

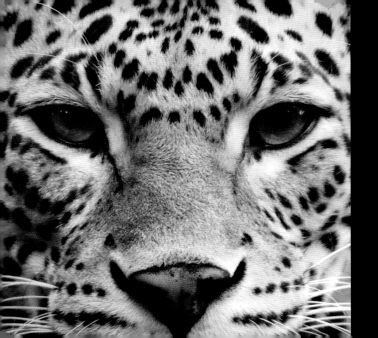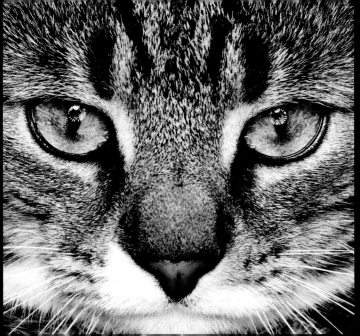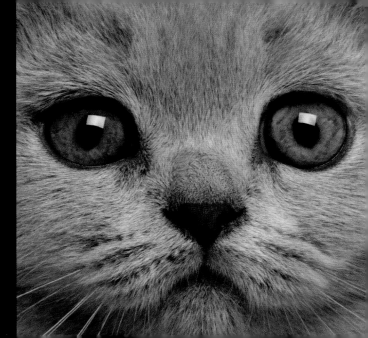

The cats became a symbol of the violence that the workers wished to inflict on their rulers. The French Revolution came early to the cats. Perhaps this is the first example of the "fat cats" metaphor that now applies to bankers and overpaid CEOs . . . only these days nobody wants to substitute a cat for a more direct dealing with human greed.

In general, though, the evolution of the cat in our lives has been a quiet, consistent, and unshowy affair. Compared with dogs, the domestication of cats has been rather discreet. Cats have not had to change drastically, but have adapted to living alongside us, and we alongside them. Their skills in hunting have been useful to us, as have our range of convenient services been to them. We have fit together well, and we have not been required to mold the species aggressively to our needs, unlike with the evolution of dogs. As the cat is restricted in size, and possesses an independent mind-set, along with eating habits that have deterred most of us, most of the time, from eating them, cats have avoided finding wider purposes in human life beyond a little hunting and petting. But quietly protecting our food from pests and providing an undemanding, but delightful and surprising, friendship are two large virtues that have opened the door to cats all over the world.

The far-flung range of nations across which cats have bred, with varying climates and related conditions as well as cultural influences, have inevitably drawn out some differences. And from the nineteenth century, the emergence of cat-fancying and breeding has seen a new range of human-led cat evolution. Nevertheless, breeding variations to date seem less than precise in their purpose, as they tend not to be motivated by simple functional needs; instead, a customization of the cat exists for cultural or even personal requirements. What has emerged is yet a fairly limited range of breeds. Some might be thought more or less intelligent, others less or more sociable, and others valued simply for beautiful coloration or long soft hair . . . but these really are rather indulgent appreciations on our part—not the stuff of working dog breeds or racing horses. The varieties are in fact relatively minor, and there is the sense that cat breeds tend to share similar attributes, in a way that a Chihuahua and a Saint Bernard dog, or a Shetland pony and an Arab stallion, demonstrably do not.

The breeding of cats, the finessing of difference, is an endless work in progress. There has been a discipline—regulation if you like—that has kept the field remarkably small compared with its potential. The highlights of breeding and where they might head are our next topic. Meanwhile, when we look at cat evolution we should realize that of the 600 million cats out there, the great majority are self-determined, without pedigree. Their genetics are largely handed down by the natural mating habits of cats without human intervention. In this they depart, once again, from so much that we tend to expect and impose on the nature of domestic creatures. Cats still do what cats want to do. And with whom they want to do it.

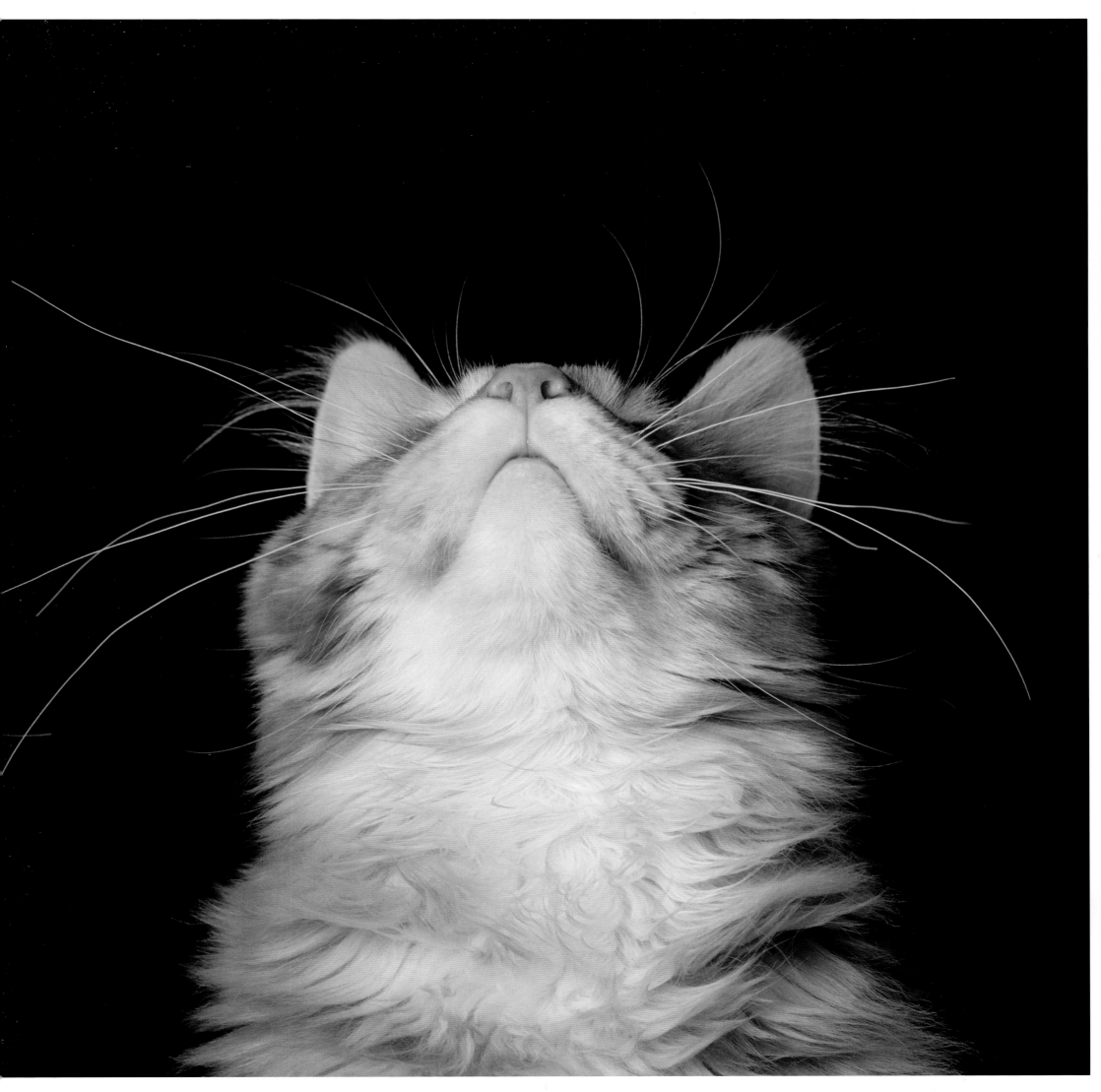

Cats sleep anywhere, any table, any chair.

Top of piano, window-ledge, in the middle, on the edge.

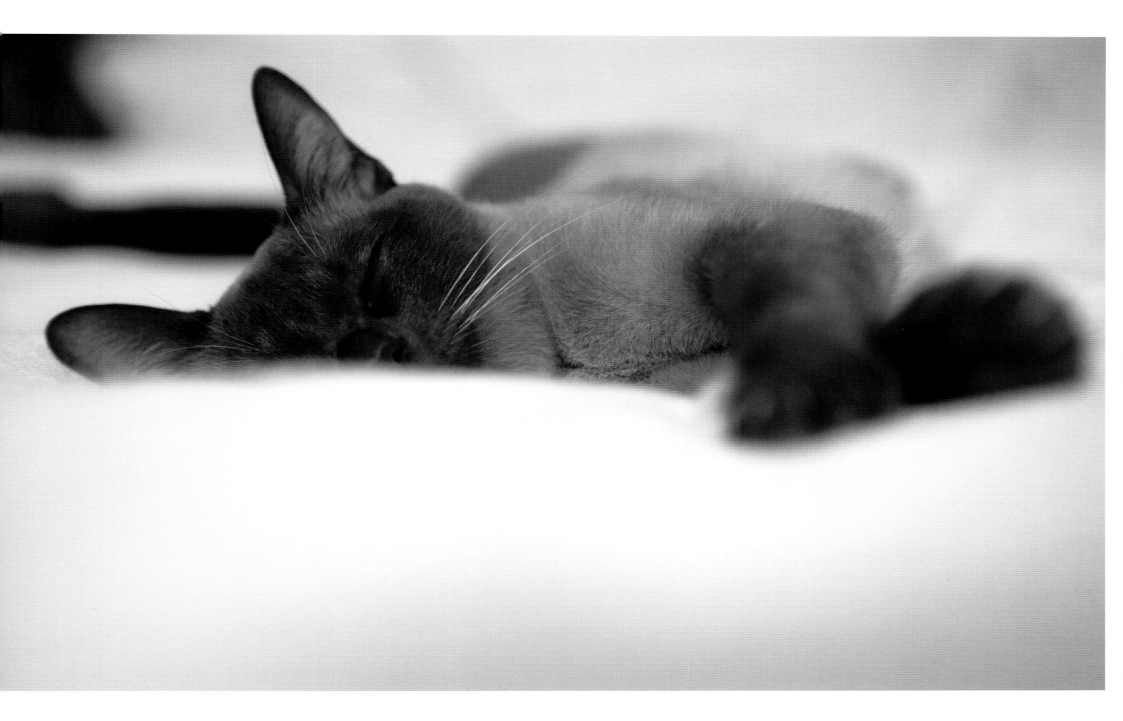

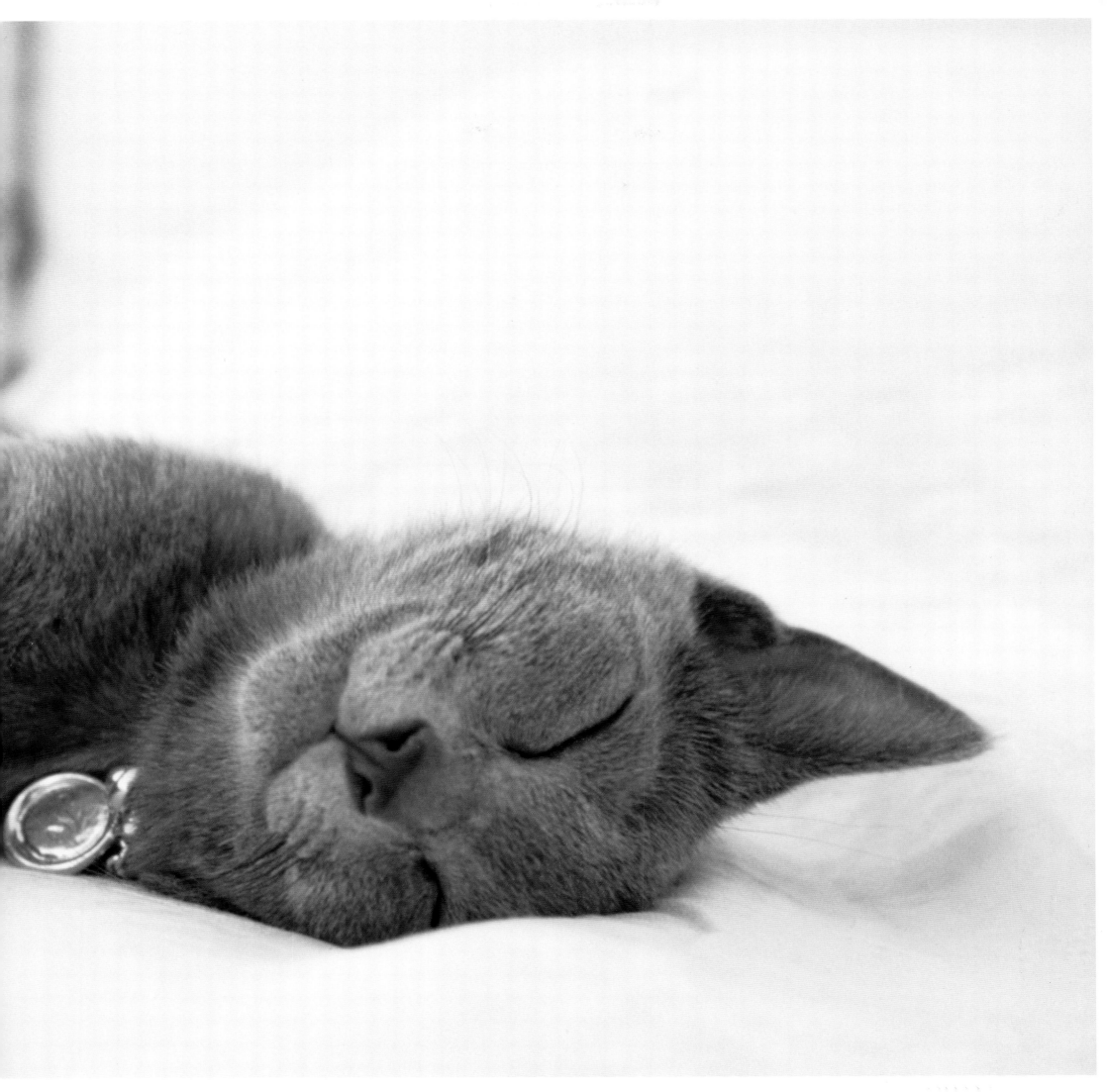

The cat is domestic

only as far as suits its own ends.

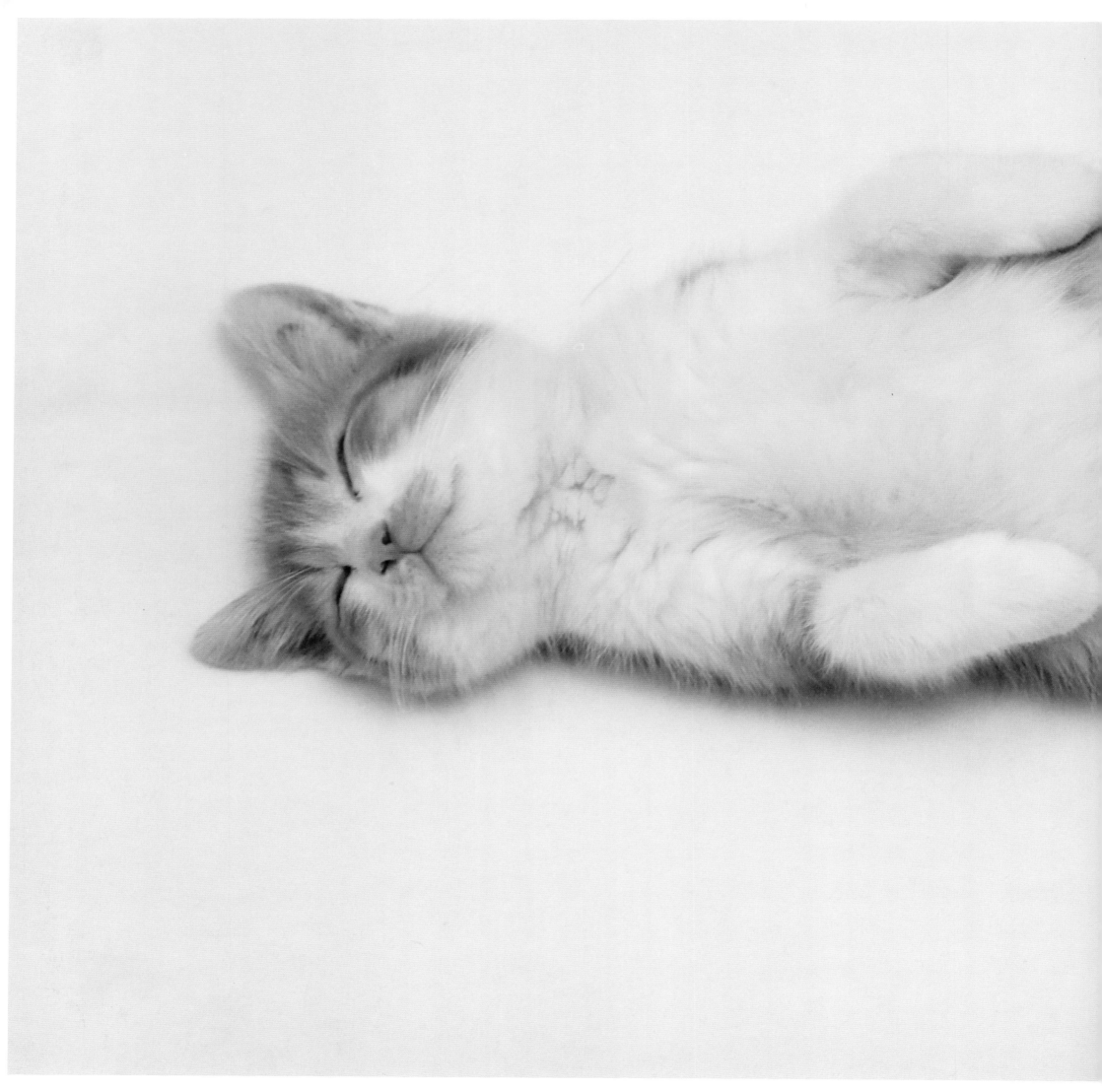

Domestic

Let's begin by considering why we like to live with cats. Or should that be put the other way around: why cats like to live with us. With any other creature we bring into our home or life, there is a very definite sense that we are the decision maker. When it comes to cats we cannot be quite so sure. In fact, we know we are not the only decision maker. We are not in charge. We are not the masters, owners, keepers, or anything finite of our cats. We can appoint ourselves to one or more of these grand positions, but our status-seeking is, at best, tolerated. Our behavior is usually accepted and occasionally encouraged—but it is clear that we are being constantly assessed to see if we are up to scratch. Sometimes literally. Having a cat in the home sets up expectations that can lead to performance anxiety, and it won't be the cat who is worried. We are allowed to make suggestions and we service requests in return for . . . for . . . in return for what?

Companionship for us, food and shelter for them, might be the quick summary of this relationship. But this would be oversimplifying. There is so much more to what cats mean to humankind, to how we have involved ourselves in their lives and they in ours. The roles played by our feline friends are greater than companionship—they range from stark utilitarian applications (such as mouse-catching) to matters deeply enmeshed in our search for the meaning and origins of our lives. That may sound pretentious, but the facts demonstrate this elevated role: from the dawn of recorded history, cats have appeared to hold formal religious and more informal folkloric significance—they have always been a class act.

Through the ages it seems we have engaged with cats as pets as well as workers (see previous chapter, Evolution). We have continuously found in them something inscrutable, magical, mysterious, and even essential. While the superficial observer may concede those added functions, they might still tend to view cats as hangers-around, interested only in the benefits of food and shelter. But this does a disservice. Cats and humans bond at a level beyond simple material exchange. There are signs that cats enjoy our company, and that they understand us at some profound level. We can look to tales of their insights into our health and contributions to our well-being (which we will return to in detail later). But, of course, cats do not explicitly tell us anything and almost seem to contrive their mysterious ways, ensuring we don't quite know all that they think of us.

Consider the behaviors that we still struggle to give reason to (or to at least agree on the reasons for). There are many differences between what the scientist might say about a cat's habit of kneading your lap with its paws and what you might think. It is now recognized that cats do this because they remain infantilized in relation to your eternal mother position. They perform the same action when seeking milk from the teat as kittens as they do later on your lap, because they still hold that kitten-like relationship to you, even when they are the biggest tomcat in the garden. You might still prefer to think they are just making themselves comfortable, or telling you to flatten out a bit, or whatever—everybody thinks they know their cat best. It is also easy to take issue with zoologists, when their theories on cat behavior seem riven with conflict. The idea of the human owner being a fill-in cat parent is turned on its head when science explains away your darling cat's habit of depositing some bloodied half-alive prey in front of you. "Ugh, take that away!" you think or even shout—but the cat, apparently, is educating you and is not requiring instruction. In this situation you are not the parent figure, but the inadequately taught family member who needs to be brought up to speed on their hunting skills. What you are seeing, before you shoo the gruesome spectacle away, is a demonstration of how to go about effective vermin hunting, and how to safely derive maximum pleasure from the activity. At least this is what zoologists have argued. Most people encountering this performance are convinced their cat is simply a sadist with no sensitivity to others' feelings—mouse or human—or a boastful sadist of an even more warped mentality who has to have an audience.

This is because, of course, we can only see cats through our own eyes and our own idea of what is appropriate behavior and motivation. As with any animal, we view them and interpret their actions as extensions of ours—we just can't help it. We are at the center of our world, even if science tells us that the world goes around the sun and that animals are in fact beings with a very different sense (or lack of sense) of self. It is called anthropocentrism—which is a big word for our small-mindedness, and our inability to see beyond our own lives. And when we see in an animal appearances and activities that we read in quasi-human terms, we are imposing anthropomorphic values on that animal.

And when it comes to the domestic cat, we just can't stop doing these self-centered things. Perhaps the cat behavior we get most confused about is the "wagging" of the tail. Of course, it doesn't really wag much—usually more of a wave—but we immediately need to categorize the behavior into the familiar and so we associate it with the wagging dog tail. And then we have to work out a way of accounting for the radical difference between the simplicity of a wagging dog tail—which seems to state "Hello! I'm enjoying this, are you?"—and the ambiguous waving or switching motion of a cat tail, which does not signal a fawning, overenthusiastic happy cat (sorry if those adjectives offend, dog lovers). But neither does the cat tail "wag" indicate an angry temperament, which is what is so commonly thought. In interpreting the "wag" in this way, we are simply imposing the conflict story we always tend to on cats and dogs, reducing them to cartoon enemies leading oppositional lives.

Our domestication of the cat perhaps causes us to feel that a moving tail should be something we can easily interpret, when in truth it has a range of expressions. While open for interpretation, they are not particularly designed for our appreciation. Even today, not all the finer inflections of cat-tail display and movement are easily agreed upon among experts. Between a madly swishing tail that should tell you to back off if human, or run like the wind if you are prey, and a gentle swishing movement to be seen in moments of indecision, such as standing by the back door wondering whether to go out in the rain or stay in, there are many variants involving bristling of the hair or being more or less expressive with the tip.

And if that is all going on with the tail, let's not get started on the potential for a misreading of cat sounds. They are a language that we can guess at, that we can have received wisdom to apply, and through experience come to have confident responses to, but we

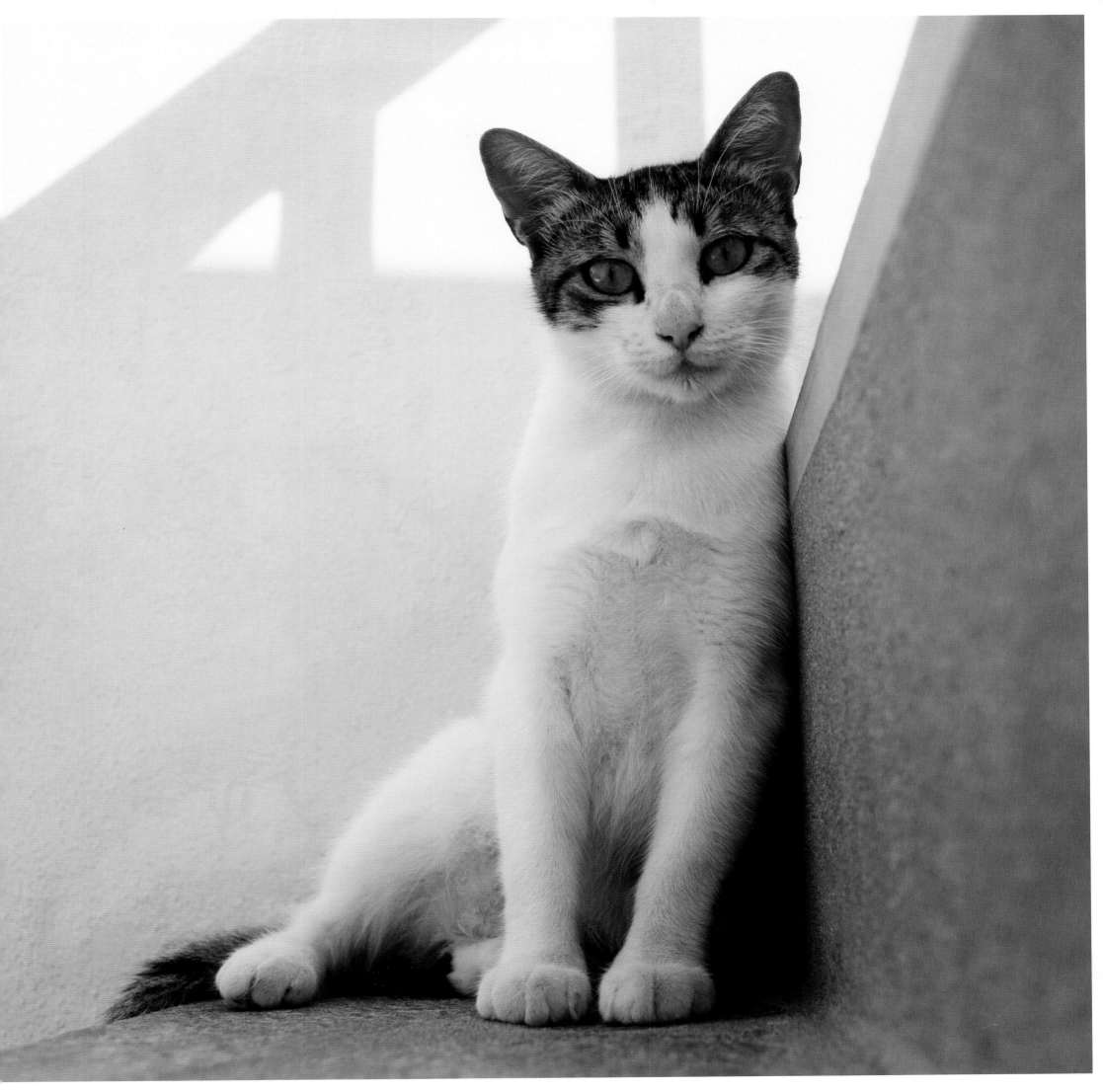

never really know for sure. Does the meow we think means "food" not actually mean "Why can't you serve something different for a change?" The fact is, we are not cats and we have done relatively little to tame them into beings that operate as extensions of ourselves (unlike dogs, horses, and the various unfortunates that we raise to eat). We live side-by-side and find ways of getting the most out of our limited comprehension.

We might think we should know more. As with other domestic animals, it is easy to think that a cat is what we have made it . . . only we haven't done much making here. We are increasingly accustomed to seeing breeding programs and genetic manipulation deliver designer life-forms, but cats have largely been left alone. Given our desire for cats to play a part in our lives, the laws of supply and demand would seem to require that cats be delivered carefully attuned to our every need—but this has not really been the case, even though it happens with so many other domestic animals. Occasionally it occurs in some of the newer breeds of cats: a new kitten on the block that becomes fashionable. But whether it is the haughty elegance of the Siamese or the luxurious coat of the Russian Blue that comes to mind, or a host of other breeds, there is little real underlying difference in function that we can clearly articulate. There is something inherently "other" about the cat, and we can't quite pin it down to meet our functional needs in the way that we can with other pets. When it comes to cats, our needs are not always so easily understood; we can't really break them down, and perhaps our need is best defined as wanting "cat" in our lives. Given the subtle and almost infinite variety of non-pedigree cats that we keep as cherished pets (an emphasis on random breeding that is perhaps stronger than with dog owners), it would seem that cats, for most of us, are not something to be so easily typecast as other domestic creatures.

Cats behave in ways that relate to how we wish to live with them. They eat the food we put out, they patrol territory and catch small creatures (if needed and if not), and they sleep a lot and look cute while doing so, thereby making us feel happy. They sit on our laps and purr, making us think they might be happy, which in turn makes us happy, but in both these regards we may discover we are mistaken. And yet they do much more, having many tendencies that are not designed to fit our requirements or that leave us baffled, or even ignorant. Of course, many cat lovers choose to avoid recognizing this. There are hundreds, if not thousands, of blogs and forums, along with millions of images uploaded in social media, where highly specific and curiously human attributes are assigned to innocent cats going about their unexplained business. But, as with any humans we love, we would rather think we understand the objects of our devotion. So we impose the nice thoughts we have on the other partner, be that a lover or a pet. At some point, misreading the signals can lead to a need for serious correction: with our fellow humans this may require serious retail therapy, a groveling apology, or a visit to the divorce court; with a cat you may be surprised by claws, or surprised by a no-show, or merely by some ongoing unfathomable behavior.

The cat's life, lived in our midst, remains a mystery in many ways. And that is part of its attraction to us, of course. A cat is like a work of art, in that it is the subtle differences from anything we have yet encountered, but which emerge from the familiar, which create in us sparks of delight and insight.

Contrast this with the dog, which we tend to position as a principal rival in the pet stakes for human affection and employment. The dog is developed to do our bidding, and by and large does this if it is well trained (walking to heel or on a leash, coming when called, and executing various duties if so conditioned). But if poorly trained, it demonstrates various functional inadequacies (such as barking when not needed, or chasing after other creatures, or not coming to heel). A dog functions or malfunctions, and often manages both. (I write this also as a dog lover: I am one of that large group that straddles the middle ground, able to see unlimited virtues in both cats and dogs.)

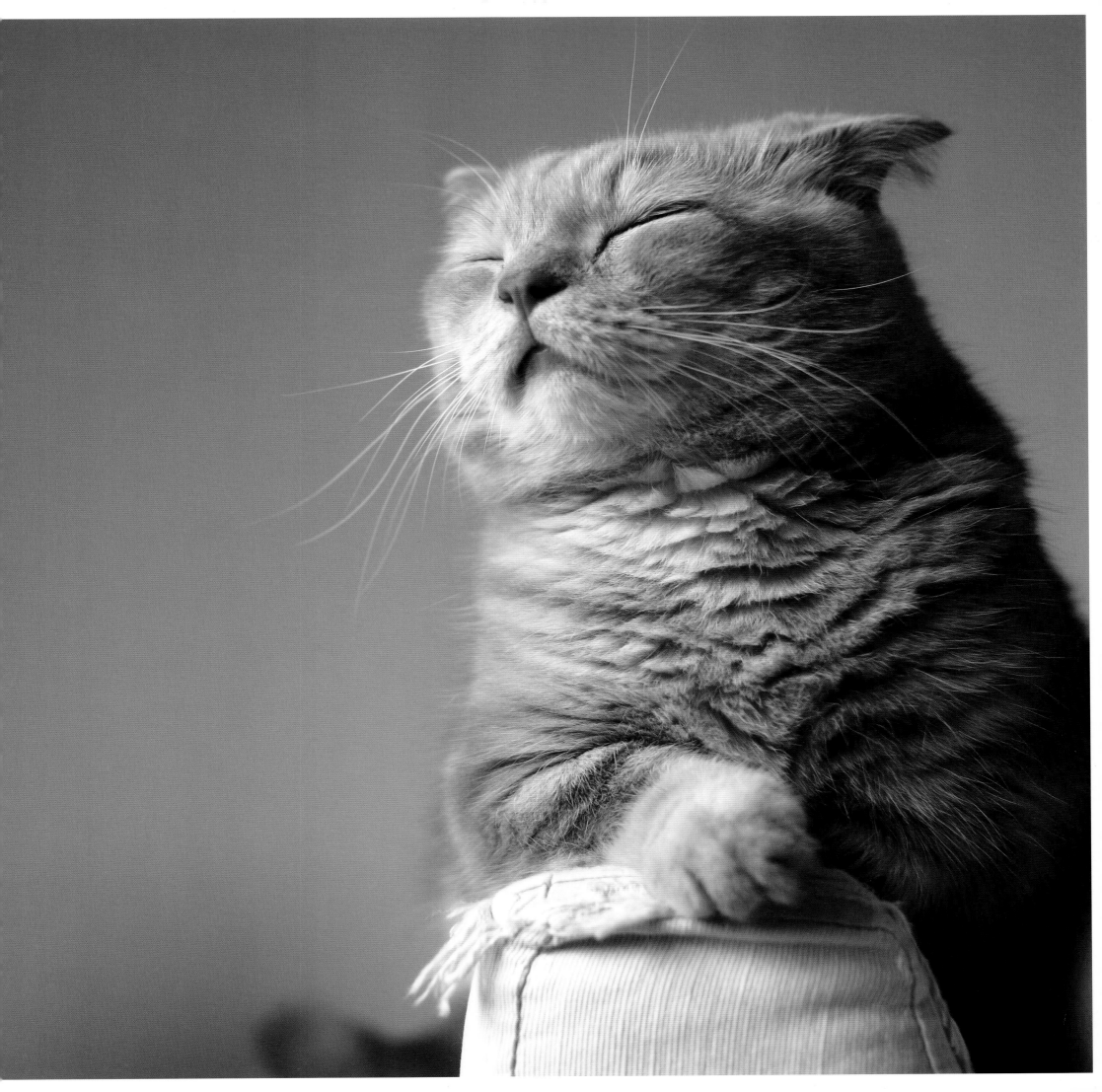

The cat has proved a lot less pliable to our will and our science. Dogs demonstrably want our company, our leadership. Across their various breeds they display attributes that enable us to outsource a whole range of tasks—from hunting to guarding, to fetching and herding, to sitting on our laps and keeping us warm. Cats demonstrably do what cats want to do, and, if this coincides with our needs, then we might get along just fine. So we try to encourage these points of shared interest, but in general it seems the cat itself will decide—not some system of training. For sure, you may get through some imposition of mealtime discipline or toilet training, but don't get carried away: you will not be able to teach your cat tricks.

The core shared functionality that is at the origin of the relationship—the compulsion to hunt—can be a curse as much, if not more than, a blessing in today's homes. Cats like to catch, torment, and murder creatures, and for the most part, but not always, we are happy to have them do this (although we would prefer they did not confront us with the evidence, which they are only too inclined to do). The victimization of birds rather than mice can be undesirable, and verges on the environmentally unacceptable. I have an eminent naturalist as a neighbor who thinks it is a genocide-like crime that people own cats who cause such damage to the bird population. But there is little we can do other than lock the cats up, or do to them what they have done to the birds.

And that is not going to happen. For cat lovers, the truth is that it is the mix of the wild with the tame that we find appealing. We are drawn to this domesticated creature because it remains un-fathomable and distant, yet also displays real curiosity about us too. It is as if from time to time it is intrigued by the mystery of humanity as much as we are intrigued by it. "Human and cat, we try to transcend what separates us," said Doris Lessing, the 2007 Nobel Prize for Literature winner, in her fond memoir of El Magnifico, one of the many cats she has known. And it is that opportunity to take our thoughts to some space that is neither human nor cat, but is facilitated by meditating on cats, that perhaps explains the secret functionality of this domestication. Where other tamed creatures serve a physical purpose, the cat has by chance and design evolved in our lives to serve a spiritual one.

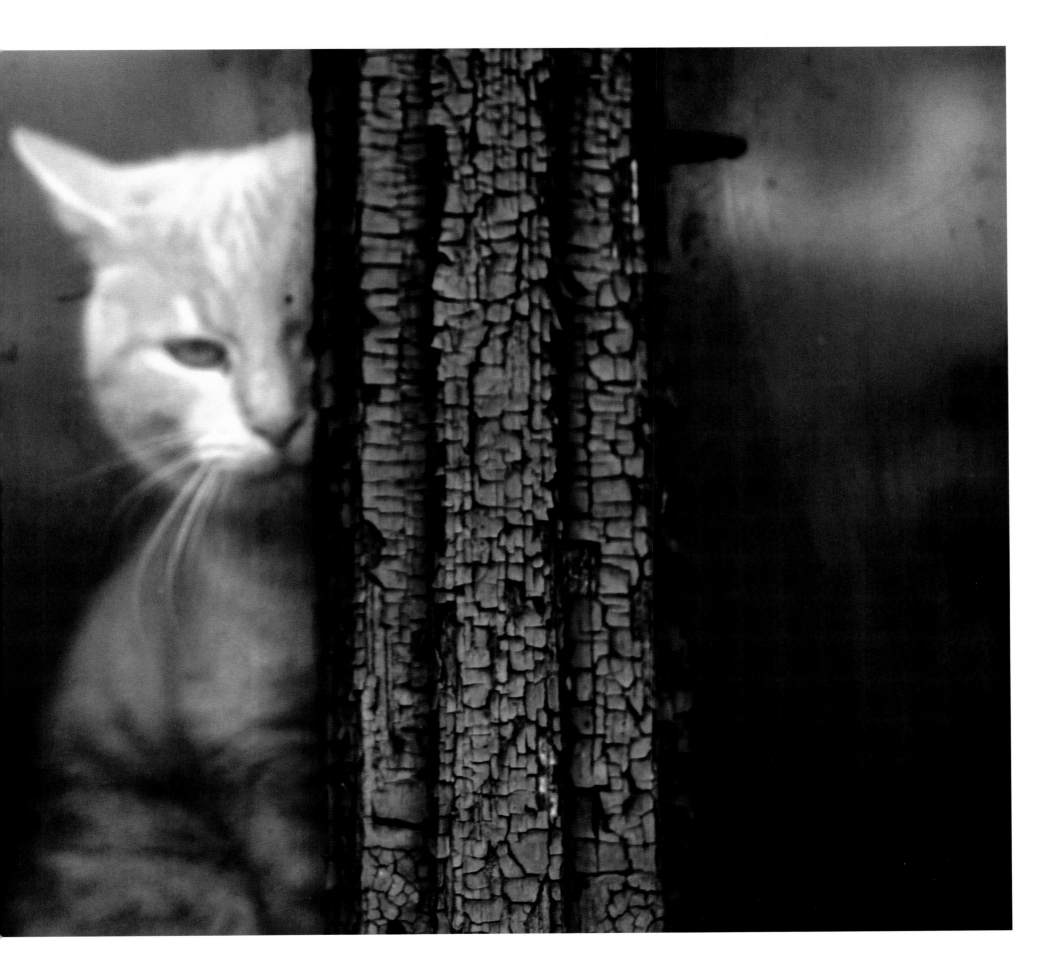

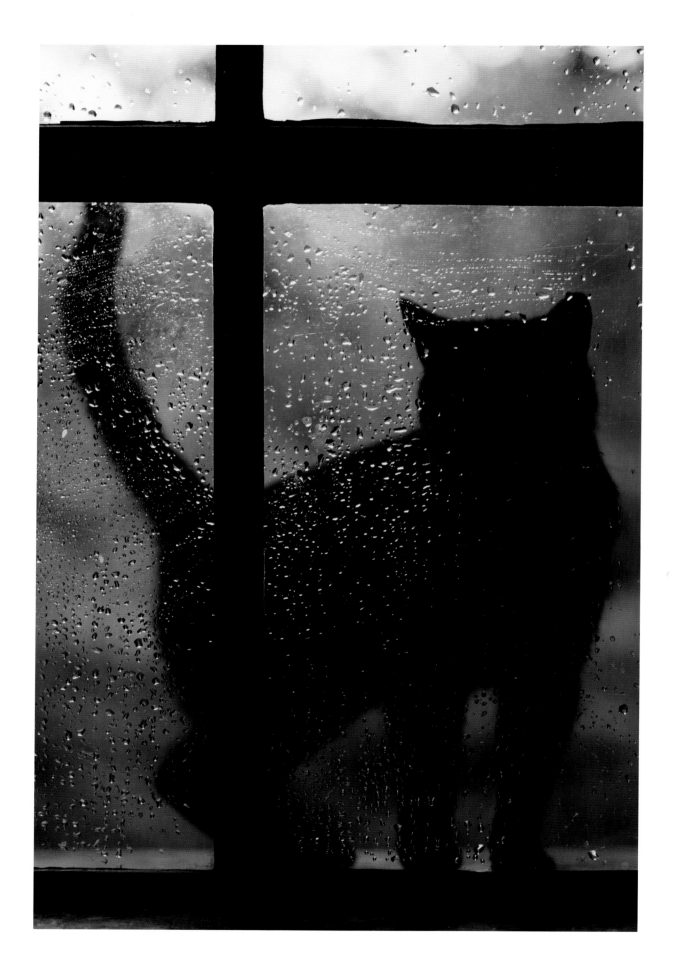

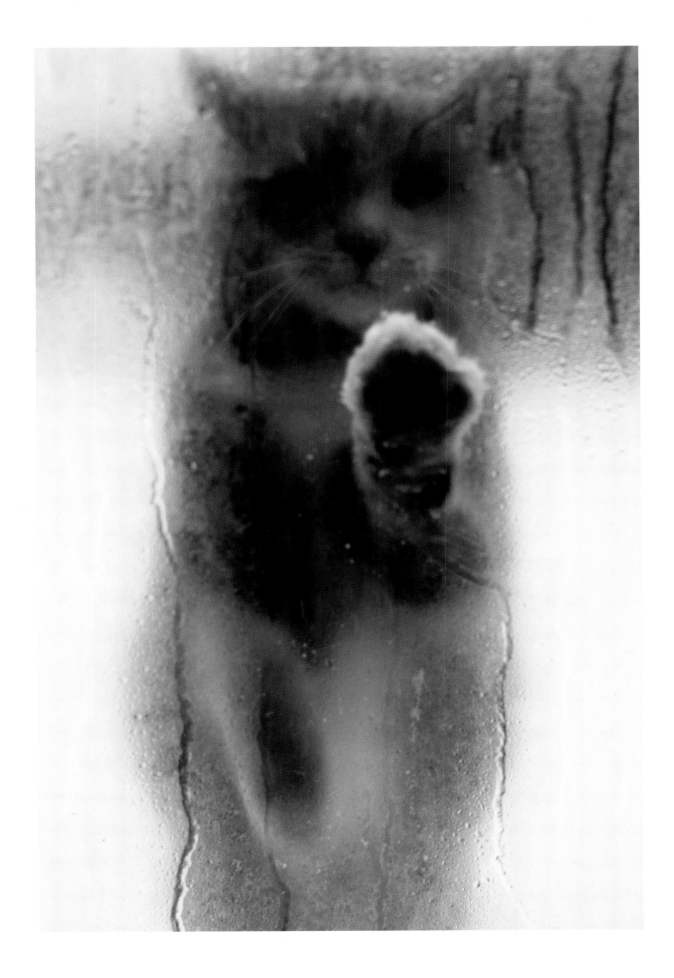

They are wild at heart, with a veneer of domestication

that helps them live alongside us.

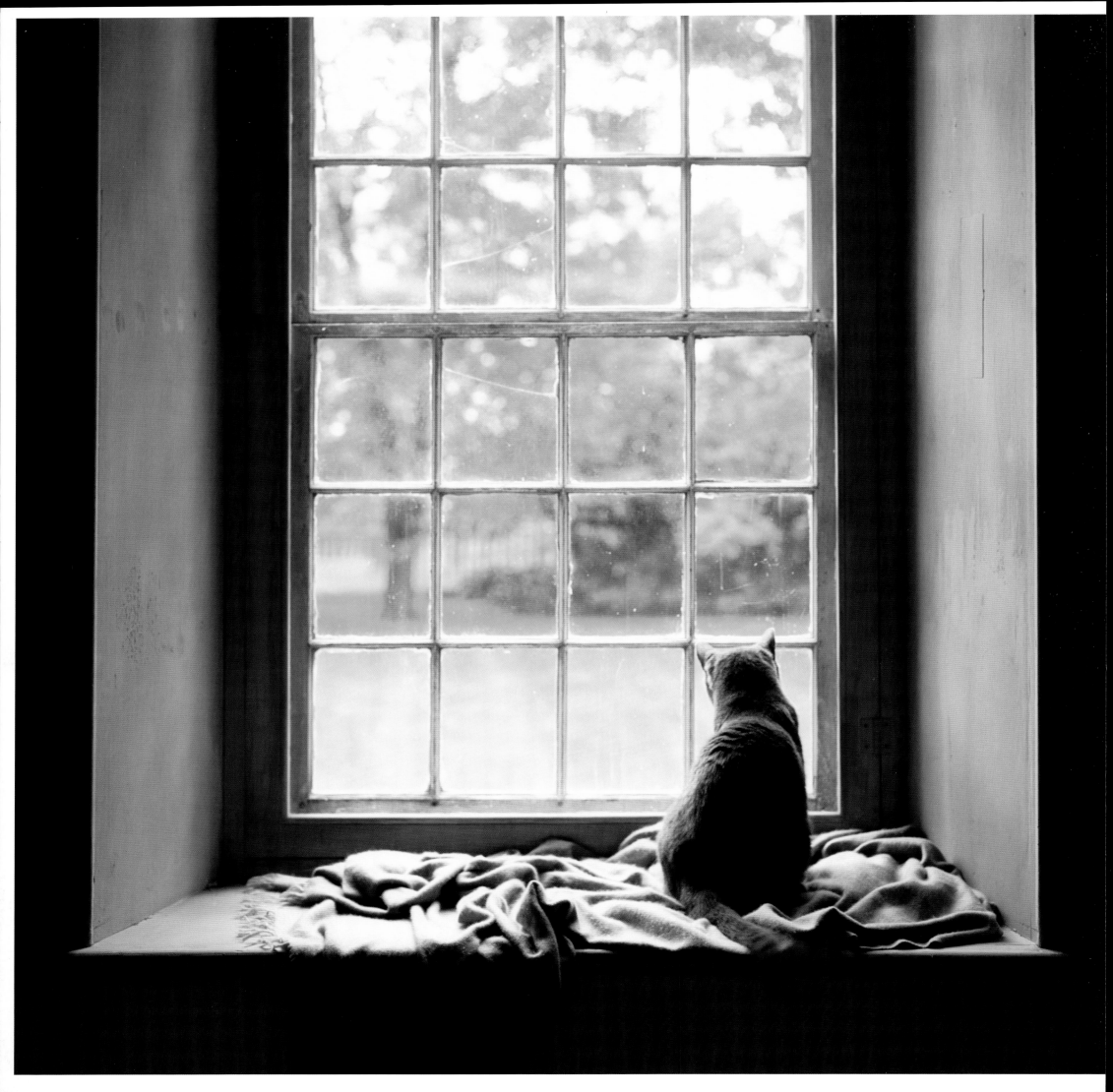

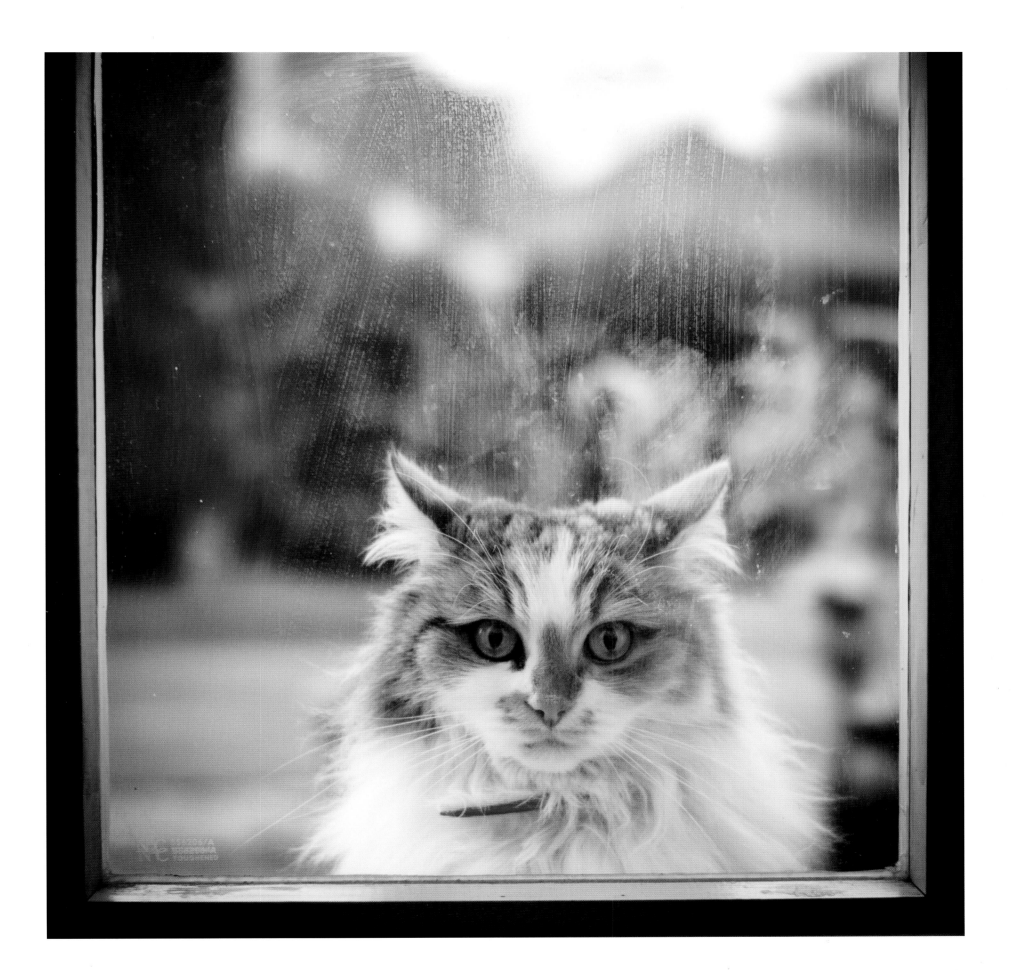

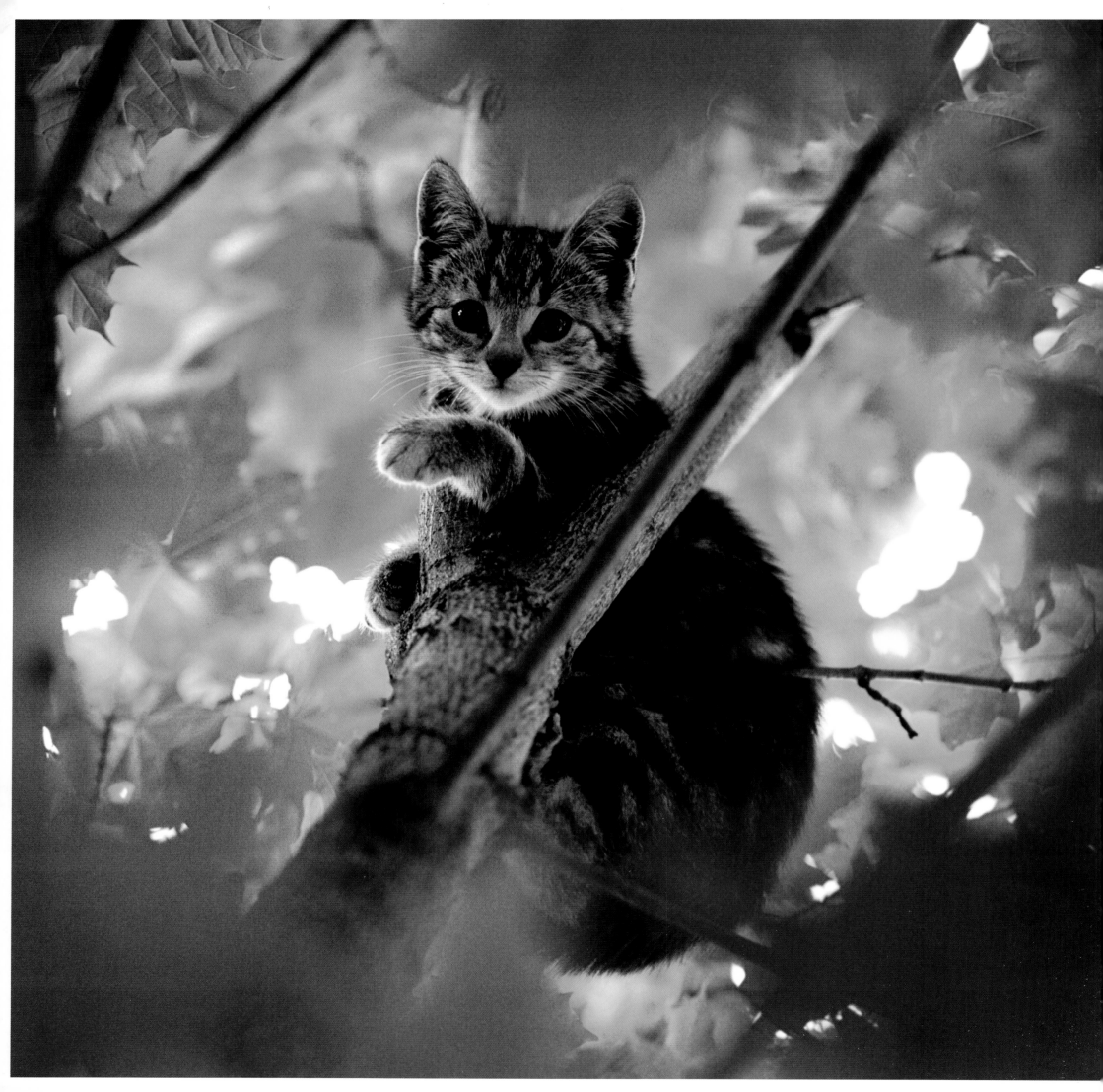

Usually you can tell when a cat is up a tree. You can tell by the distraught children, anxious owners, sympathetic neighbors, and excited dogs who surround the tree.

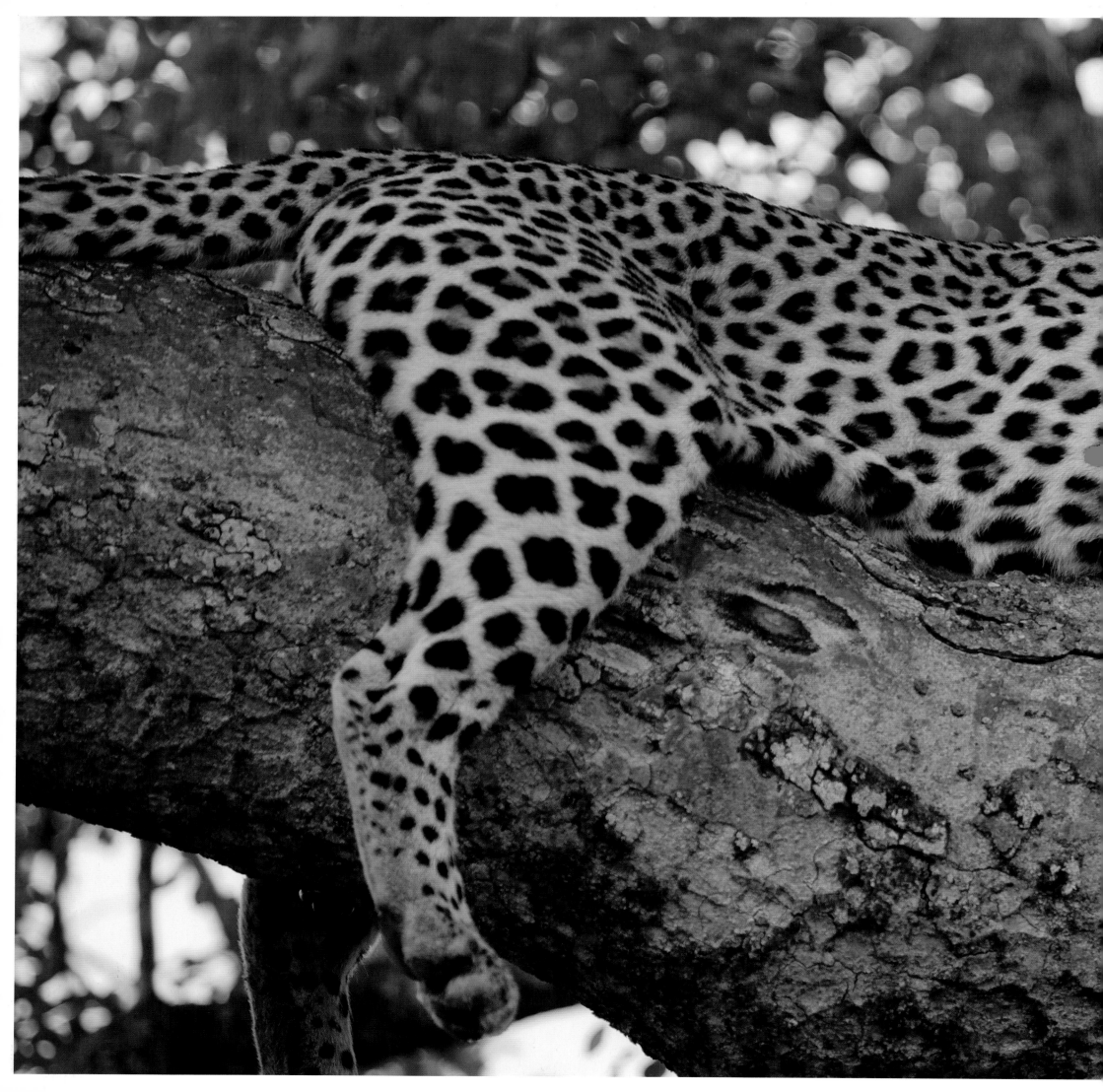

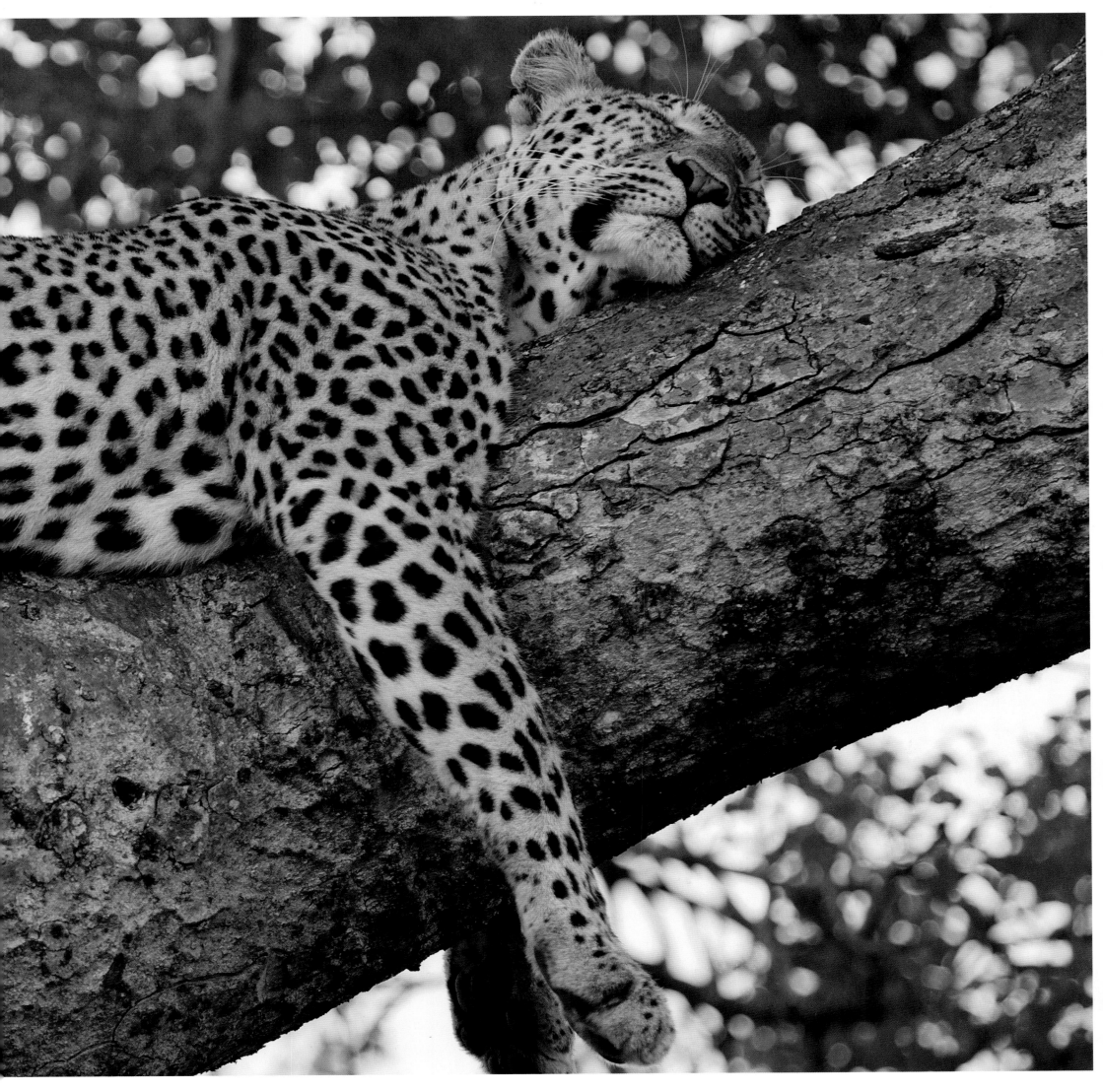

Wild

I am inclined to divide the cats in my life into two kinds: city cats and country cats. Having grown up in a remote village, then having lived my adult life in a big city, and now spending some time every year in a rural town in a different country, I have enjoyed an assortment of cat friendships. There have been cats that would catch a rabbit for breakfast in the country, while in a city apartment another would climb into my bed (definitely not one and the same cat, and certainly not behaviors I would want to see mixed).

On the face of it, they would seem to be two different creatures altogether. What would a sleek—or, you might say, fat—Persian that is accustomed to premium feeding, a choice of comfy chairs to idle the day away in, a window onto the city street, and a walled garden for a safe stroll, have to say to the twitchy and scarred inbreds that now hang around the back door of our country home, hoping for a handout of almost anything, even an oil-soaked piece of stale bread? While I might struggle to switch my English to Italian in the move between the two locations, the cats would seem to be from two worlds. But as with humans, where beneath the differences we quickly find a nature that holds many things in common—for good or bad—so it is with cats. Lifestyles come and go, but underneath the appearances, the true nature will win out.

That city slicker and the rough country cousin have much in common: living intensely in the moment with what is probably a similar mind-set, if different circumstances. Both retain a wildness in their natures: they stalk a territory, whether hunting for birds in the garden or mice in the field, both cleaning themselves methodically at regular intervals during the day to suppress any giveaway scent, and resting for eighteen to twenty hours of twenty-four, seeking their quiet corner—whether in the back of the barn or the master bedroom. They are wild at heart, with a veneer of domestication that helps them live alongside us. We engage in their wild ways, and encourage the mouse-catching while lamenting the bird-murdering. How different this is from the human-designed dependencies and manipulated genes that many other pets and domestic creatures possess.

Just how close *Felis catus* remains to its wild origins is demonstrated by an exploration of its evolution—it has been continually remixing its genes back into the wildcat populations. Concern has been raised in recent years about the genetic purity of the European wildcat and the African wildcat. Both are endangered perhaps due to the success of their domestic offshoot: pure wildcats occasionally mate with feral and domestic cats, and as a result the gene pool of the wildcat is contaminated the world over. This marks the success of the domestic cat, which has spread into just about every civilization in the world (with exception of the odd tribe tucked away deep in a virgin rainforest or protected island). The genes of the house cat are flexible and adaptable, putting most species to shame. Rather like their human partners, the domestic cat quickly fits into different situations and learns to survive and thrive. As a result, it intrudes on other life-forms around the world, including its own ancestral species.

In Africa, US-based group Alley Cat Rescue has been among the backers of an initiative to spay or neuter feral domestic cats in an attempt to reduce the erosion of the pure wildcat. It has sent funds and help back to Africa, in particular supporting an initiative to clamp down on the intrusion of feral cats into game parks where wildcats are more common and most likely to retain pure breeding. In Scotland, there have been similar attempts to protect and encourage the Scottish wildcat (a variant of the European wildcat). A 2001 study suggested that no purebred wildcats have survived, and that at some point domestic cat genes have become fully mixed across the wildcat population. Most endangered of all wild subspecies is probably the Asian wildcat, which has disappeared from much of the wide territory it was once native in, and has seen its genetic purity seriously undermined by its mixing with domestic and feral cats.

The accidental mix of wild and domestic is one thing. In recent times, though, the culture of designer breeding and trophy pets has led to several new exotic crossbreeds. The most popular of these is probably the savannah, a cross between a domestic cat and the serval, which is a mid-sized cat that lives on the African savanna. The result is an animal that can weigh as much as thirty-three pounds, perhaps three times that of the usual mixed-breed. Savannah breeders and owners speak highly of its temperament, not surprisingly, as they have a lot at stake—not just their love of the creatures, but the very hefty price tag that is attached to the kittens. There is some opposition to the keeping of such creatures, whose temperament is not entirely proven, the cat having claws and teeth that can inflict more damage than the average domestic cat.

Another crossbreed is the safari, which is a mix of the South American Geoffroy's cat and a house cat. The Geoffroy's cat is an endangered wild breed that is about the same size as a domestic cat; however, a first-generation cross with a domestic cat can produce offspring that will be double in size (seemingly a result of the Geoffroy's only having thirty-six instead of thirty-eight chromosomes, and the offspring ending up with thirty-seven . . .).

These are still perhaps early days in the development of domestic cat breeding, of further refining and defining the kind of cats we like to live with. There are many other new breeds with a greater or lesser amount of the wild mixed in: the Bengal sees the domestic crossed with the leopard cat (a wild animal from Asia), while the cheetoh then mixes the Bengal with the ocicat (which looks like a wild subspecies but is in fact an all-domestic breed, a mix of Siamese and Abyssinian). The Bengal crossed again with a domestic cat becomes a toyger, while a Bengal crossed with a pedigree Oriental shorthair results in a Serengeti. Then there is the Bristol, which is a domestic crossed with a margay (a small leopard-like feline from South America), while the chausie is a cross with an Asian jungle cat. Confused yet? There are more—some occurring naturally, and many increasingly devised by human intervention. It is as if we want to produce the equivalent of a paint specification chart, but one made up of all the possible variants of cat form, color, and markings.

The sophisticated breeding recipes concocted for the domestic cat may echo some of the curious and often questionable cross-breeding methods that occur with big cats. The liger is the progeny of a male lion and a tigress, while the tiglon is that of a male tiger and a lioness. The liger, like the tiger, is a happy swimmer (unlike many cats),

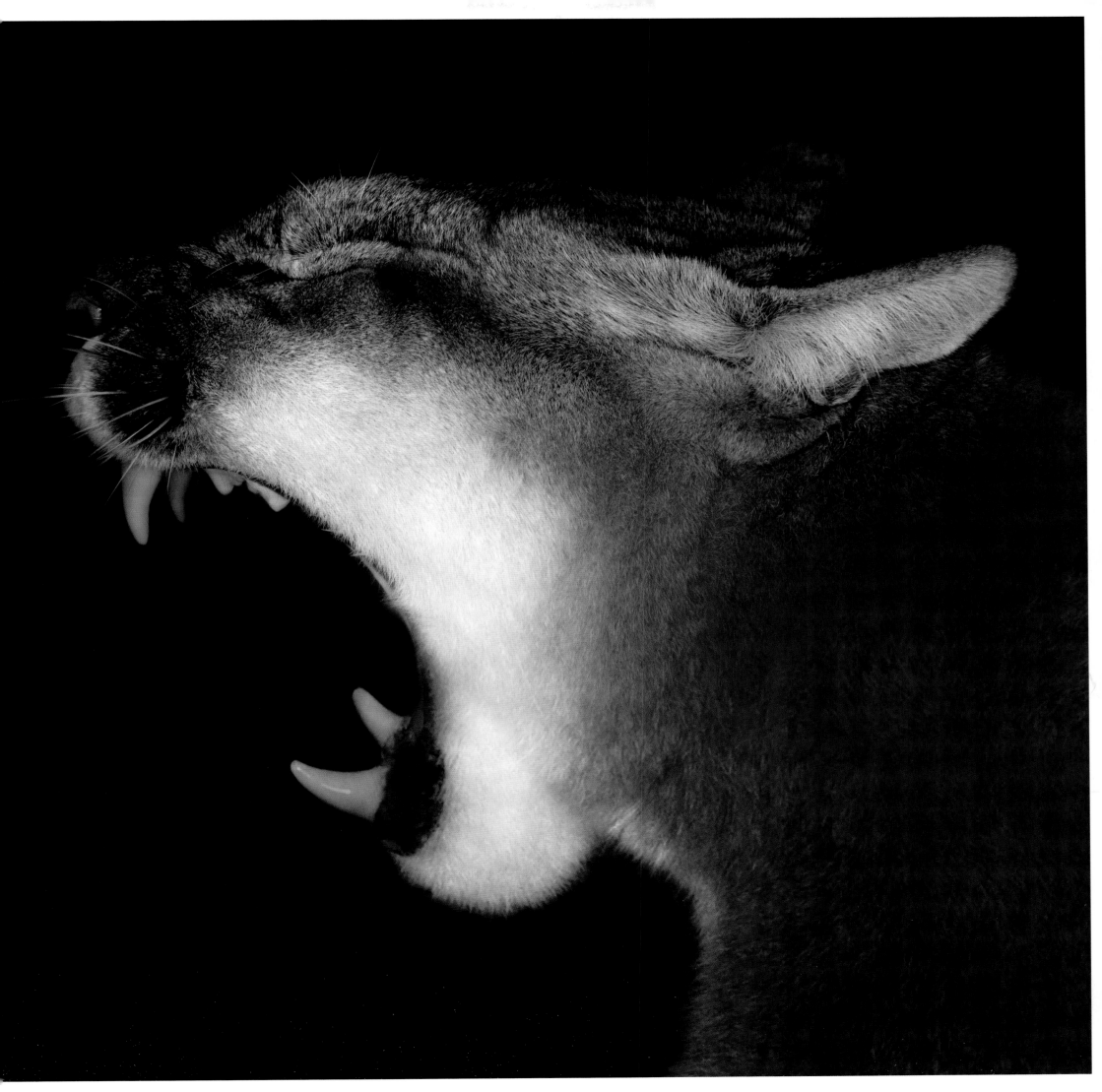

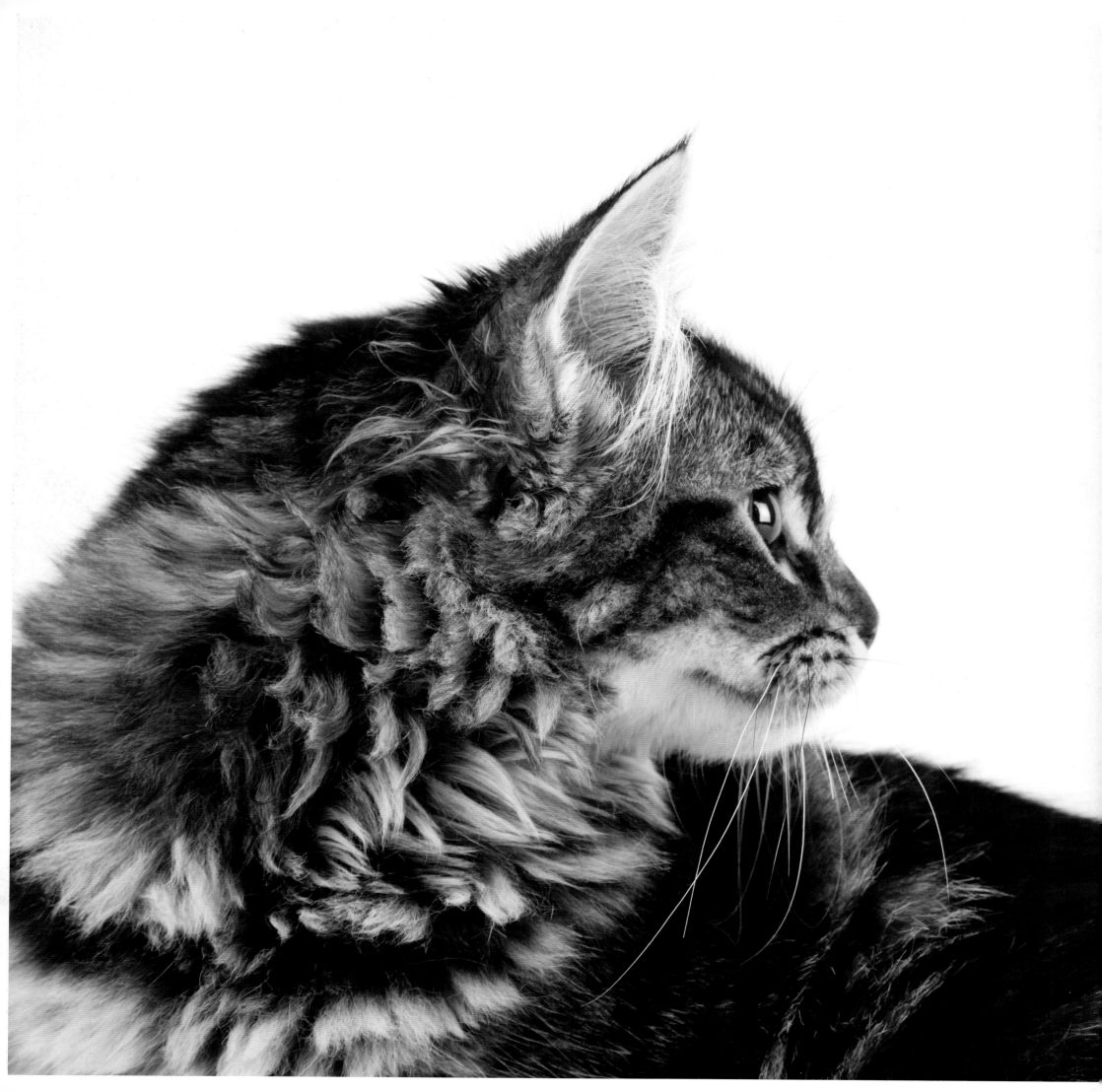

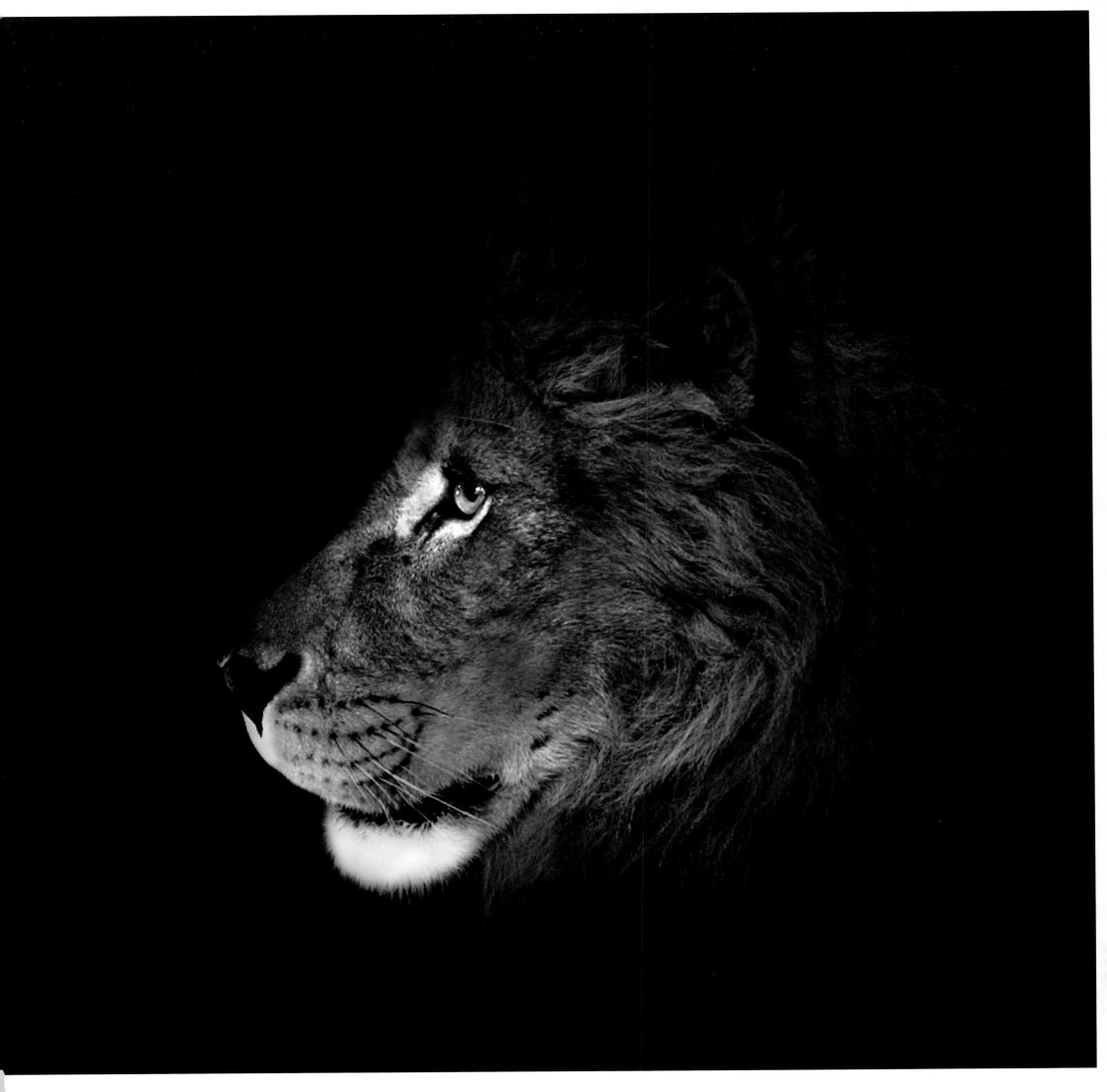

while both varieties are unlikely to occur in the wild. This is because the territories of the tiger and lion have not tended to overlap since the disappearance of the Asian lion. In the United States in particular, where it is thought there are more tigers and tiger crossbreeds held as pets than there are tigers in the wild worldwide, the allure of the big cat has taken feline ownership to strange new proportions. Ligers, the largest cat alive, are prized as some kind of status symbol. It is perhaps an irony that the artificially created liger is about the size of the long-extinct prehistoric American lion.

Just how many other variants of wildcats are possible . . . well, undoubtedly somebody, somewhere is working on creating more. In general, the results seem something of a freak show, not always motivated by the most scientific or ethical of considerations. The creatures often display weaknesses as a result of the genetic crunching, while the general trade in exotic animals means many are created and then kept in inadequate conditions.

However, these numerous crossbreeds of small and large wildcats, and their blends through to the domestic, suggest that we have many more questions we would like to ask about the cat. We still want to define just what it is and what it can be. It is rapidly evolving—and we are pushing it along by artificial means, or at least by helping breeds to spread. The *Felidae* family, which goes back to a common ancestor some ten to fifteen million years ago, seems to maintain a function in our lives that can't be met by other creatures. It even plays a part in defining our humanity: just as we have not got to the bottom of this, neither have we fathomed the meaning of the cat.

When we see a cat out in the garden, climbing a tree with calculated agility, then picking its way along a branch, finally freezing and intently focusing on potential prey, the moment is primordial: the hunter in action, so in-the-moment that time seems to be arrested. The deep, wild unconscious is revealed and takes over: an unchanging urge driving fate forward. Our interest, admiration, or dislike of that behavior is a mark on us, rather than the cat. It is asking questions of what it is to be wild, of what we may once have been as hunters. Today we define ourselves as civilized and expect civility of others, but we don't see ourselves as tame; we would be insulted to be seen as domesticated. And so in our cats, we have a kind of mirror. In that balancing of the wild and free against the house cat's domesticity, we are seeing a reflection of the tensions in our own lives.

Of course, this is just us projecting on to the cat, who is itself always in the moment, never standing back from its own intensity, just shifting between behaviors (at least, that's what we think). It is not troubled by whether it is playing the homely cat or the wild beast. It just is . . . sometimes sweet, sometimes bloody. Sometimes both.

For cat lovers, it is part of the cat's charm that so much wildness remains. While we may be appalled at the murderous slaughter that results, we thrill to the knowledge of the unquenchable individualism and confidence of this furry creature, which perhaps only a few minutes before was another part of our soft furnishings.

This contradiction was perfectly caught—without any sentimentality and with a rich evocation of the mystery—in Rudyard Kipling's *Just So Stories*, in "The Cat that Walked by Himself." After outlining how the cat declined to be servile like other domestic animals, but still managed to trick his way into home comforts on his own terms, the story ends by capturing the tension of how the wild-at-heart cat is at the same time a friend of ours:

He will kill mice and he will be kind to Babies when he is in the house, just as long as they do not pull his tail too hard. But when he has done that, and between times, and when the moon gets up and night comes, he is the Cat that walks by himself, and all places are alike to him. Then he goes out to the Wet Wild Woods or up the Wet Wild Trees or on the Wet Wild Roofs, waving his wild tail and walking by his wild lone.

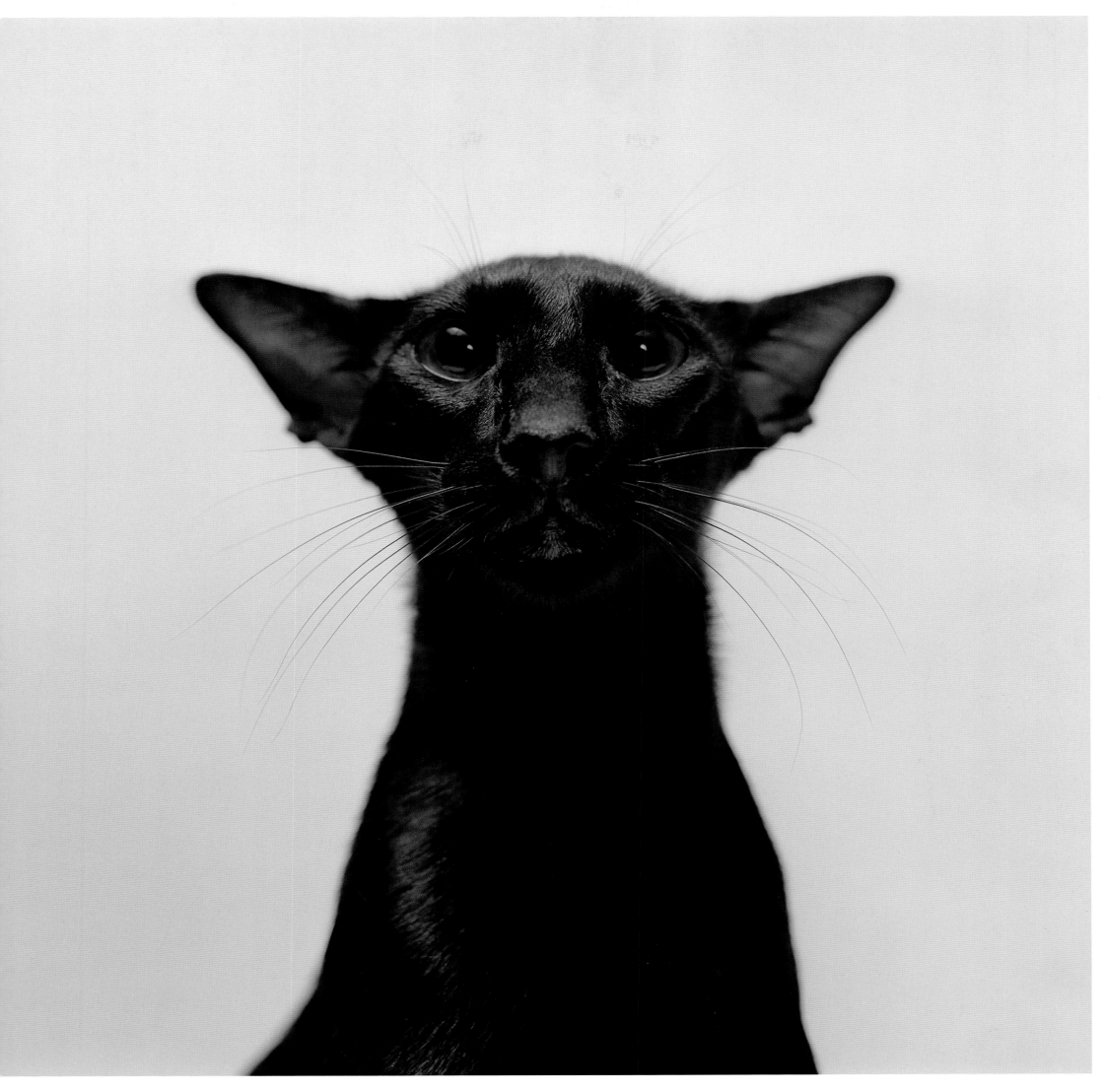

The truth is that it is the mix of the wild

with the tame that we find appealing.

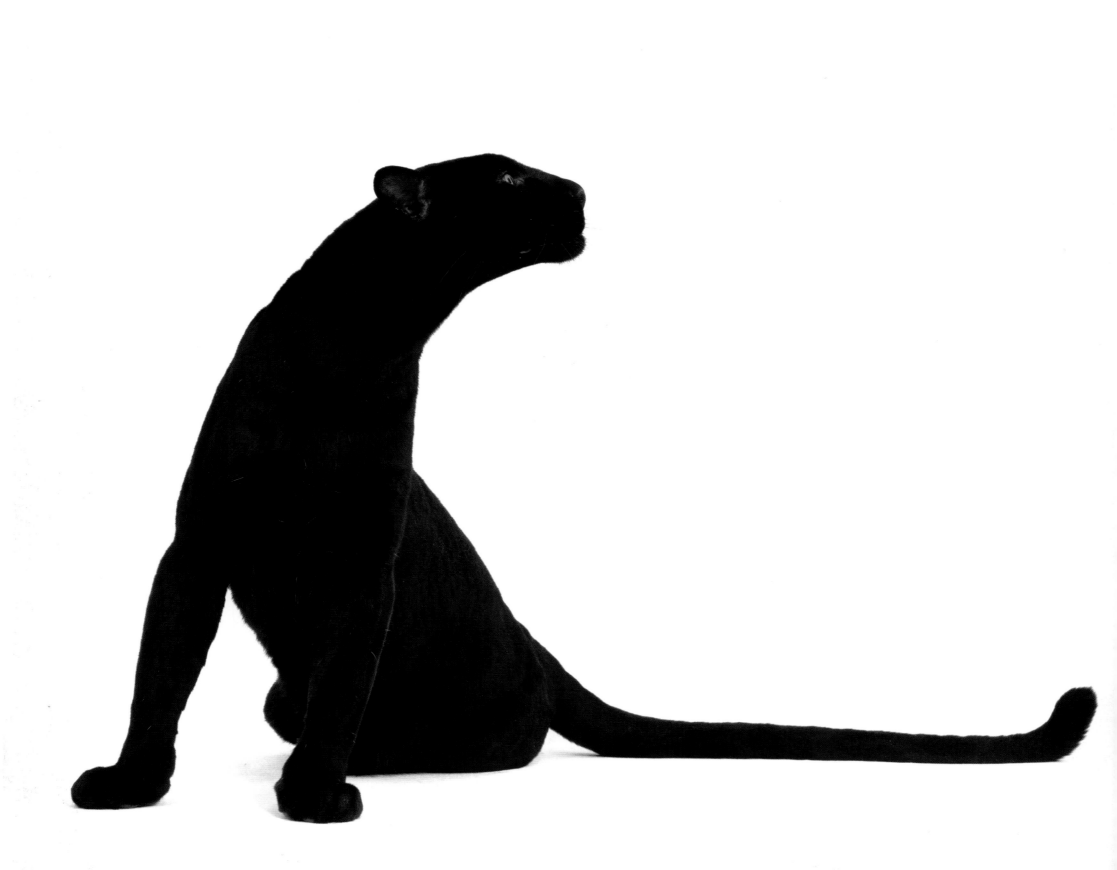

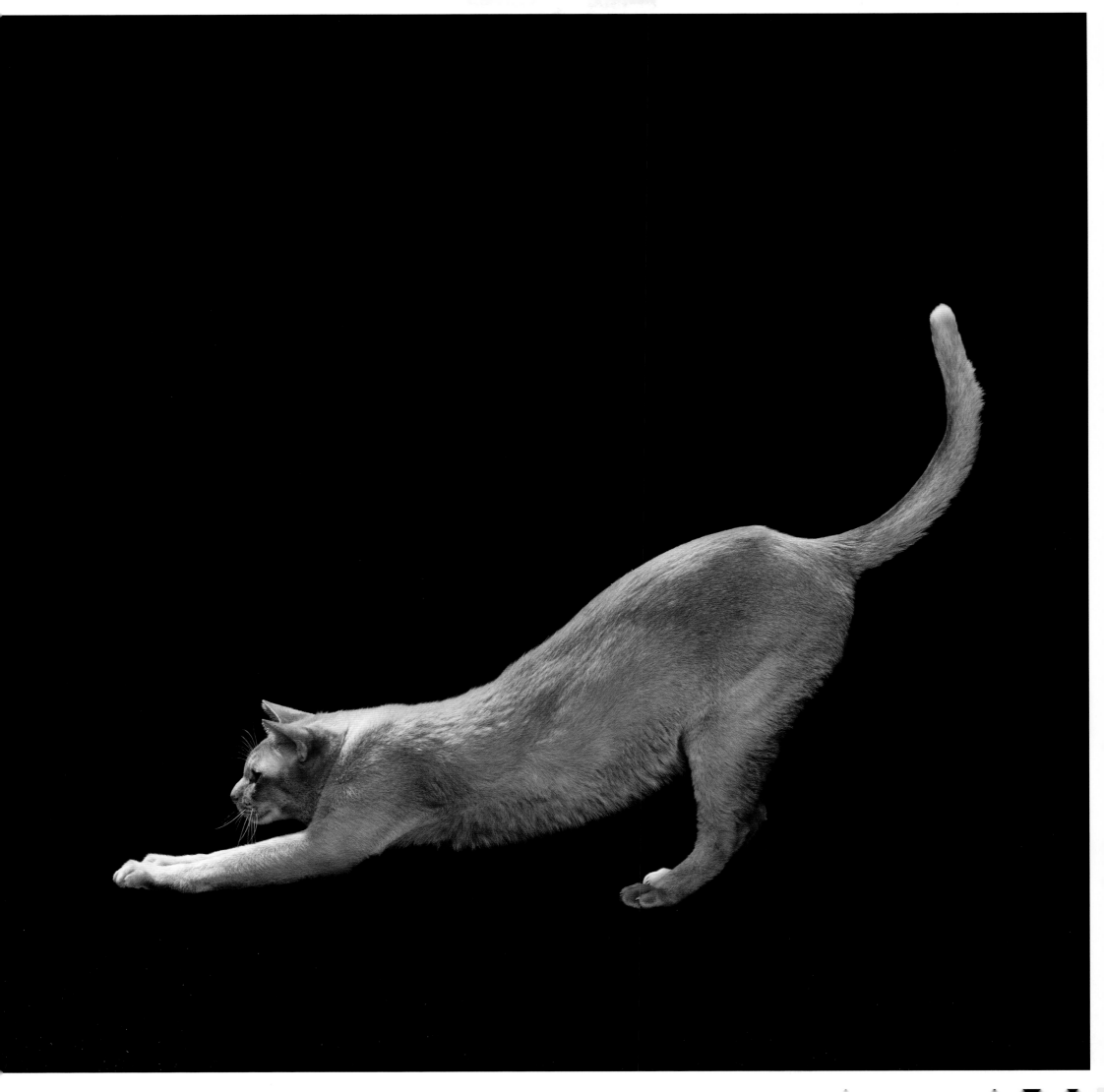

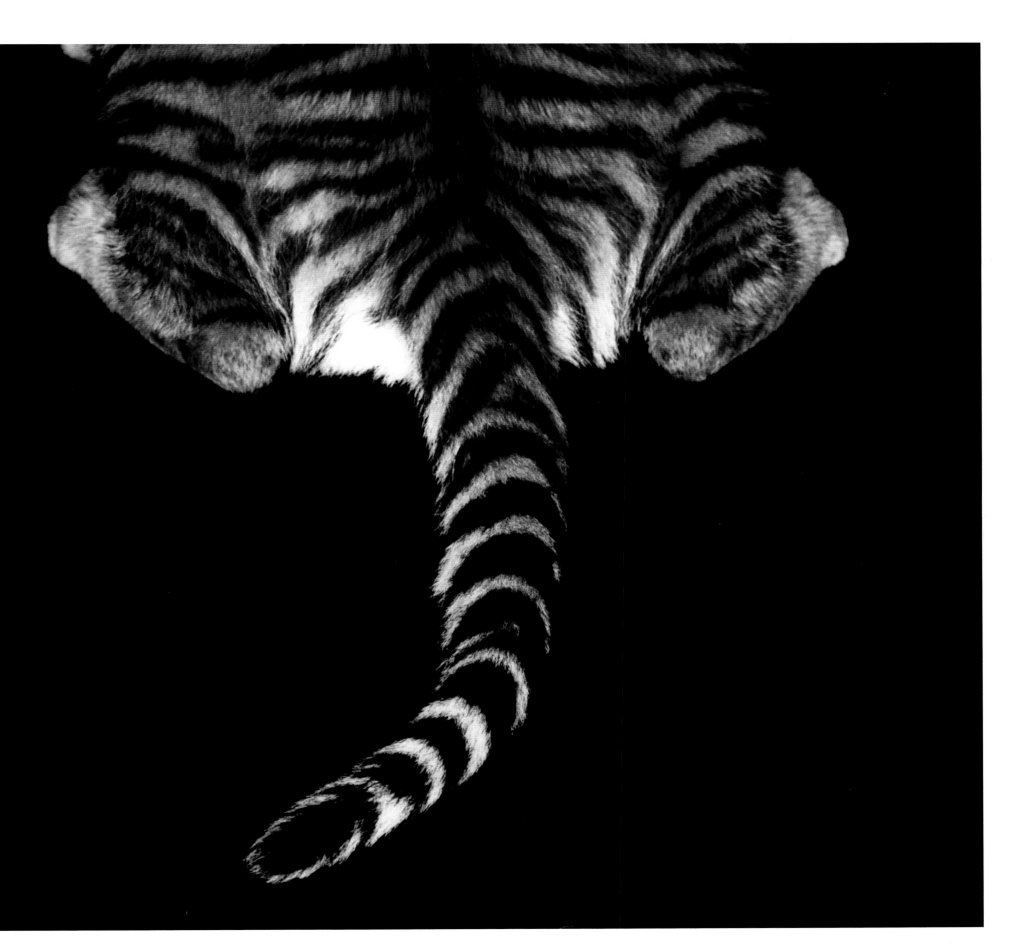

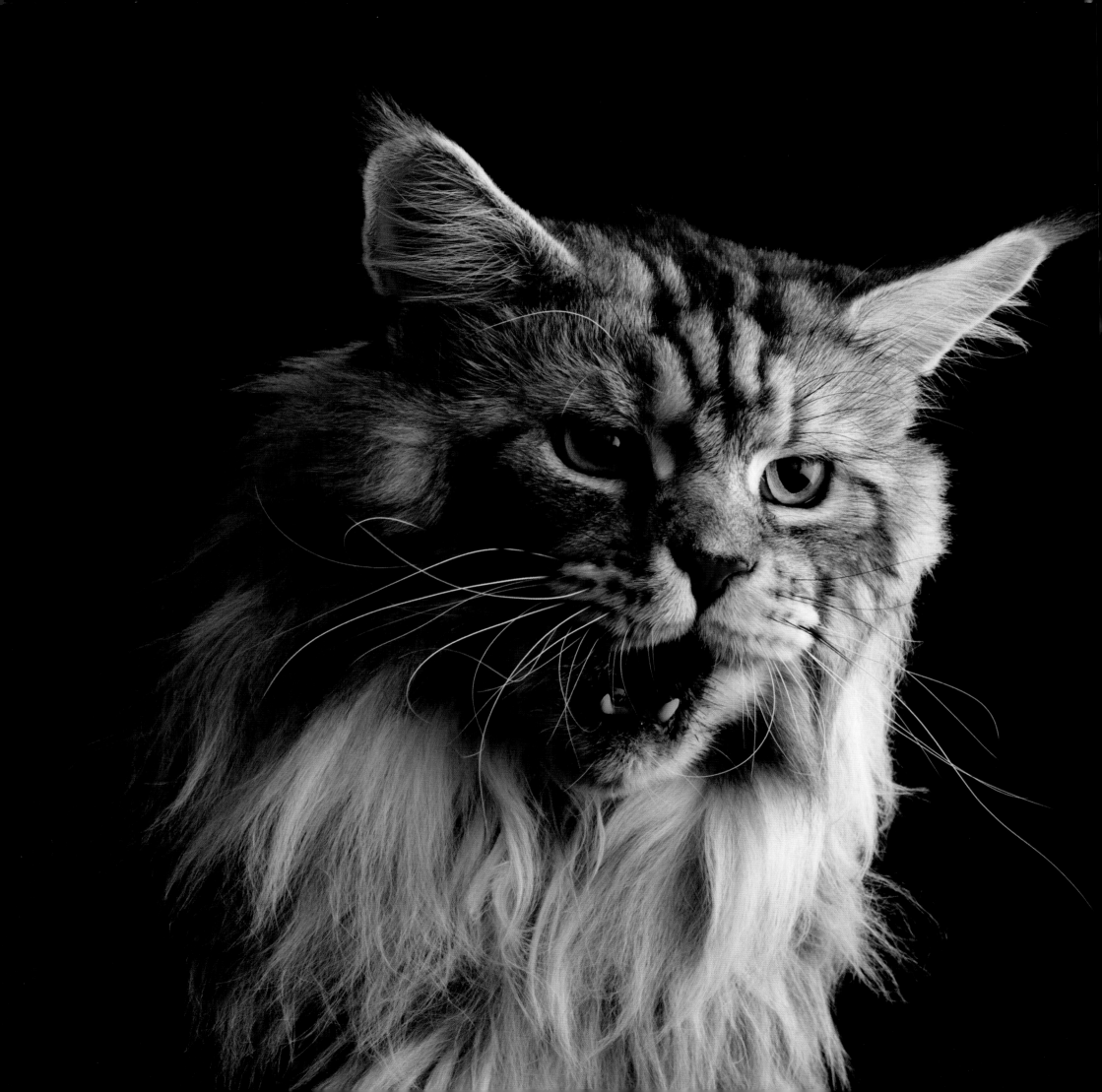

It always gives me a shiver

when I see a cat seeing what I can't see.

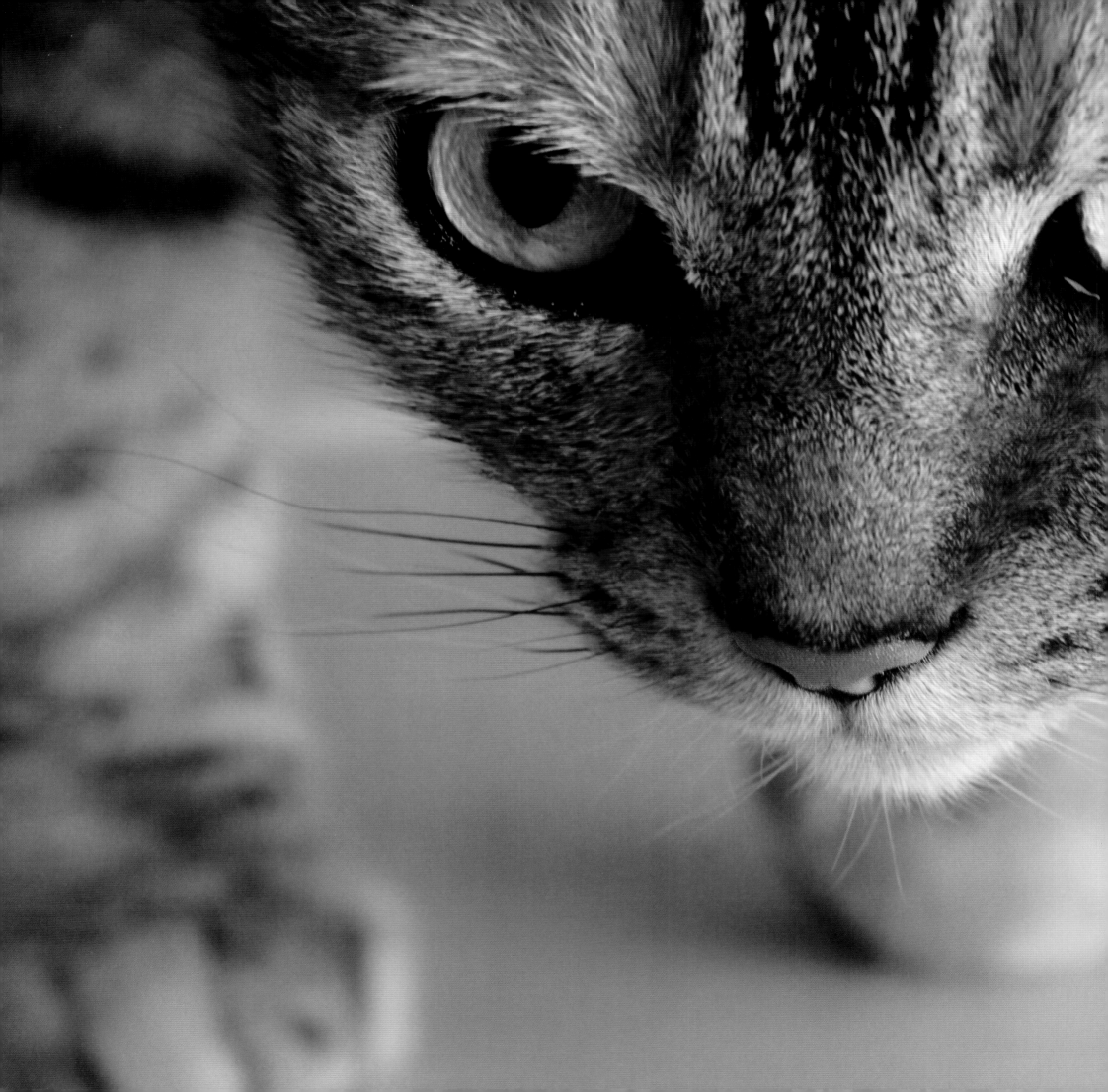

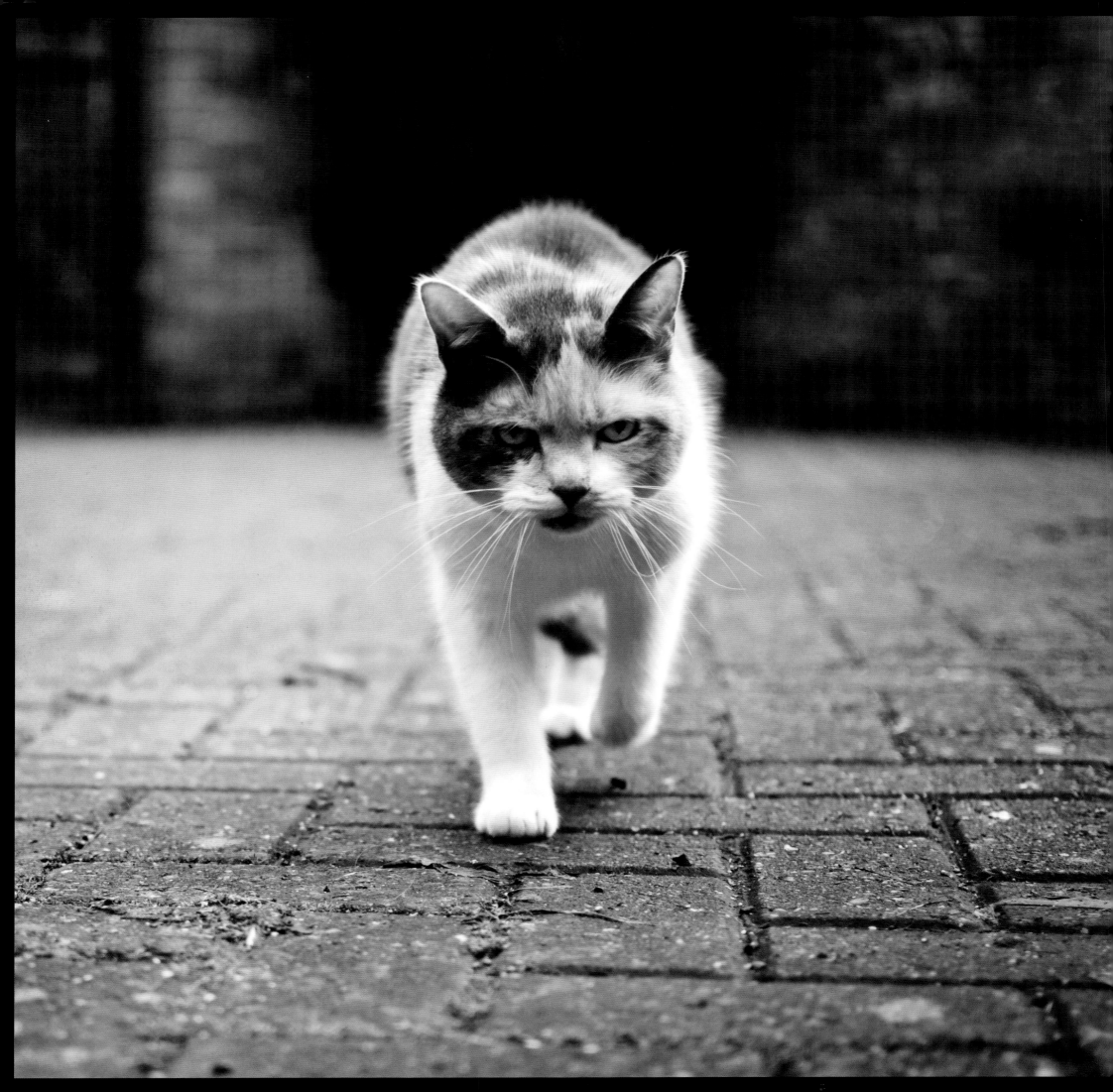

It is practically impossible for a cat lover
to meet a stray feline on the street without
stopping to pass the time of day with him.

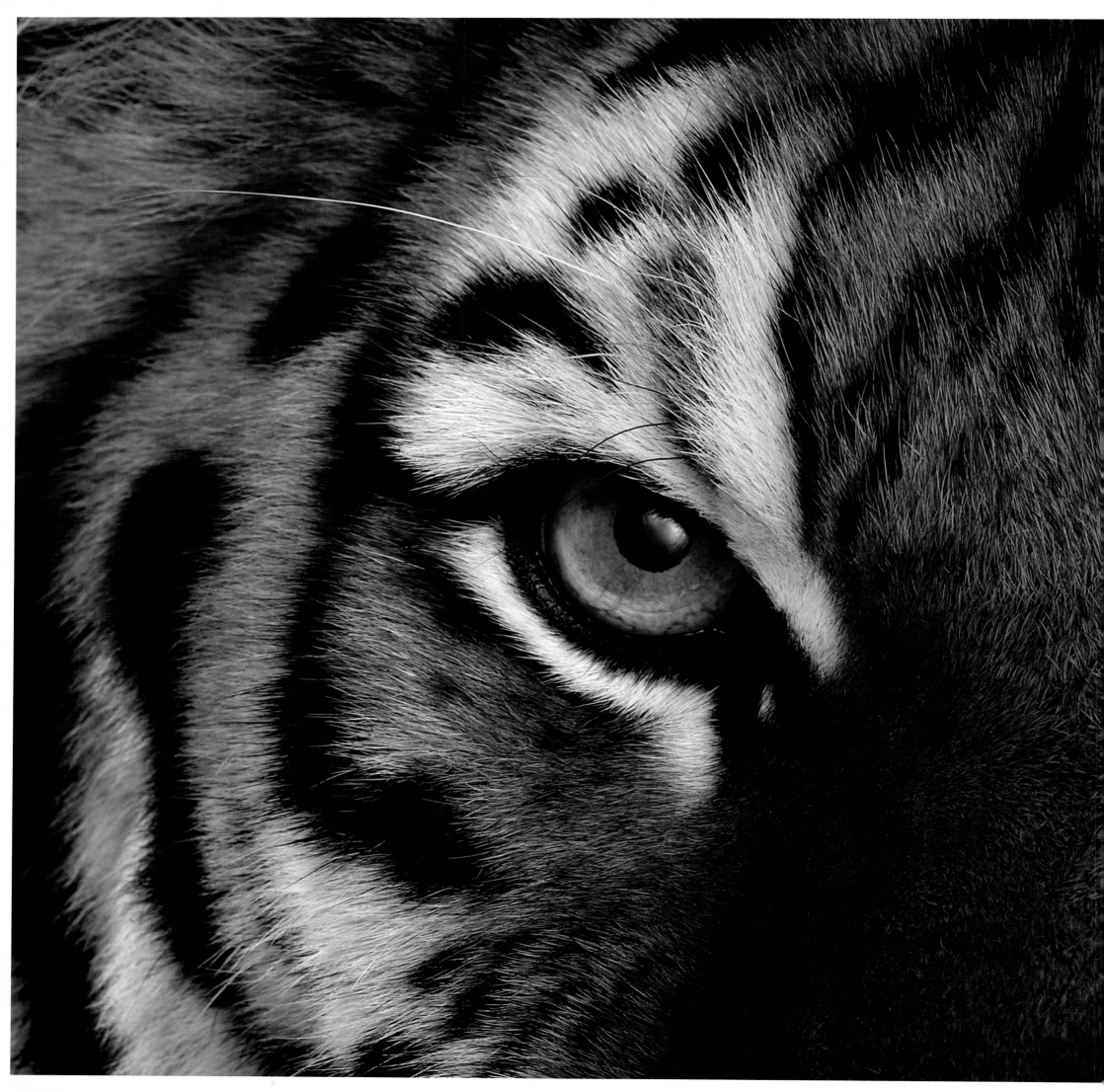

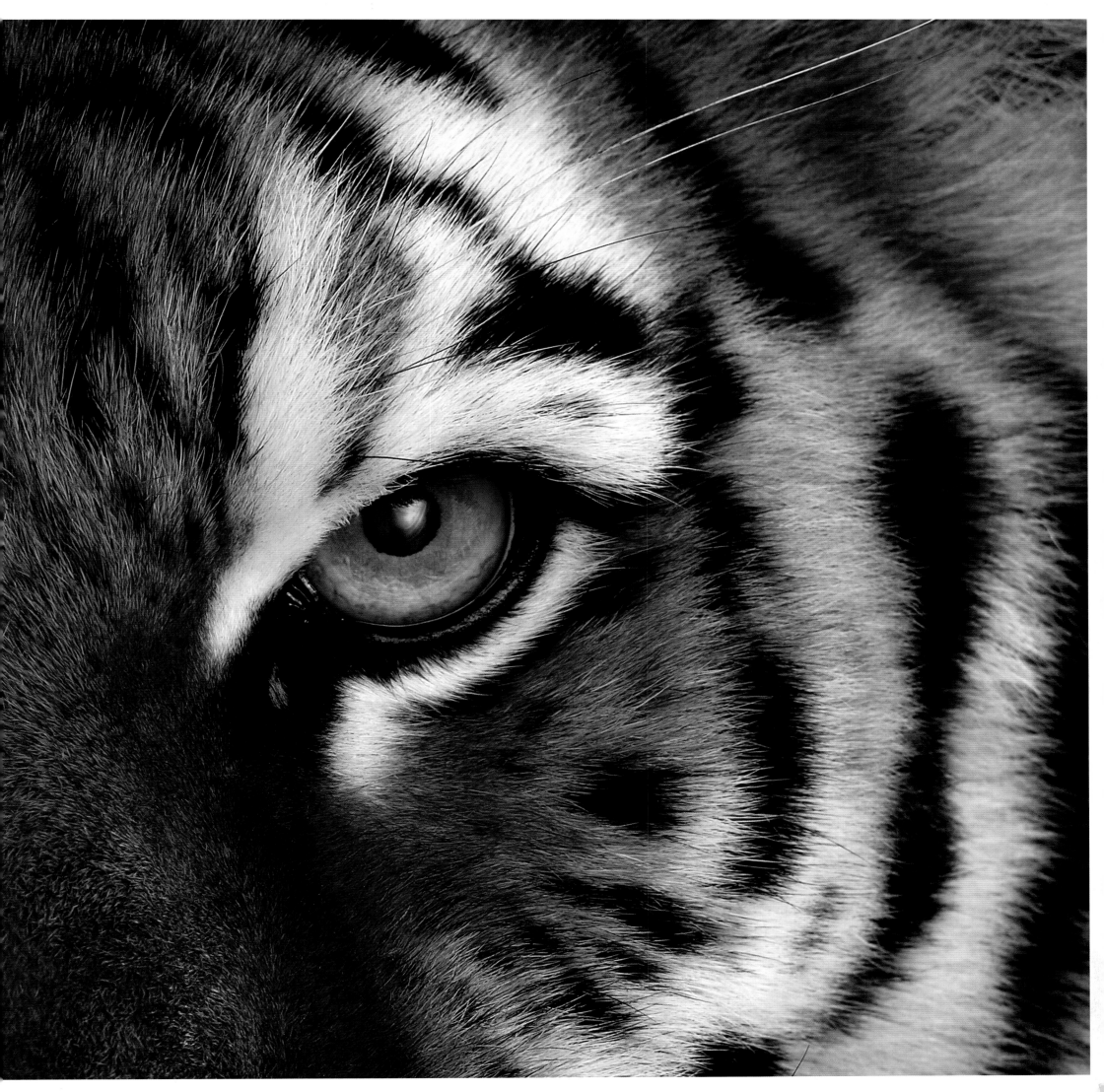

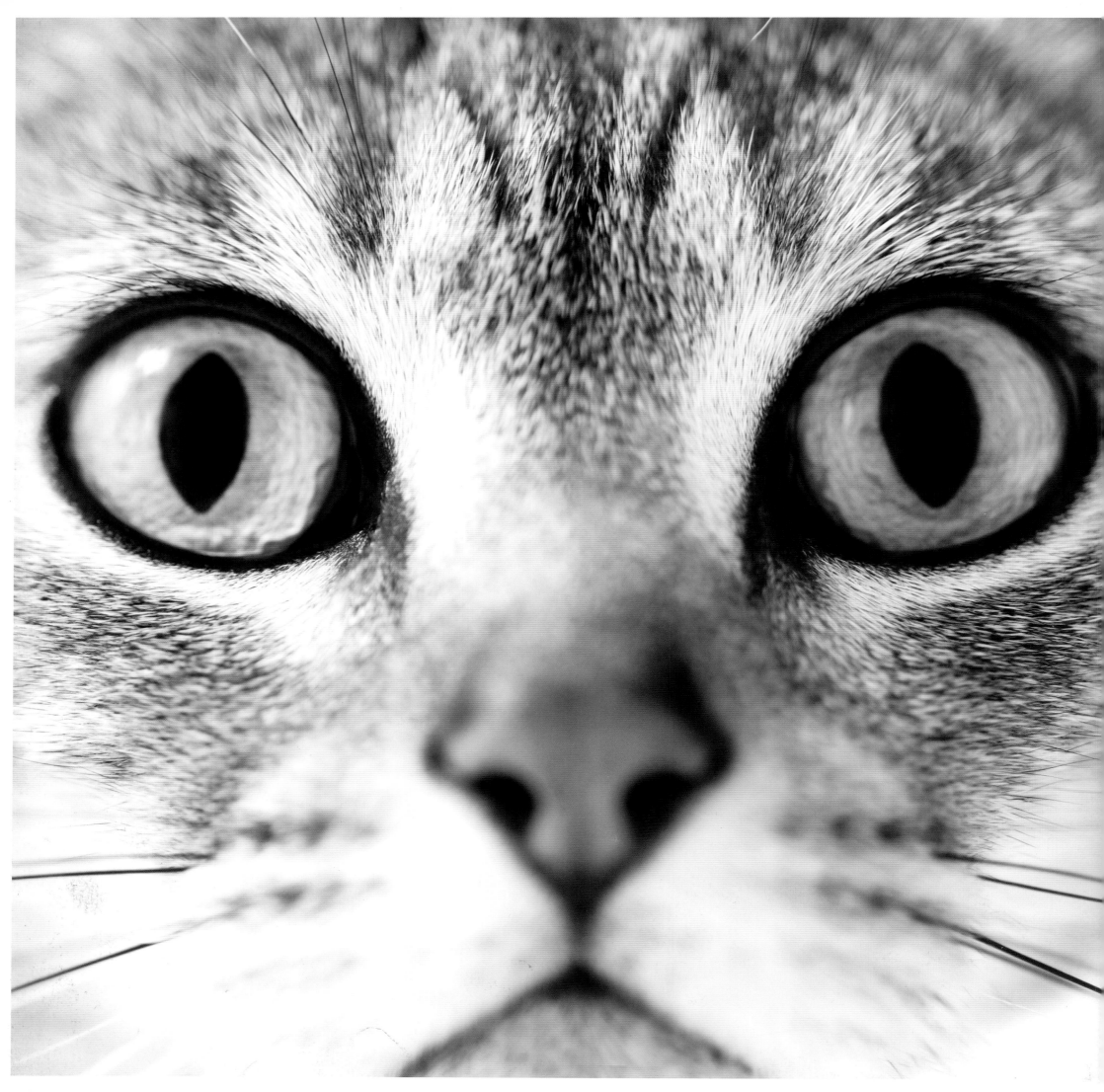

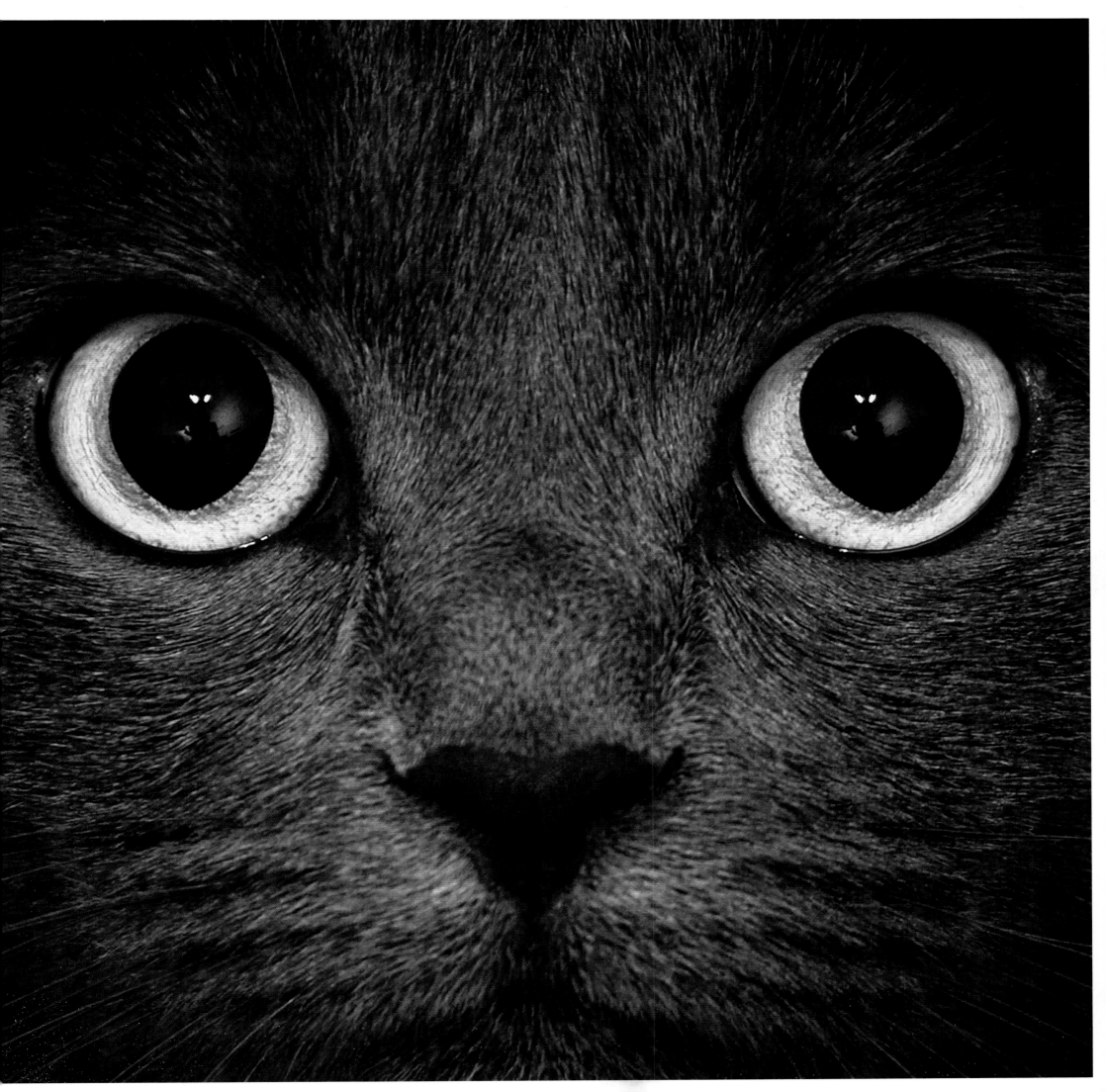

Sense

Few people, whether cat lovers or not, fail to note the acute sensory responses that enable cats to be efficient hunters, able to detect their prey from great distances and locate it with accuracy. In our pets we witness a miniature of their big cousins of the savanna and jungle. But we also see something else—a sensitivity that is not just about catching supper, but that also seems to be about just sensing the day, celebrating life and its mystery in a chilled-out way that humans struggle to match. At least we would like to think so: that untroubled Buddha-like pose our cat will sit in for ages seems to be meditative, but we really don't know what is going on.

A strong combination of smell, sight, and hearing creates the heightened awareness that has allowed cats to flourish in the wild and which makes them such successful mouse- and rat-catchers. But among those who own cats or study feline behavior, there are many who would go much further and claim that cats also possess a kind of sixth sense—giving them the power to predict encroaching dangers such as trespassers, earthquakes, and even imminent deaths.

A belief in the supernatural powers of cats was widespread during the Middle Ages: What other explanation could there be for this ability to hear and see things that people couldn't? Nowadays, of course, we know that cats have heightened senses that account for their success in tracking down prey and avoiding predators. But many of us would also cite examples of our cats' behavior that suggest a sensitivity to emotions and atmospheres as well as physical presences. Most cat owners would also claim that their pets express these feelings to them using the slightest movement of their eyes and whiskers.

Those mesmerizing cats eyes can bewitch even the most un-interested of admirers, who may find themselves unable to resist gazing into luminous pools of green, copper, orange, yellow, blue, or lavender. Numerous people confess that "the eyes have it" when it comes to choosing a pet cat, and many will even claim that their cat seemed to beseech them with their eyes to take it home. Feline experts, such as cat shelter workers and veterinarians, concur that the eyes can provide many clues as to a cat's state of health, mood, or intention. Some even say that one can soothe a wild, feral cat by calmly staring into its eyes and blinking slowly. More often than not, the cat will blink back, signaling its compliance.

The size of a cat's eyes certainly gives it plenty of scope for expression: if our eyes were as big in relation to our heads, they would each be about three inches long. Not only are the cat's eyes big, but they also bulge out slightly, giving them exceptional peripheral vision. As a result, a cat's field of vision is about 186 degrees—far greater than ours. With that advantage (along with acute hearing and sense of smell), it's no wonder that a human with even the lightest tread could never hope to sneak up and surprise a cat.

It's not just their size, but the unique structure of cats' eyes that gave rise to the old adage, "cats can see in the dark." They can't actually see in total darkness but do have excellent night vision. Their vertical irises can close down to the thinnest slit in bright light or open out to cover 90 percent of their eye area in near darkness. A key element is the rare membrane in the back of their eyes—the *tapetum lucidum*—that reflects light back through the retina and boosts the image. This ensures our cats' sure-footedness in prowling around the garden or navigating a dark room, while we stumble through, trying to locate the light switch.

The other secret of feline success in spotting prey (even the tiniest bug, in time for an accurate pounce) is the proportion of rods to cones in cats' eyes. This is in reverse proportion to our own: we have more cones, which react to color, while they have more rods, which react to the intensity of light. So while our color vision is better, cats have a more acute awareness of motion. Consequently, like those of us who need reading glasses, cats do not see close objects so well—but what does that matter after the mouse is in your grasp? You're only going to eat it anyway and it's probably not such a pretty sight once it is clenched in your paw. As for their color vision, it is now known that cats can distinguish red and green and are not completely color-blind, as was once thought. It is even conceivable that the notion of "seeing-eye cats" for the blind could be raised in the near future.

But what about the assertions that a cat's eyes are indeed "a window to the soul"? There is plenty of evidence to suggest that they are a reflector of mood—hence the narrowing of pupil size when a cat is angry, or widening when it is excited or frightened. Some owners even report that the eyes of a relaxed and contented cat appear to grow darker than their normal shade. But whether or not they mirror its spiritual state, a cat's eyes will certainly reflect its state of physical health. Dull and glazed eyes are usually a sign that something is wrong, and if a cat's inner, "third eyelid" (which is actually a nictitating membrane that protects the eye from dryness and damage) partially closes, it's time to call the vet.

If there is one sense that is infinitely more sophisticated in cats than in humans, it is the sense of smell. When you come home from work of an evening, your family might not guess what you had for lunch, whose hand you shook, or whether you walked home over grass or tarmac . . . but your cat will. She'll know if you patted any neighbors' dogs, and she'll be able to tell if you remembered to put salt in the vegetable cooking water. That's because a cat's sense of smell is fourteen times more powerful than that of humans; hardly surprising with two hundred million cells in its nose, compared to a mere five million in ours.

The sensitivity to scent is a crucial element in cats' survival. It enables them to locate food and mates, mark out and establish territory, and detect potential danger. Dr. Valeriy Ilyichev, Professor of Biology at Moscow University, has published major research on the nasal organs of cats, and states: "It would be no big deal for a deaf and blind cat to live in the human world—even in the forest. But a cat with no sense of smell is just unable to survive." Dr. Ilyichev has closely studied the function of the extraordinary vomeronasal (or Jacobson's) organ. Located inside the mouth, just behind the front teeth, it connects to the nasal cavity by ducts. These open and let in air as the cat lifts its upper lip in the "smile" or grimace which is known as the "flehmen response." The Jacobson's organ then analyzes the scent, molecule by molecule.

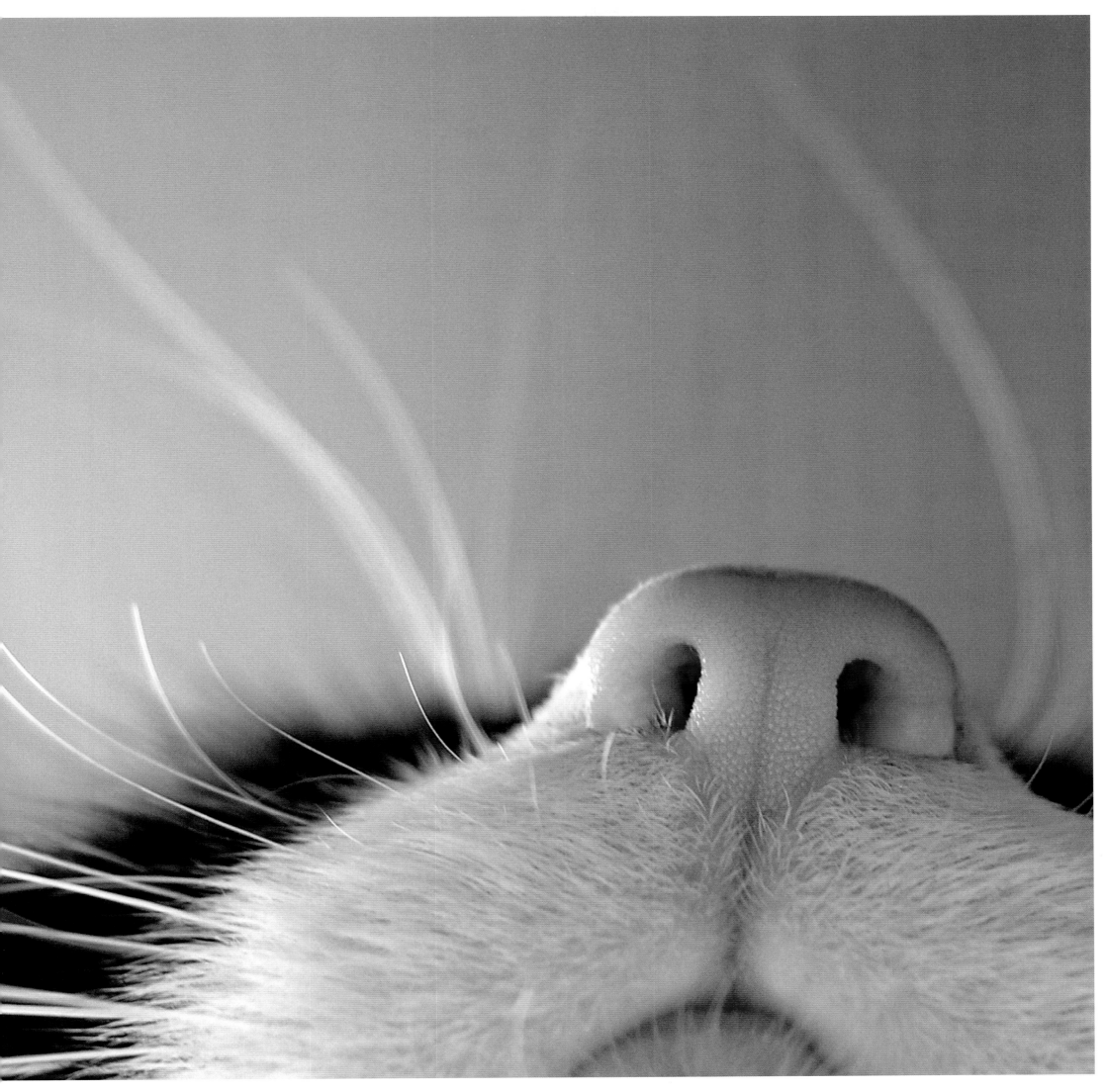

Cats depend on the Jacobson's organ to detect a potential mate, a strange cat in their territory, or, of course, the presence of food. Even the newborn blind kitten will use this sense to find his mother, and, most importantly, a teat to latch on to. From then on, he will continue to use this sense to find food, whether it is a living creature or the pet food in his bowl.

If, however, all cats can smell is the (for them) unpleasant odor of detergent, they know they're not yet in luck. Their sense of smell will also tell them which people and animals belong in "their" territory, as they deposit their scent onto others by using the scent glands on their forehead, their chin, their lips, and the side of their tail. When your cat rubs up against your leg or the sofa or your bed, she is not just being affectionate; she is laying claim to you and your home.

Perhaps surprisingly, Dr. Ilyichev's scientific research has produced some evidence to back claims made by advocates of the "sixth sense" of cats—their ability to predict danger and natural disaster. Ilyichev proposed a hypothesis that the Jacobson's organ can analyze airflow in the atmosphere, reflecting small alterations in its chemical composition caused by the imminent approach of events such as eruptions, earthquakes, and the approach of forest fires.

As yet, however, Ilyichev has made no comment on one report suggesting that a cat is able to predict the death of hospital patients. The CBS News HealthWatch report described the actions of Oscar, an animal-shelter refugee cat in a nursing home in Providence, Rhode Island, who seemed to sense when one of the residents in the home's dementia unit was about to pass away. Dr. David Dosa, a geriatrician in the Steere House Nursing & Rehabilitation Center, published his essay about Oscar in the *New England Journal of Medicine*. It related how Oscar typically arrived at a patient's bedside up to half a day before death and curled up to him, purring attentively: in many cases, this alerted nursing staff and enabled them to summon family members in time for them to say their last good-byes.

Most doctors and animal behavior experts who studied the case of Oscar concurred that he was smelling certain chemicals released when someone is dying. He was perhaps also mimicking the behavior of staff, who he would have seen holding vigils to ensure that a dying patient was never left alone. Margie Scherk, then president of the American Association of Feline Practitioners and a vet in Vancouver, was reported as saying: "Cats can smell a lot of things we can't . . . and cats can certainly detect illness." Whatever the explanation, Oscar's reputation earned him a certificate acknowledging his work by the state's major hospice organization.

When it comes to preserving their own lives, cats' sense of hearing is almost as vital as their ability to smell. Acute hearing is an essential hunting tool for cats, who preserve effort by chasing prey at short distance. They listen for clues that their prey is near—rustling in bushes, perhaps, or scrabbling behind walls—then they seize the right moment to pounce. Feline ears are superbly adapted for this technique, being large, erect, and cone-shaped, able to effectively amplify the sounds that they catch.

Cats can hear much higher-pitched sounds than we can: 1.6 octaves above human range and 1 octave above that of dogs. They can also move their earflaps (or pinna) around in every direction to as much as 180 degrees, using about thirty sets of muscles as opposed to the six sets used by humans. A combination of these two advantages means they can draw high frequency sounds into the ear canal, pinpointing their source to within three inches for sounds made as much as one yard away. A mouse rustling in the leaves thirty feet away stands little chance against a keen cat.

Even cats who haven't caught a decent mouse in ages, however, will be rather discriminating when it comes to selecting what tempts their (relatively few) taste buds. This is the one sensory area where we humans seem to have the advantage over cats: 9,000 taste buds on our tongues as opposed to just 473 for a cat. But they do have the Jacobson's organ in the roof of their mouth. When they sense a potentially tasty aroma, they will operate the flehmen response, inhaling the smell on their tongue. Then they will rub their prickly tongue over the roof of their mouth and pass the smell/taste onto the Jacobson's organ for evaluation—a highly efficient taste test.

The cat's predominant taste buds (mushroom-shaped papillae) are located at the tip and sides of the tongue, while a set of cup-shaped papillae are present at the back. Experts have long believed that cats can only distinguish between sour, salty, and bitter tastes, since they have rarely showed any interest in sugary foods. More recent

The cat wants nothing more than to be a cat, and every cat is pure cat, from its whiskers to its tail…

research has established that they do have a few sweet-sensitive taste buds on the back of the tongue . . . but your cat is unlikely to entreat you for frosted brownies anytime soon. As most cat owners will testify, cats seem to know what is nutritionally good for them, as well as how to inform their owners of their dining preferences.

Limited though their taste options may be, that tongue is an immensely useful multipurpose tool. The hook-like barbs, or papillae, point backwards on their tongues, enabling them to strip fur or feathers from their prey's corpse and to scrape meat from the bones. Even more impressively, the tongue shapes like a spoon while cats are drinking, curling down and enabling them to cast water back into their mouths, and not over their faces. This enables them to lap up liquids rapidly: they typically only swallow after every three or four laps. Finally, that sandpaper tongue is an essential grooming aid, an indispensable tool in our cats' continuous quest for immaculate cleanliness. This is not an obsession but a practical concern: being aware of the value of scent, they are keen to avoid any chance of giving off a scent for their own prey to detect.

Perhaps the most magical of a cat's sensory organs are its whiskers, the main conductors of its wondrous sense of touch. A cat's whiskers are part of an array of receptors that keep the cat in close and constant contact with its physical environment. There are twenty-four movable whiskers set in four rows on each upper lip on either side of the nose, plus a few more dotted across the cheeks, chin, lips, and muzzle. They complement the cat's keen eyesight and are especially useful for navigating at night. It is with the whiskers that a cat probes its way through darkness: this is why the muzzle whiskers are the cat's longest, helping it avoid bumping into things. They can register any minute shift in air current, enabling the cat to skirt a tree or leg of a chair. They also act as a gauge of the distance between two objects, so the cat can determine if it can squeeze between them. Another few, less mobile, whiskers above the eyes cause the cat's eyelids to blink when they are touched, thus protecting the eyes from injury.

Twice as thick as the cat's coat hair, and with numerous nerve endings at their base, the cat's whiskers provide extraordinarily detailed information about any objects they come into contact with. This means that they don't necessarily need to see obstacles in order to sense their presence. When a cat can't see its prey because it is too close to its mouth, for instance, its whiskers will form a basket shape around its muzzle. This technique allows it to precisely detect the location of the captive and check for signs of life, while the chin and lip whiskers add the final location-finding service to help it apply the killing neck bite.

The whiskers may also enable the cat to detect scents better, by directing air currents to its nose and mouth. And, as well as receiving information, the whiskers can *send out* information about a cat's mood: if the cat is in a friendly mood and curious, the whiskers will push forward, but if they are lying flat on the face, they reveal defensiveness or aggression.

Larger single hairs (tylotrichs) are spread throughout the regular hairs of a cat's coat and work in a similar way to whiskers. Feline skin is also covered by millions of touch receptors that can detect small changes in air pressure, air currents, and temperature, though we all know this does not prevent our cats from reveling in the heat of a warm fireside. The cat's nose and paw pads are also highly sensitive to temperature: cats often use their paws to check the texture and density of potential prey as well as pawing a killed victim for any remaining signs of life.

The sensitivity of the cat's paws has also been cited in its apparent ability to anticipate earthquakes and other extraordinary phenomena. Unlike Dr. Ilyichev's hypothesis that a feline "sixth sense" is based in the Jacobson organ, this theory proposes that cats are able to detect minute vibrations in their limbs. Whatever the means, and perhaps it is a combination of several orthodox senses that enable the "sixth sense," it is now widely documented that cats demonstrate extreme and atypical behavior in the hours before earthquakes, volcanic eruptions, and severe electrical storms. They become highly agitated, and flee in panic from buildings. Some females have even been observed rapidly carrying their kittens to a safer position, and some cat owners in vulnerable earthquake areas claim to owe their lives to following their cats' lead in escaping to safer locations.

The "supernatural powers" of medieval cats often led to their cruel and tragic undoing at the hands of superstitious zealots alarmed by their apparent possession of "unnatural knowledge." These same "powers" are increasingly seen to be entirely natural qualities, arising from the extraordinarily sophisticated nature of their sensory responses. That they are completely natural attributes surely makes them infinitely more, rather than less, marvelous.

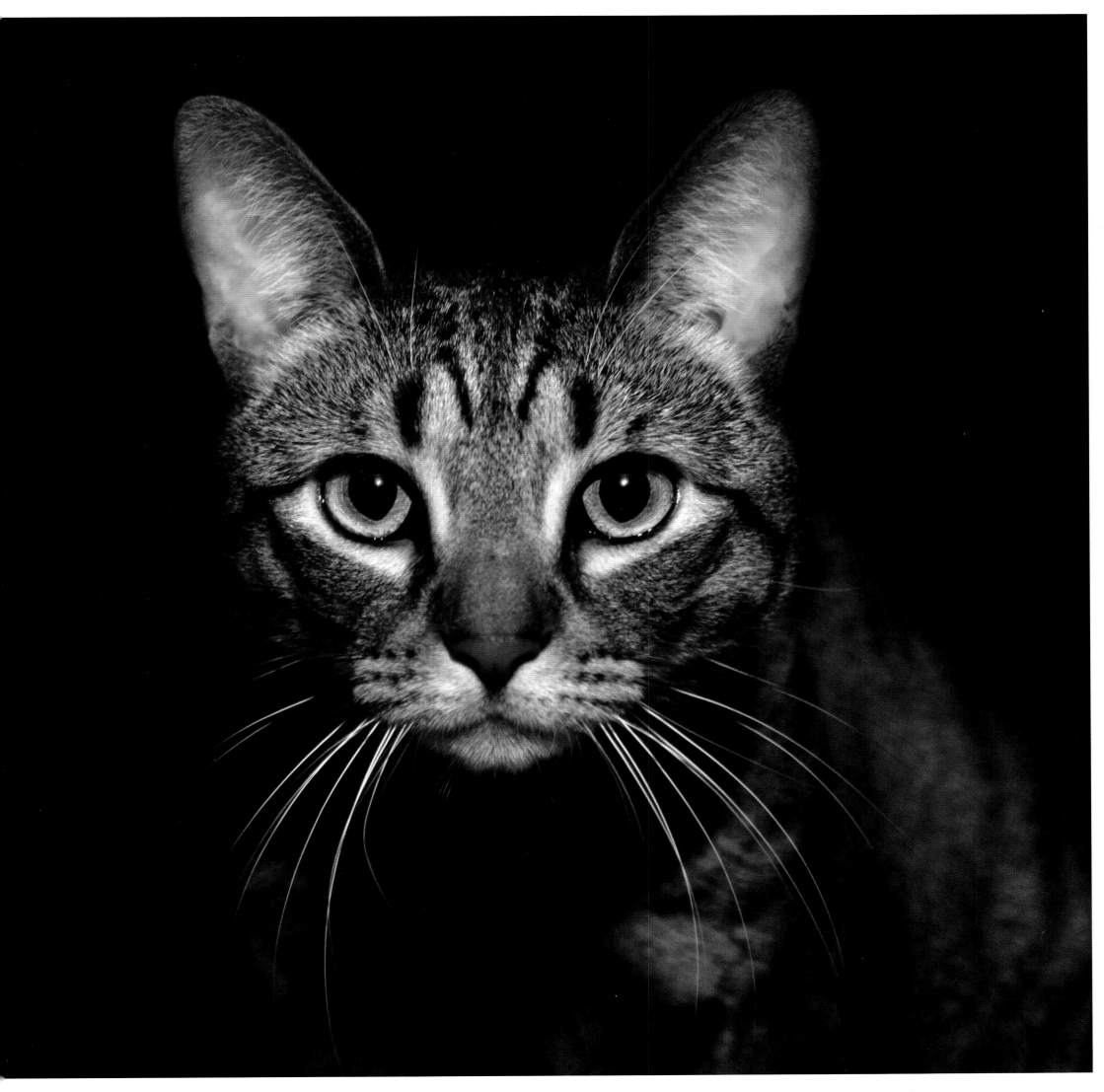

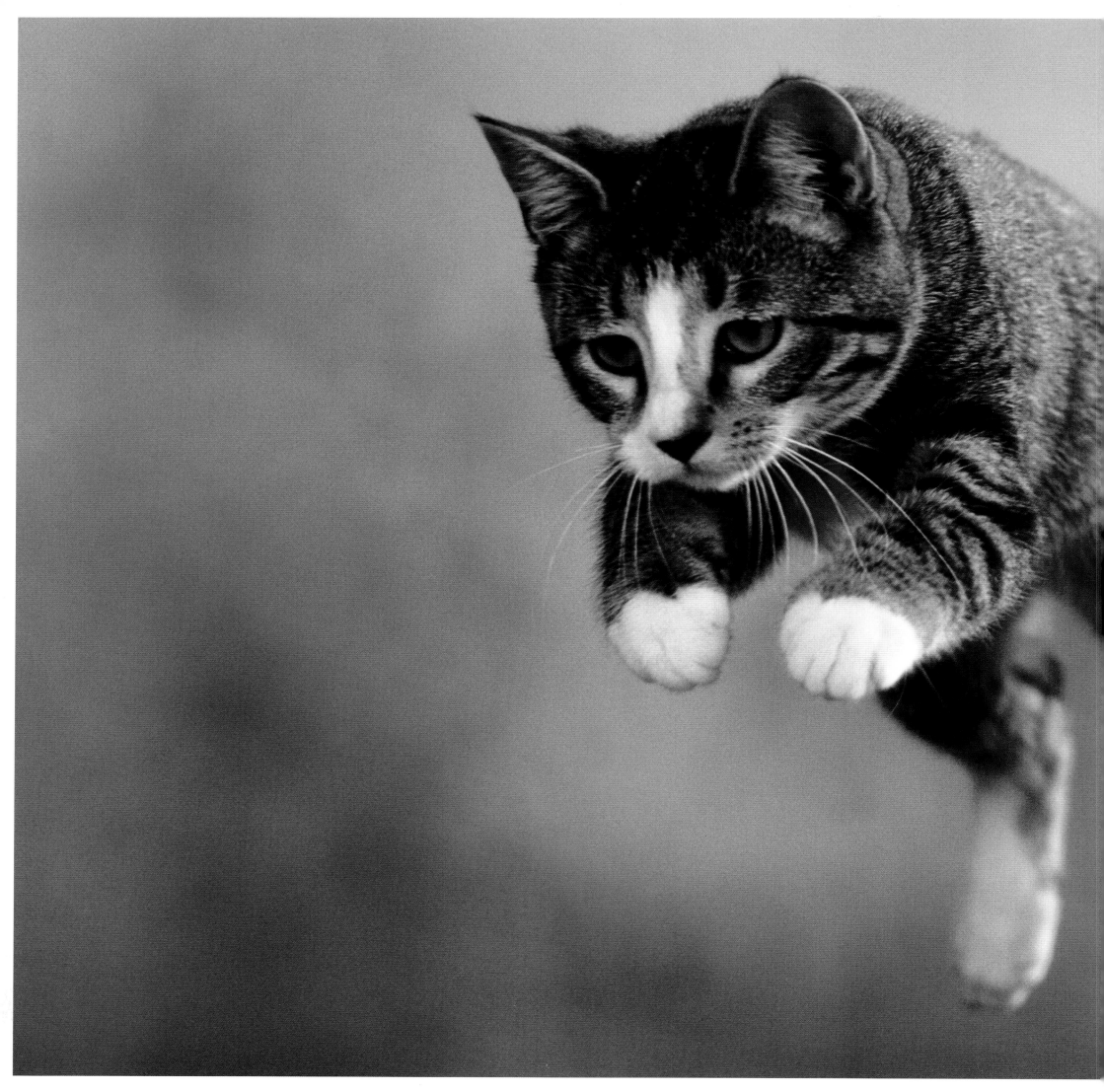

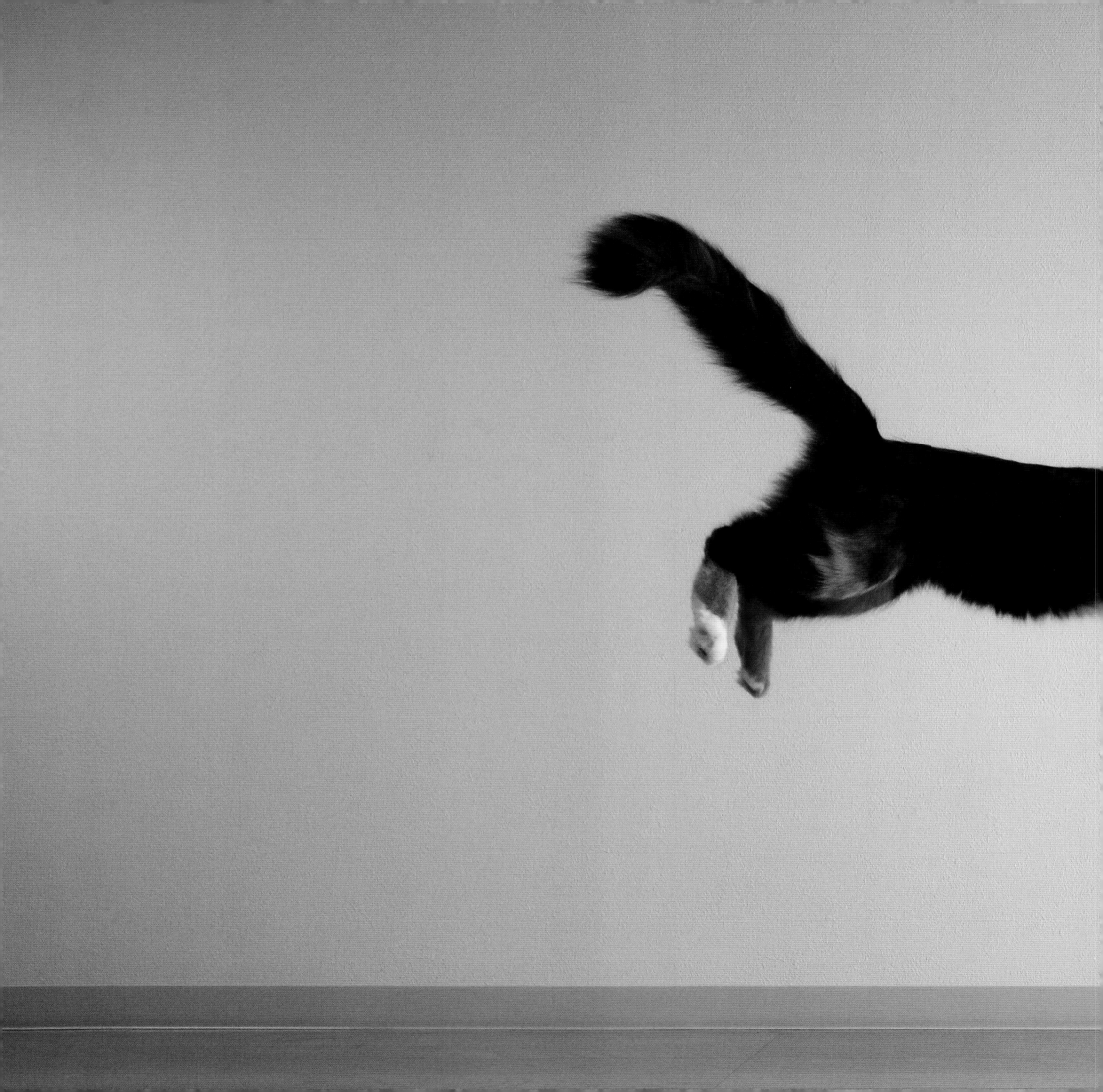

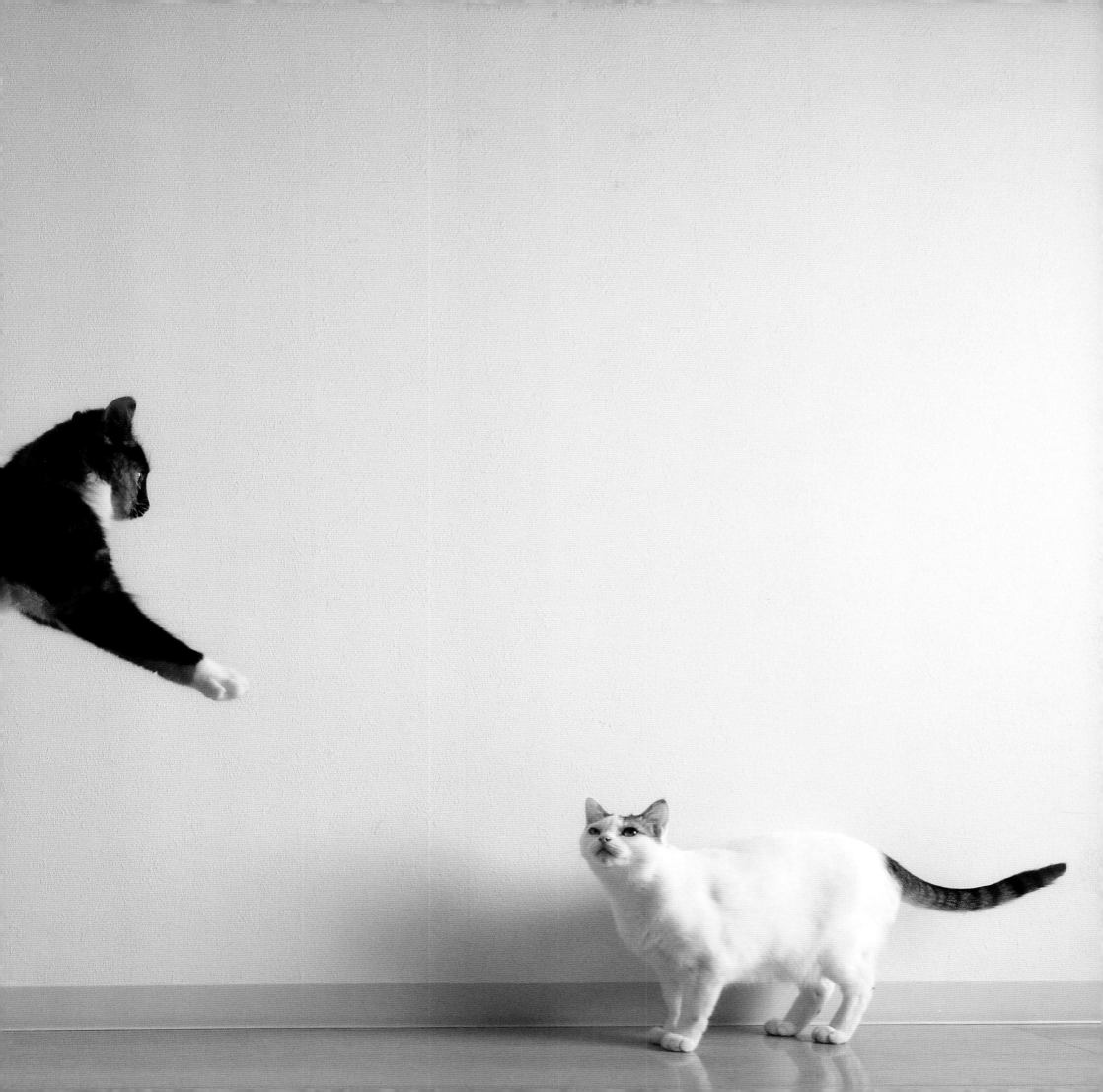

I do not think the cat can be overestimated. He suggests so much grace, power, beauty, motion, mysticism.

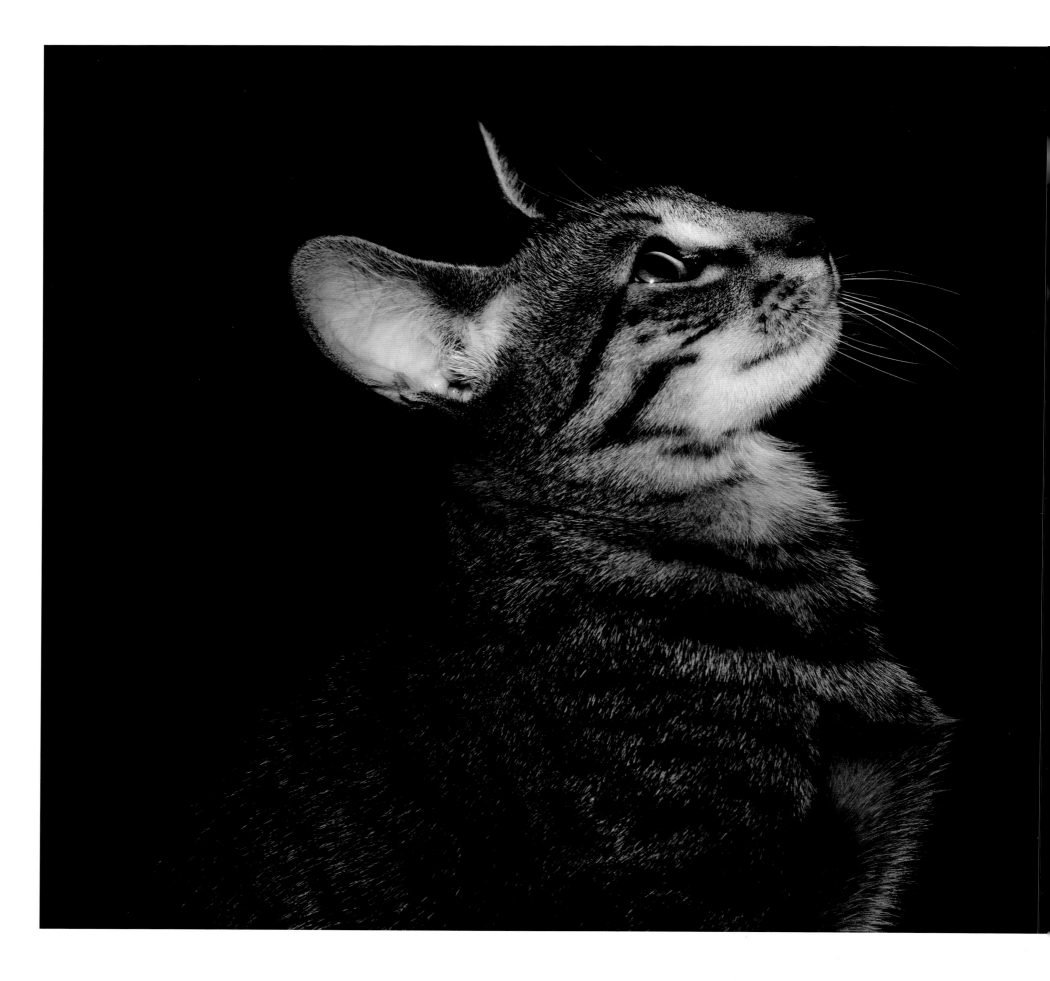

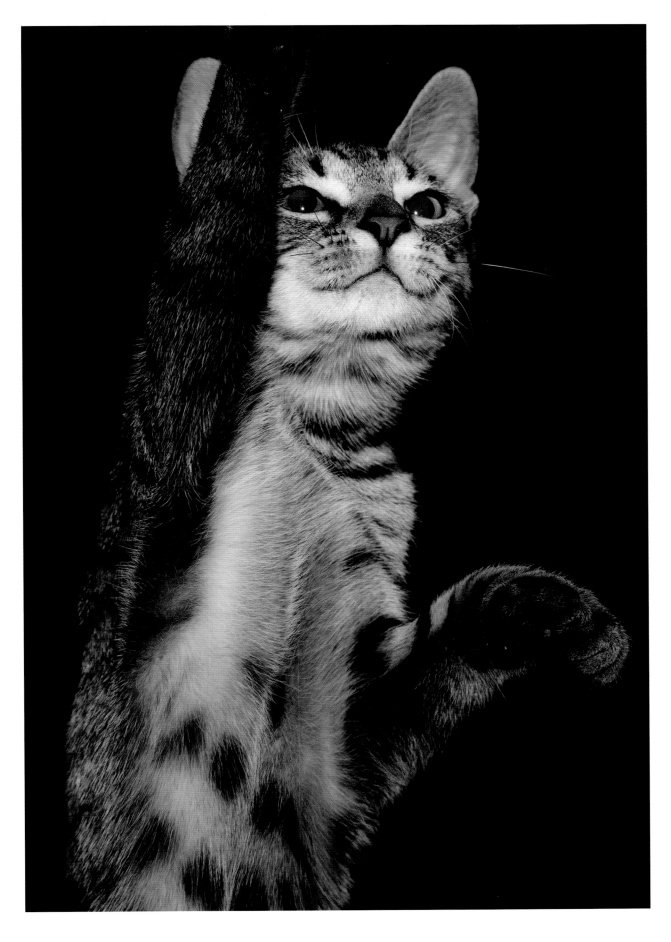

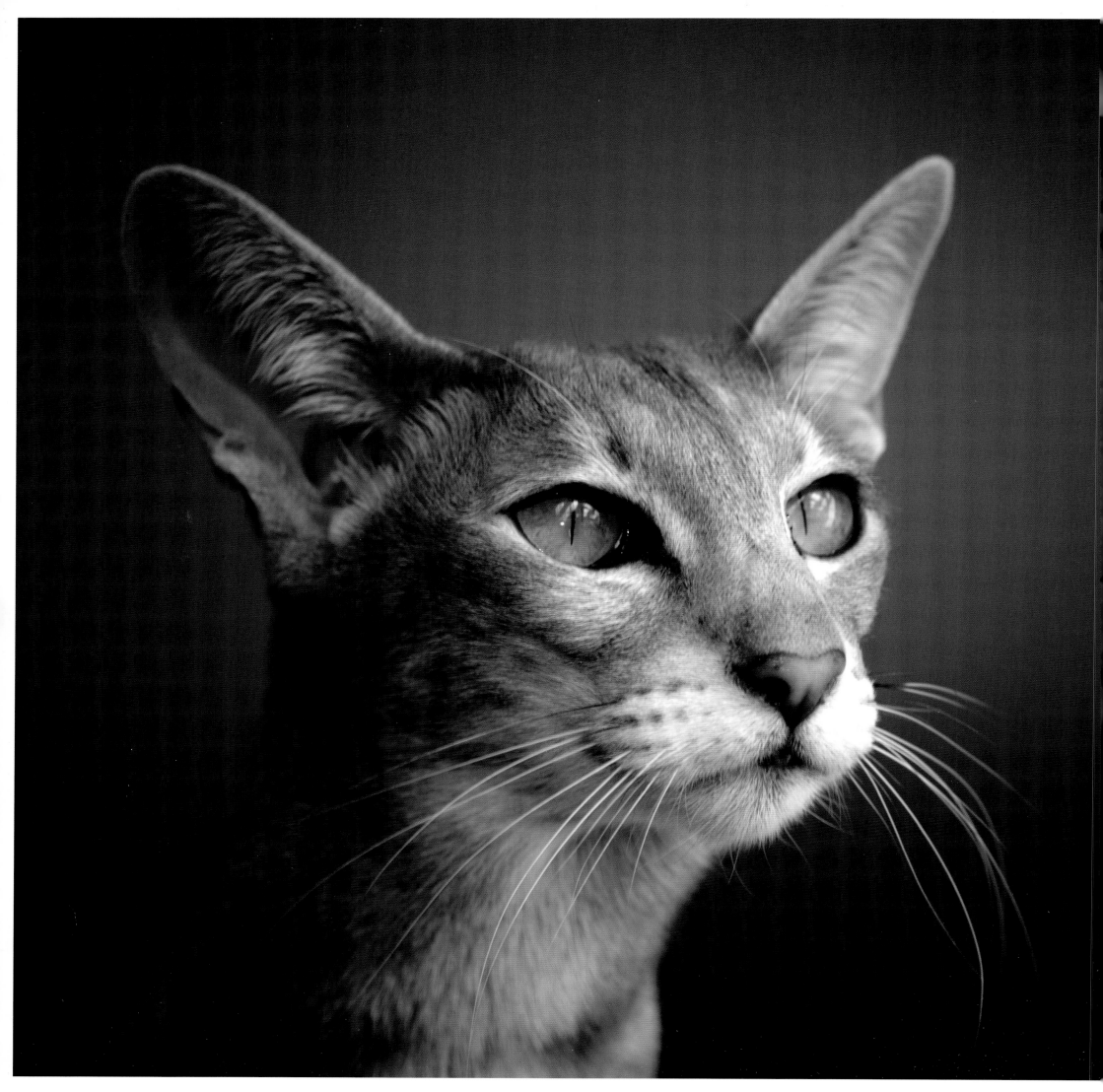

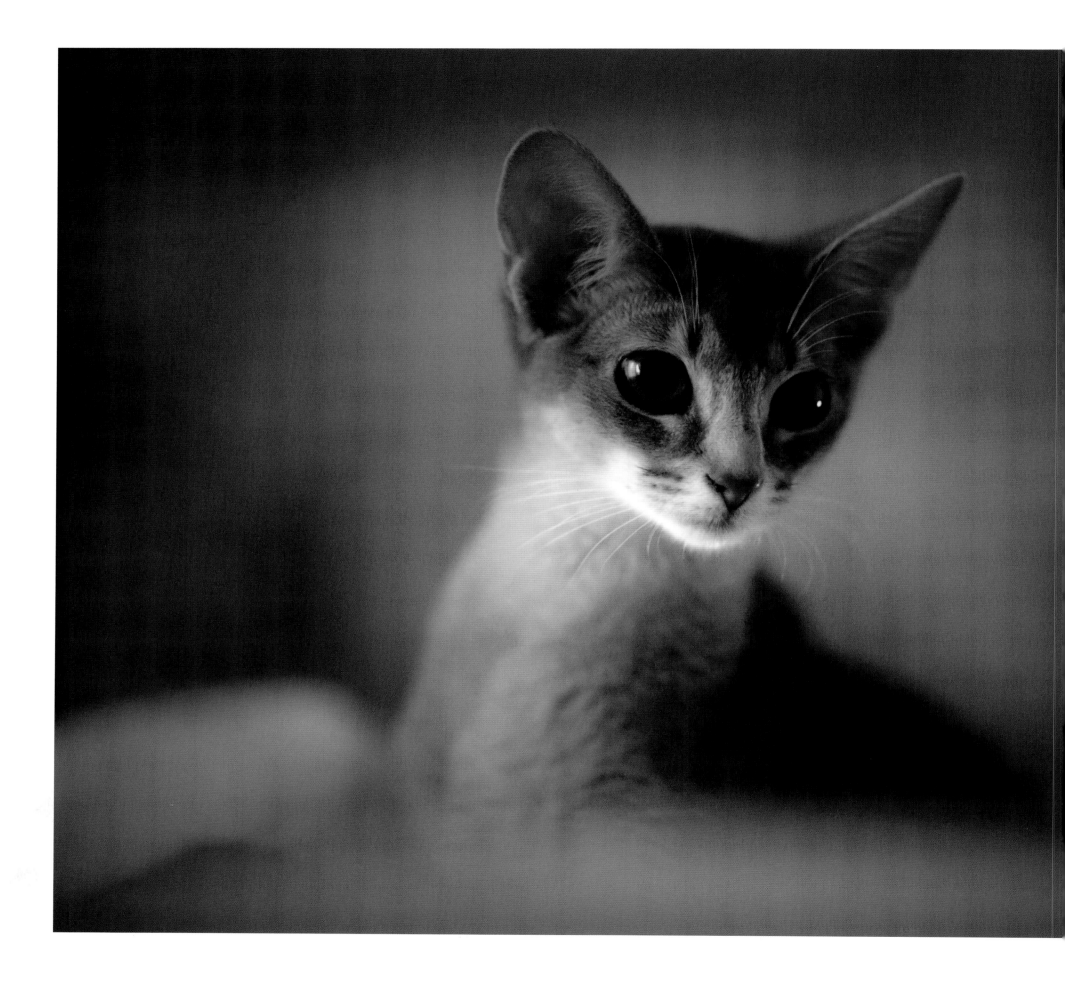

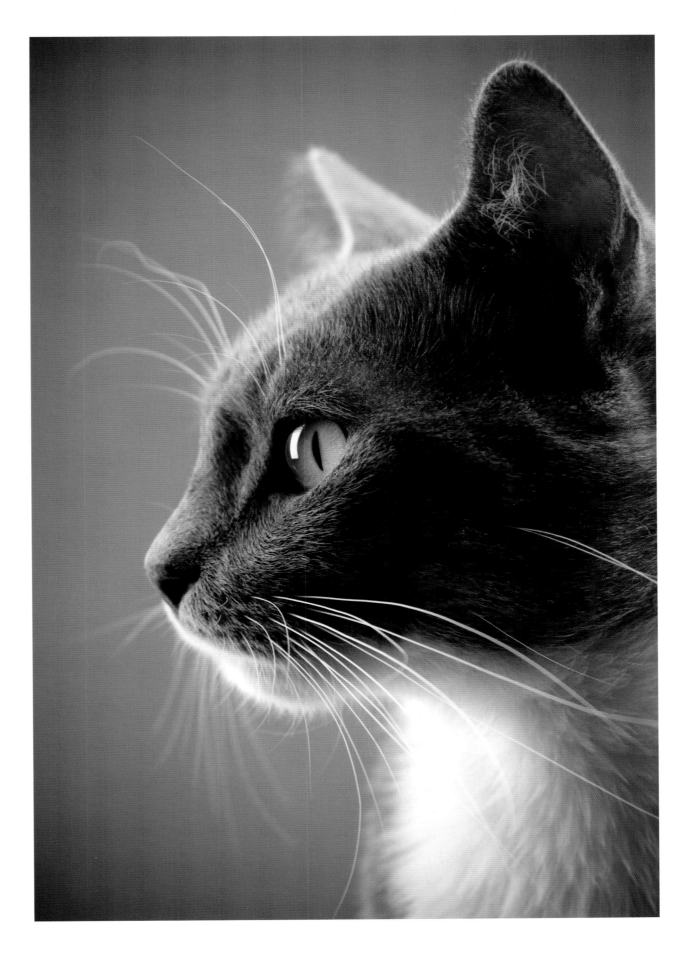

If a cat does something,
we call it instinct; if we do
the same thing, for the same
reason, we call it intelligence.

Breeds

Most cats are mixed breeds. Each beautiful in its own special way, perhaps easily categorized as short- or long-haired, black or white, or tabby or ginger. But still, mixed breeds. Of no pedigree.

But then there are the self-appointed elite, the pedigree breeds. It is not actually the cats who do the appointing of status (although pedigree cats often do seem to carry a superior sneer—but then many non-pedigree cats retain that too). They are *given* special status by their breeders, their fanciers, and the organizations to which they subscribe. In so doing, a culture of people and cat emerges that definitely considers itself a little separate, a little aloof. These are cat lovers of a different ilk, the type of people who can't love you without changing you into being what they think you should be. We've all met them. Perhaps you are one of them . . . as you can sense, I have my doubts that cats really need this. But, once again, what cats need is at times not what humans need of cats. When it comes to controlled breeding, it leads us to the curious—and still developing—world of pedigree breeds.

I have already touched on some of the more exotic mixtures—those breeds where the wild and the tame meet. Fascinating as those combinations are, the heartland of breeding is in the pedigree world that leads to show cats, expensive breeding practices, pricey kittens and one-upmanship in dinner party conversations. I am sure that I once overheard an otherwise pleasant neighbor saying, "We've had Siamese and Persian, but this time we went for something different when we heard about Maine coon." Unwittingly, they had just revealed their desperate fashion-following sensibility, naming three breeds that had at various times risen up to the top of the charts during their years of cat acquisition. This seems so at odds with what making friends should be all about. And surely that is what you do when you get a pet: you make a new friend, not a trophy to add to the shelf.

But then again, to approach the matter from a different perspective, cat-keeping, for some, can be more like a form of social media, in which having relationships is as much about showing and sharing them as it is exploring and enjoying them. In this situation, people choose to have a cat that everybody wants to see, and for this they can turn to the pedigree breed charts.

The leading body for breeders in the United States, The Cat Fanciers' Association (CFA), has forty-one recognized breeds, while leading groups elsewhere tend to have more. When I last looked on Wikipedia there was a list of breeds amounting to ninety-three, a total that comes from an amalgam of various different nationalities' cat-fancying groups. In truth, it would be easy to subdivide a few more breeds out, especially if you strolled the world's highways and byways as a dedicated breed collector, independent of the snooty standards of formal associations.

But whatever number you reach, it is likely to be a lot less than the breeds dogs are divided into. Cats have not had their form and purpose so teased out—rather they remain true to their wild origins. Yet some small differences are there to be enjoyed and to be speculated upon; the big question to ask might be what direction cat breeding would head in if cat fancying *really* took off. There are colors, patterns, sizes, shapes, and behaviors yet to be drawn out of the body of *Felis catus*.

For example, when it comes to hairless cats, we really have only the Sphynx. It is, at a quick view, entirely hairless (though close inspection may reveal vellus hair, which is almost invisible). This breed only stretches back about forty years or so, and has emerged from inbreeding. After some trial and error and dead ends, a stable and sustainable form of the hairless cat emerged. There are now some variants of it—such as the Donskoy and the Peterbald—but they are all pretty similar. In contrast, hairless dogs have a wider range of appearance and depth of breeding. These may also have emerged as an inbreeding by-product, but this was a long time ago and the breeds, notably the Chinese Crested and the Xoloitzcuintli, have since developed a strong following and cultured back-story. Given a bit more manipulation and competition, and a few more decades, it is easy to imagine that hairless cats will exist in a wider variety of sizes and colors, perhaps even with some additional enriching stories to justify their oddity.

Cat breeds are still lacking in this historical basis. They often seem rather new and ill-thought-out in design, or to be reaching for results that would better be left to nature. Consider the Himalayan: it exhibits great coloring, but needs help to groom its coat and wash its face, and can have trouble breathing. The cat is a cross between Persian and Siamese and has no connection with the Himalayas—other than somebody in the naming process thinking that the distinctive coloration and blue eyes was similar to Himalayan animals. Is that really a breed worth encouraging? As pet fanciers we have been here before, in the trials and mishaps of past methods of dog breeding. We have seen dozens of breeds that have suffered bad breathing, weak hips, and a tendency to organ failure when rather young. At least there was often a purpose to this form of breeding—a working-dog function usually in the background somewhere—and thus there is some weight to the breeding traditions of dog lovers now. But cat fanciers are now following suit, chasing the illusion of pedigree status, and seeming to obtain more plentiful results. Their seriousness in this quest is indicative of more money coming into cat ownership than sense. More breeds may not necessarily be better. And you can't buy history wand tradition—so breed development really does seem something of a cosmetic exercise.

That said, I must admit to admiring the rigor and great seriousness with which pedigree development is carried out. The CFA's choosy approach is revealed by the fact that it does not recognize as breeds the two most common types of cat—the domestic longhair and the domestic shorthair (chances are, if you have a cat, it falls into one of these categories). While most cat lovers divide cat types into tabby, tortoiseshell, black-and-white or ginger, short- and long-haired, that won't do for pedigree cats. Only the minority of cats can claim pedigree status, in the same way that only the minority of humans can claim a grand heritage. And, like those inbred nobles in societies of old, so it is too with pedigree breeds: the dangers of inbreeding in royal families bear many unfortunate similarities to the less acceptable end of pedigree breed development.

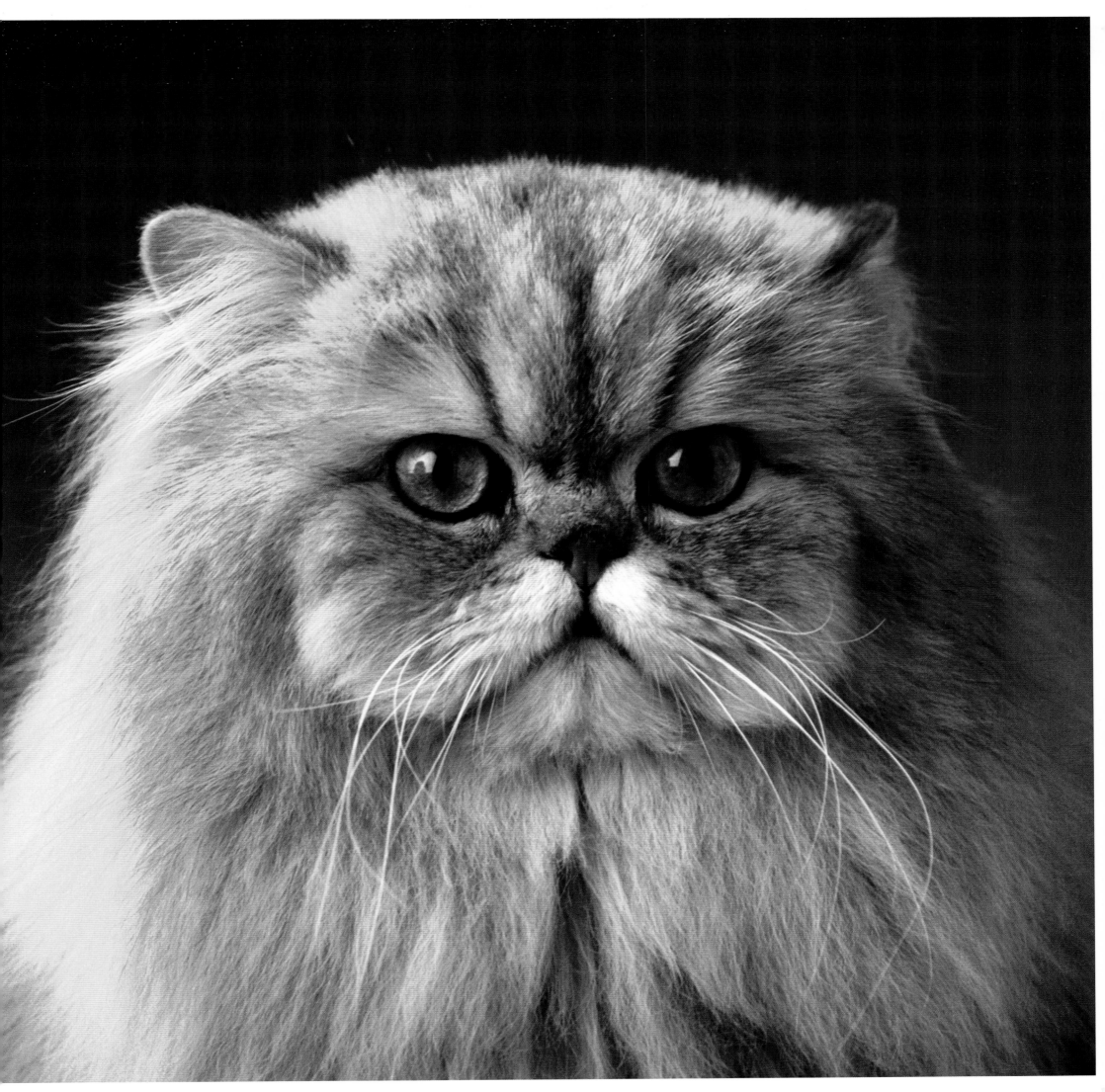

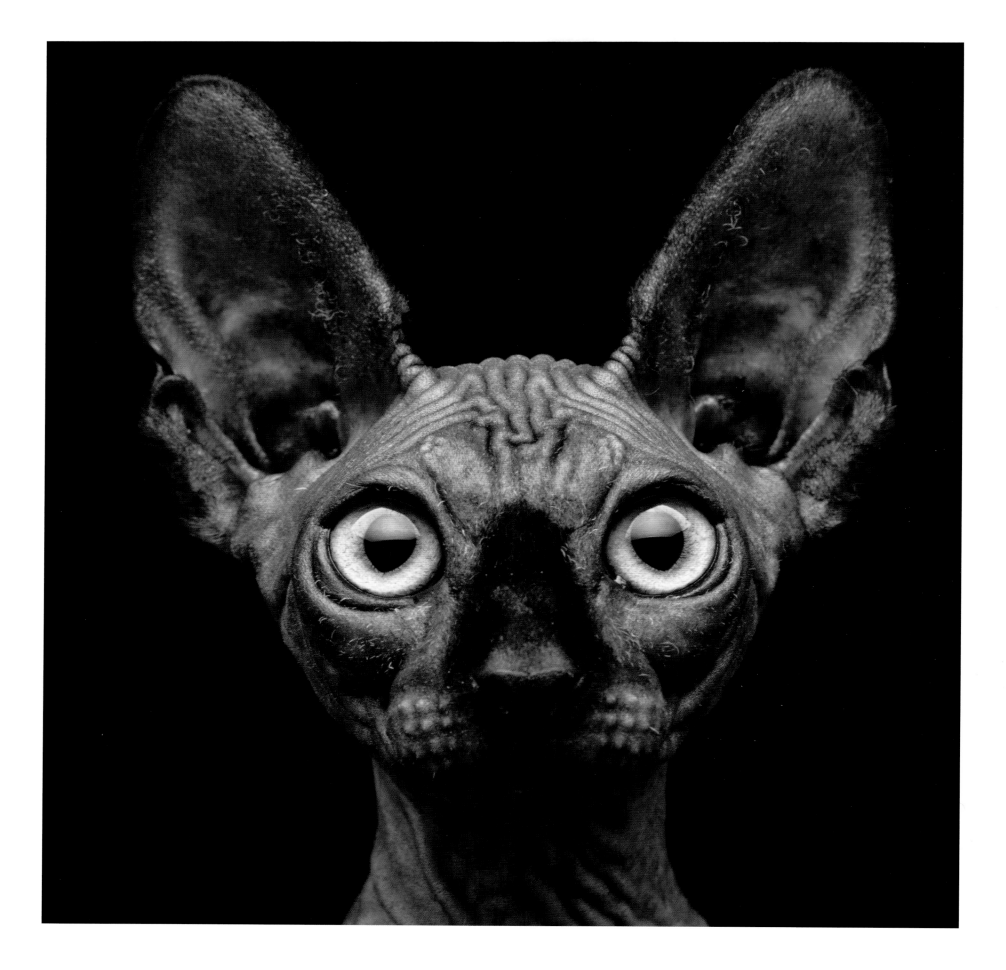

One can pick a cat to fit almost any kind of decor, color scheme, income, personality, mood. But under the fur, whatever color it may be, there still lies, essentially unchanged, one of the world's free souls.

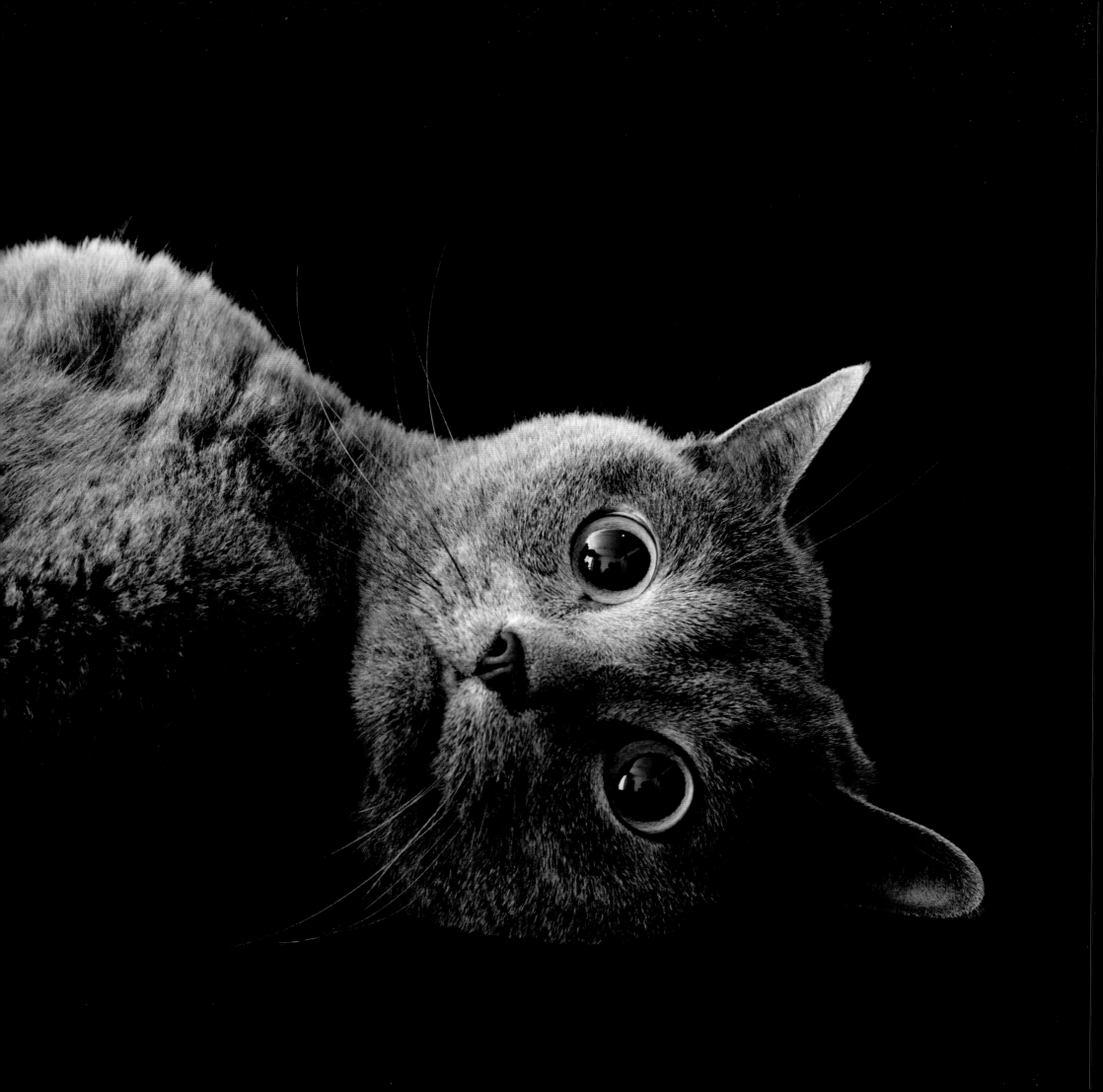

Nevertheless, the rising number of cat breeds reflects a developing awareness of our relationships with the cat, its history, and significance. The Norwegian forest cat, unlike the problematic Himalayan, does have a bit more substance. This breed has only recently acquired any widespread renown beyond its home country, and brings with it an intriguing history that connects it with old Norse mythology. Undoubtedly the breed originates from the naturally evolved, thick- and long-haired cat of the northern forests, a farmer's cat. But it may go back more than a thousand years and have been a companion of the Vikings, protecting their stores from mice, even being the source of cat references in myths of the god Thor and goddess Freya. One way or the other, it most likely evolved from domestic cats brought north by the Romans. The newfound celebration of this breed around the world can be seen as one little step in building national pride for Norwegians, as much as a statement about the functional attributes of the cat.

When it comes to the list of most popular breeds, one has the sense that popularity is driven by human trends again, rather than qualities in the cat. One could argue that our taste for the exotic, and also for animals that go with interior decor, is driving the list. At the top of the US charts is the Persian, followed by Maine coon—two tasteful longhair breeds that add a stylish look to most living rooms. But the fact that the Persian requires daily grooming assistance indicates the extent to which pedigree breeds are not for all: the average mixed breed is quite able to groom itself.

Beyond any superficial similarities in appearance and behavior, the variety of cat breeds tells a story about how we have tried to domesticate the cat—and in a way have failed. Cats today do not display a great deal of distinction from their ancestors. Instead, cats seem pretty unchanged the world over. In fact, when you look at how cats have gone from being useful associates keeping vermin under control, to well-kept house animals with full board and lodging, it would seem that they have domesticated us.

Despite our best efforts, cat breeding has done little to adapt cat behaviors to meet our needs, compared to the variations we have achieved with dogs. Dogs can be influenced to be super-friendly and keen to act on our orders, fetching with enthusiasm in the case of the highly popular Labrador retriever, or conversely, be developed as large and scary with a tendency to view strangers with deep suspicion, such as the average rottweiler. But cat breeds are much more restricting in terms of types and behaviors. And these variations

are also less predictable in output. For example, a Persian cat is reputed to have a more melodic "voice," but many an owner has commented the opposite after enduring years of tuneless yowling; and a Maine coon is presented as being "very friendly," but I have encountered more than one member of that club whose idea of friendliness, if that it is, hurts. And as those are chart-topping breeds, we might think they are as good as the genetic manipulation of cats gets.

When we look at the variety in cat appearance, what are we working with? Breeds may have short hair and long hair, various patterns, perhaps a folded or upright ear (or, preferably, two). Some breeds are more elegant or sturdy than others, some more hairy or attentive, but so far the multigenerational labors of breeders have done relatively little to warp and divide up the essentials that unite them.

But while the cat has been with us a long time, new breeding practices may be opening up potential that most of us can hardly grasp, challenging our very notion of what a cat can be and do. Drawing out a wider range of behaviors would seem a key next step that the cat fancier may take in developing breeds further. Consider the ocicat, which is named after the ocelot (although it has no breeding link with the wildcat species). This cross of Abyssinian, Siamese, and a sprinkling of American shorthair looks very handsome, but it is the behavior that is particularly remarkable. It has a sociable nature, so biddable that it is described as having the character of a dog in a cat's body. It can be trained to fetch, walk on a leash, come when called, and perform various other dog-like behaviors. Rather like a friendly dog, ocicats will approach a newcomer and invite petting without prompt.

We have hardly begun to really probe what lies within, behind, and beyond that mysterious manner of the cat. Domestic cat behavior is largely consistent in that it remains a mystery in many areas, albeit with some common clues. This may change as the cat fanciers, with new genetic tricks at their disposal, start to unlock the secrets of what makes a cat so cat-like. For now, our cats make it known when food is expected, or a warm lap desired, and retain their capricious behaviors. Even the most chilled-out and family-friendly cat will find ways to clearly communicate that it does nobody's bidding but its own. I like that individualism. Long may much of that difference stay beyond the breeder's understanding. Who really wants cats to become like dogs?

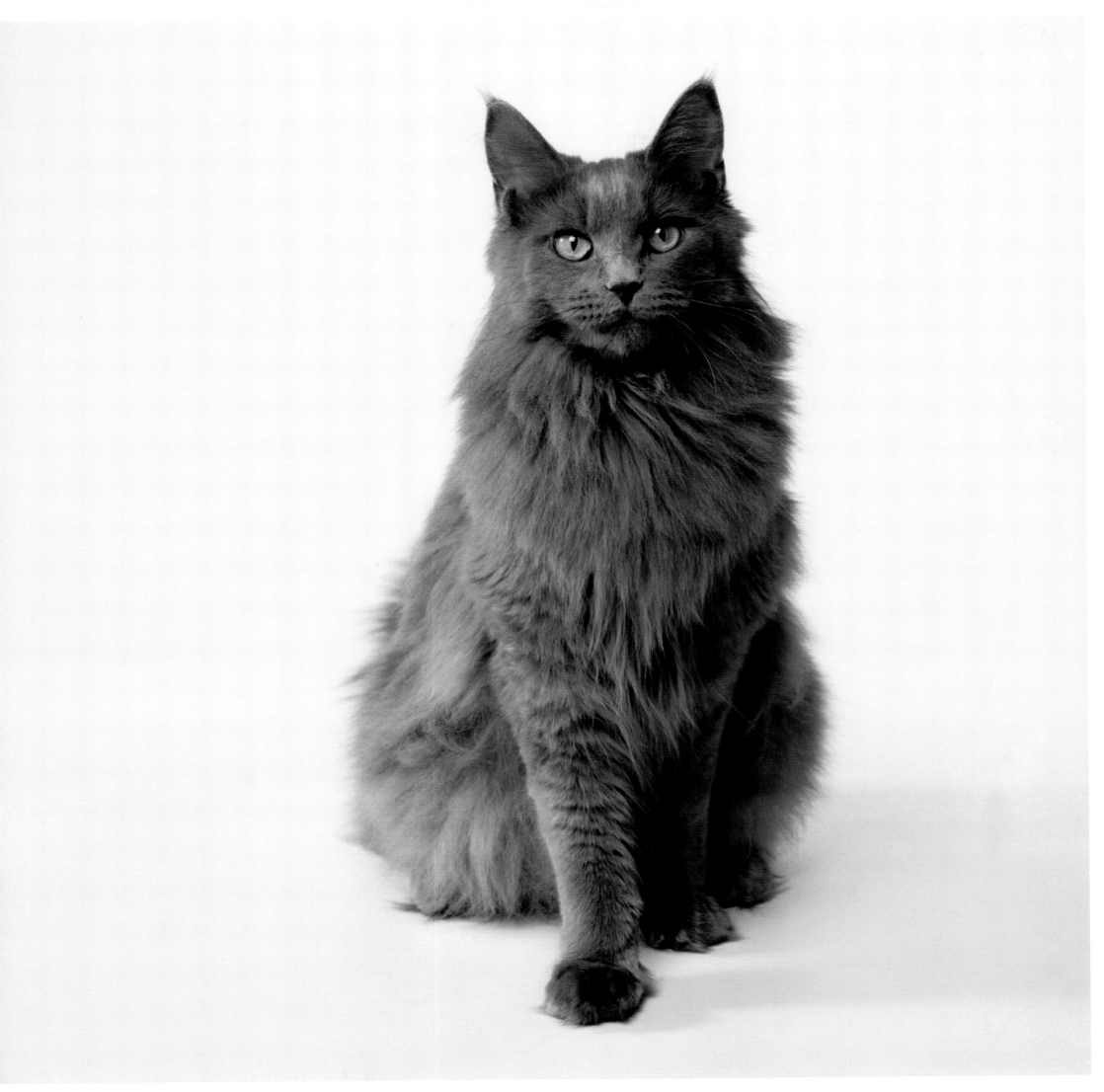

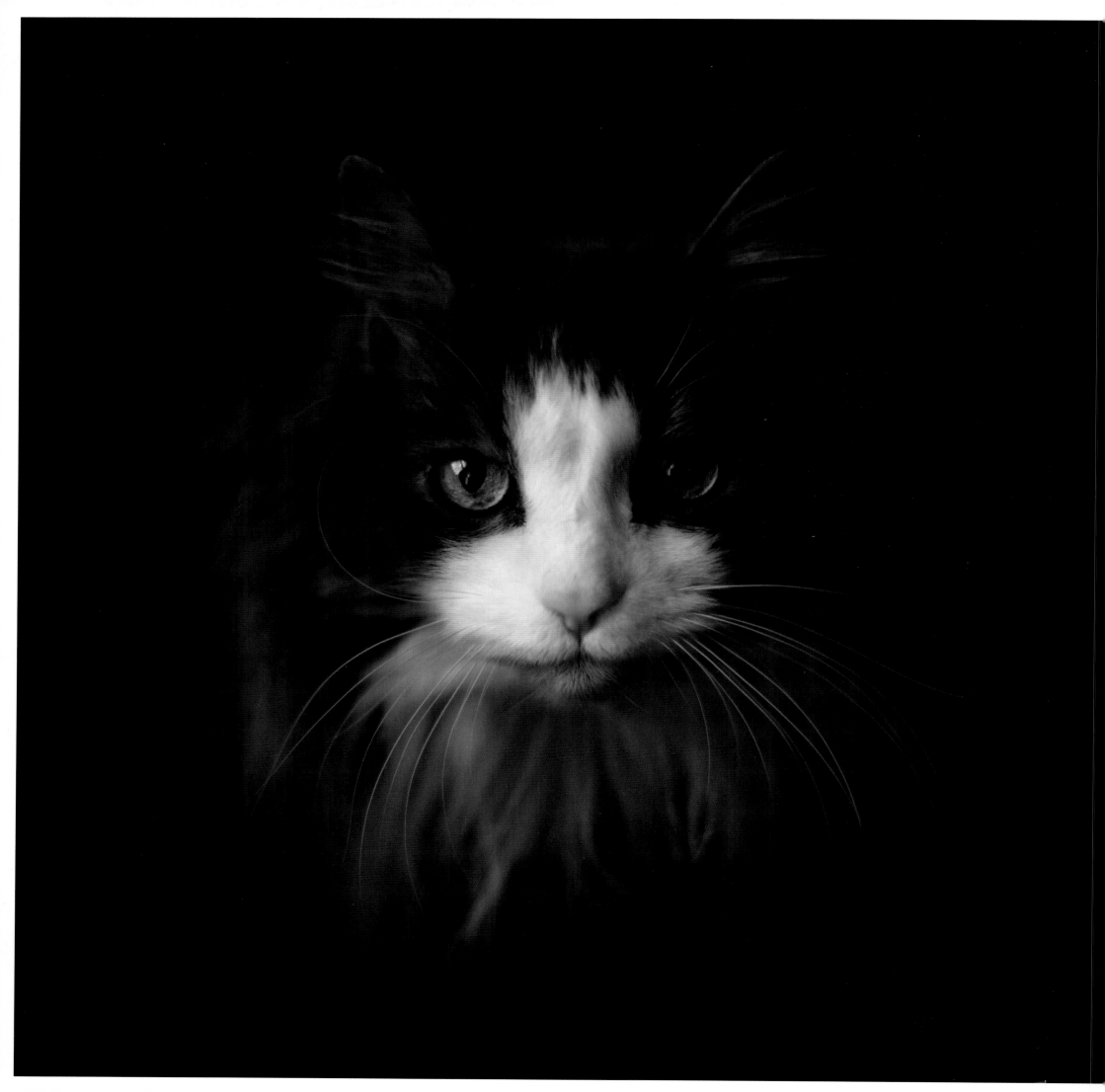

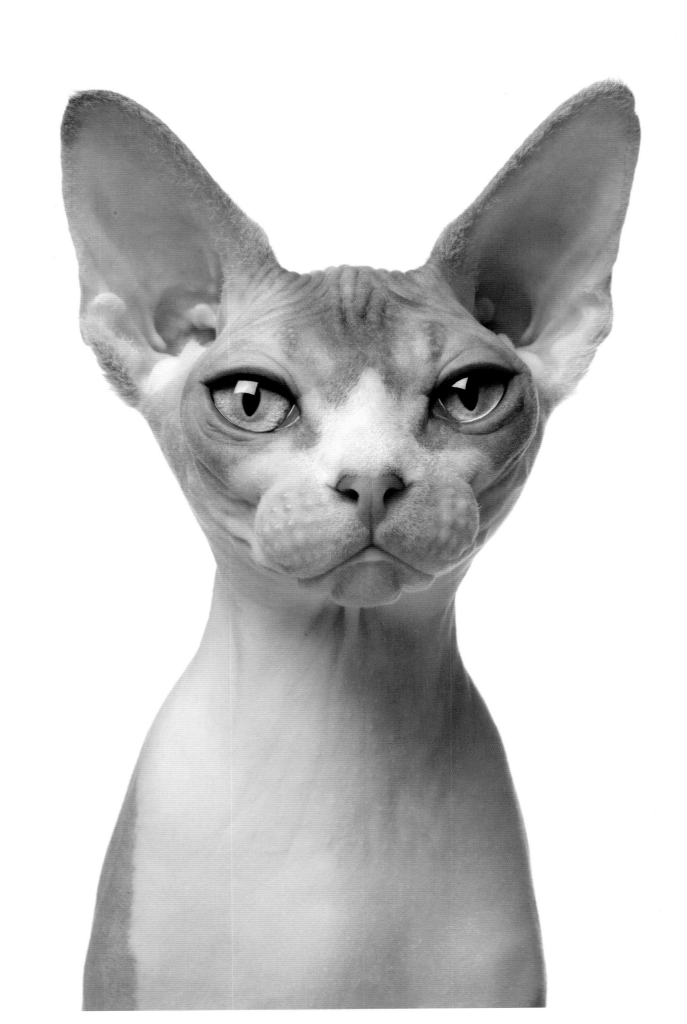

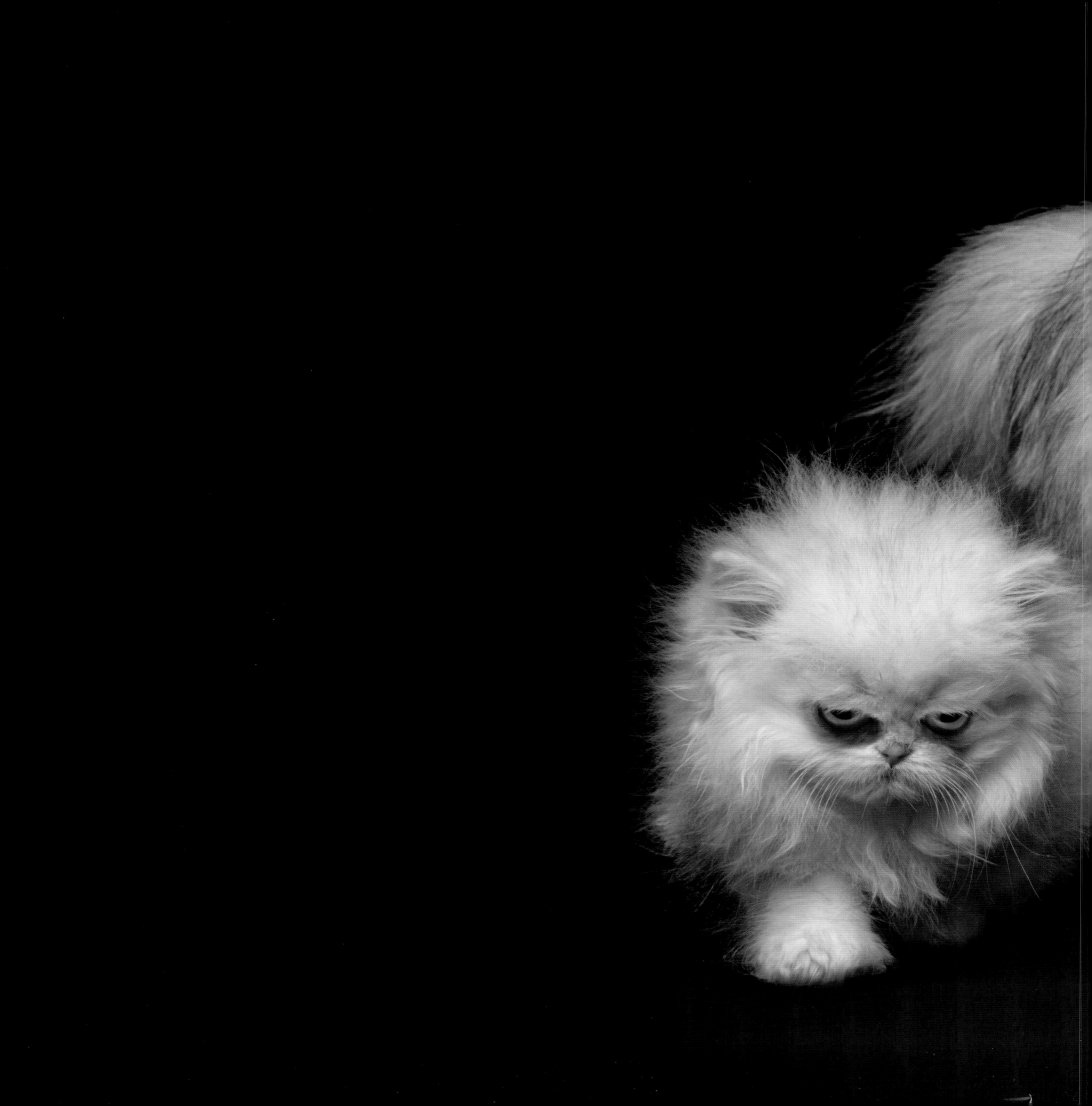

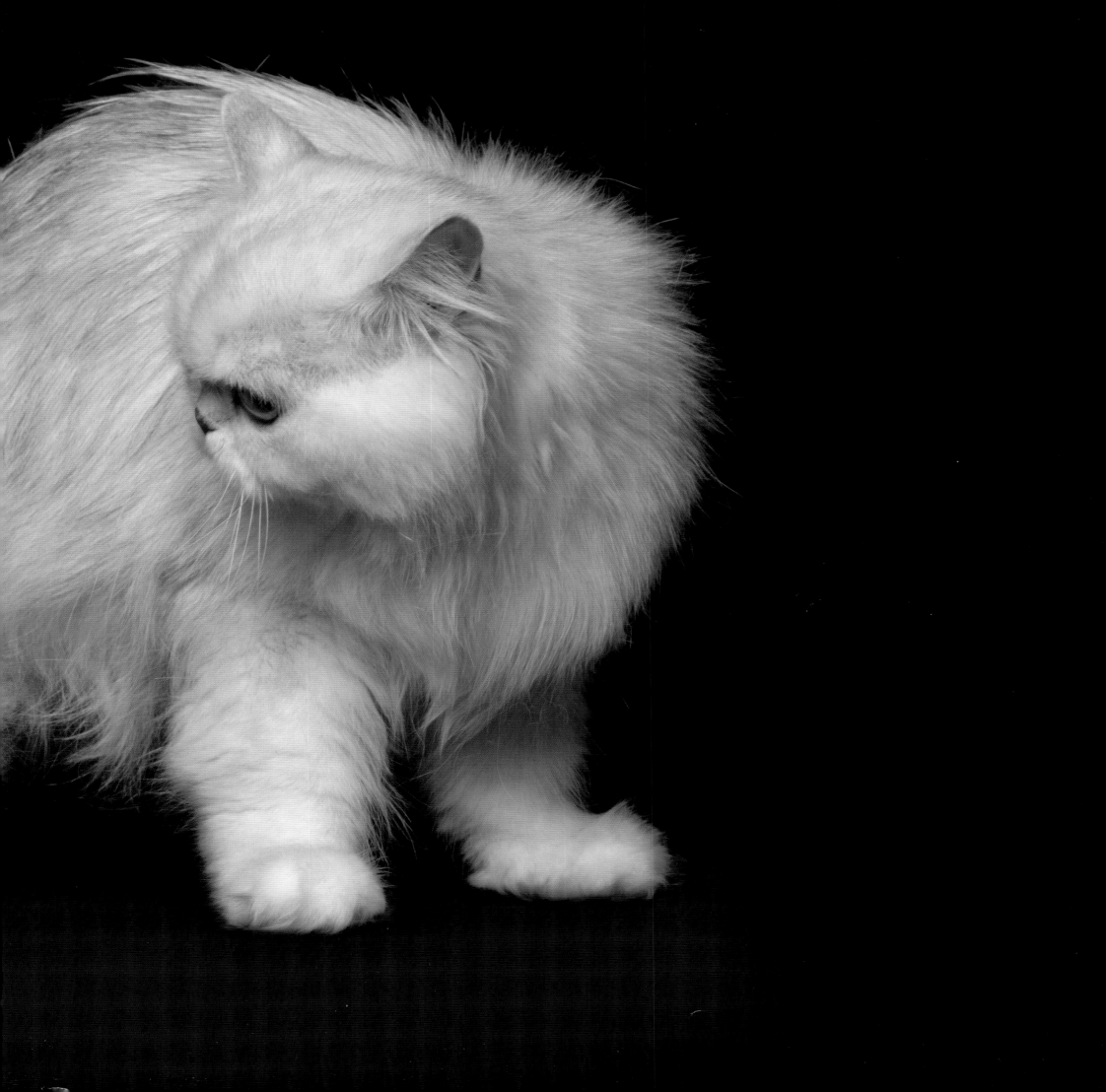

The smallest feline

is a masterpiece.

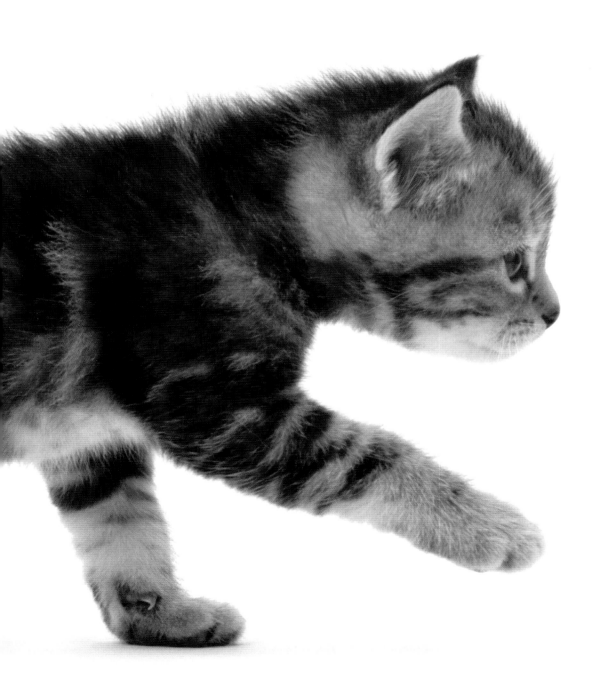

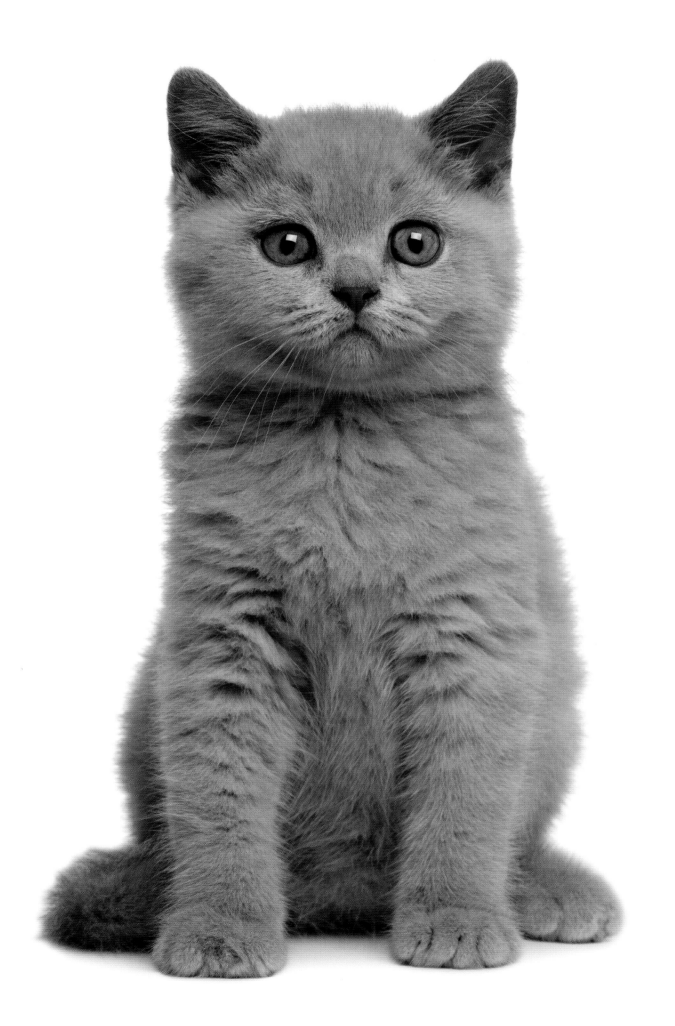

There is no more intrepid explorer than a kitten.

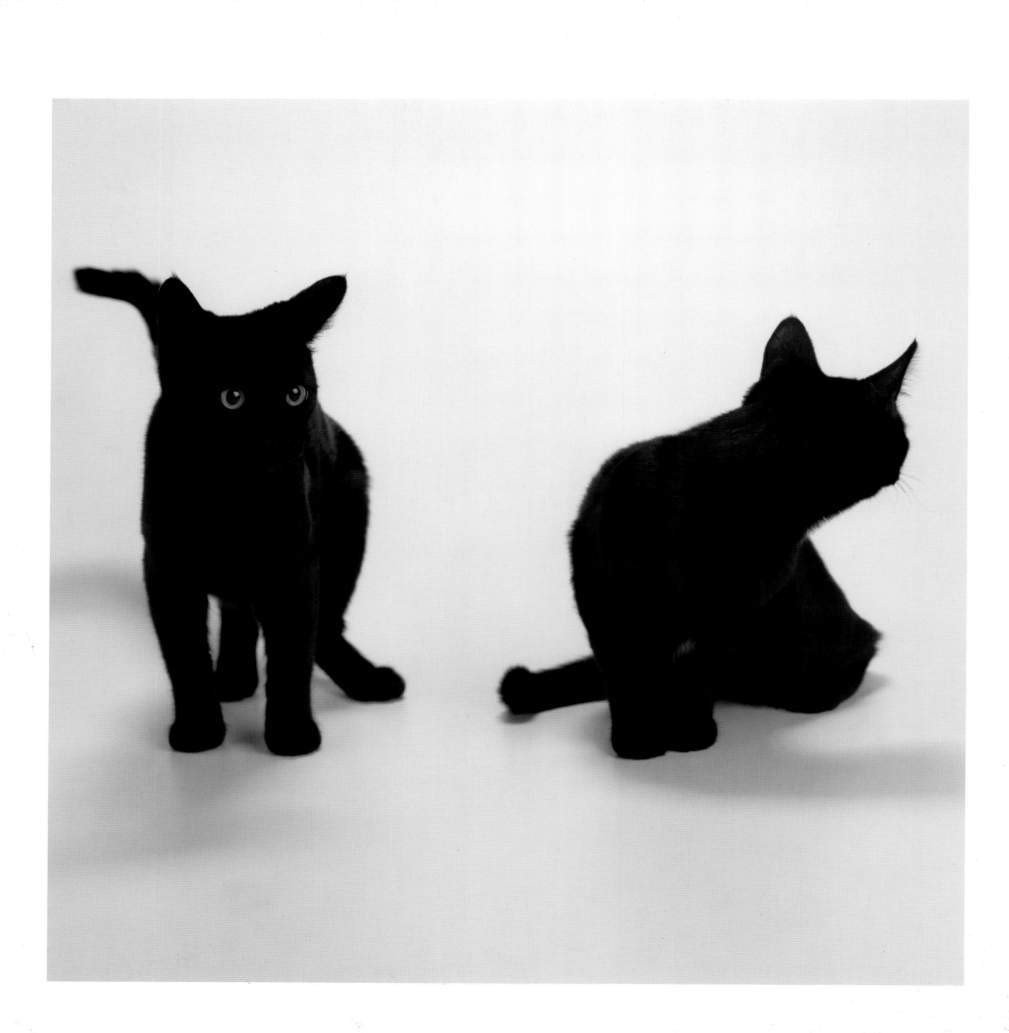

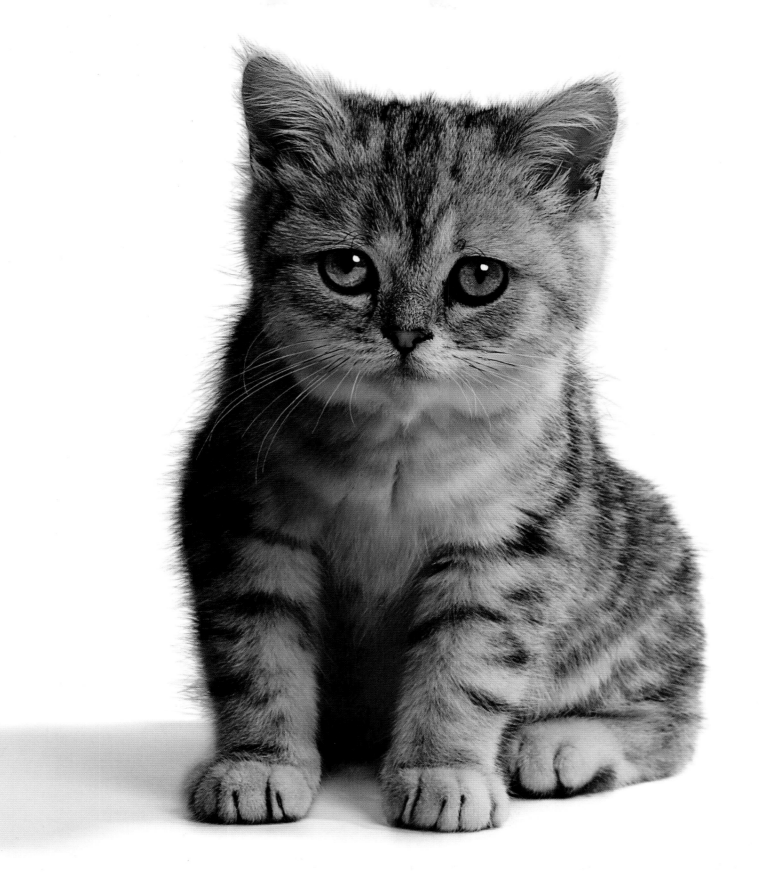

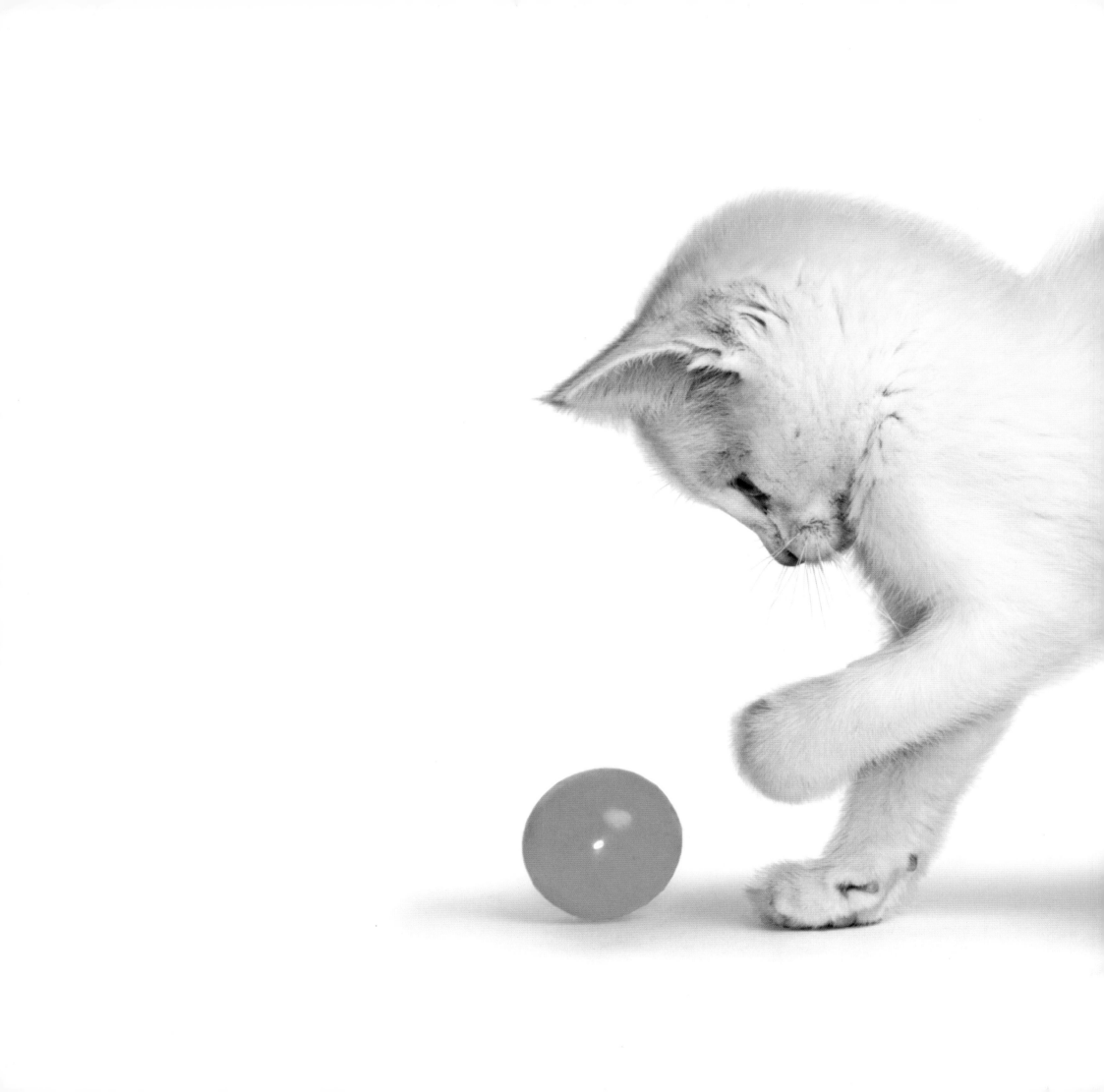

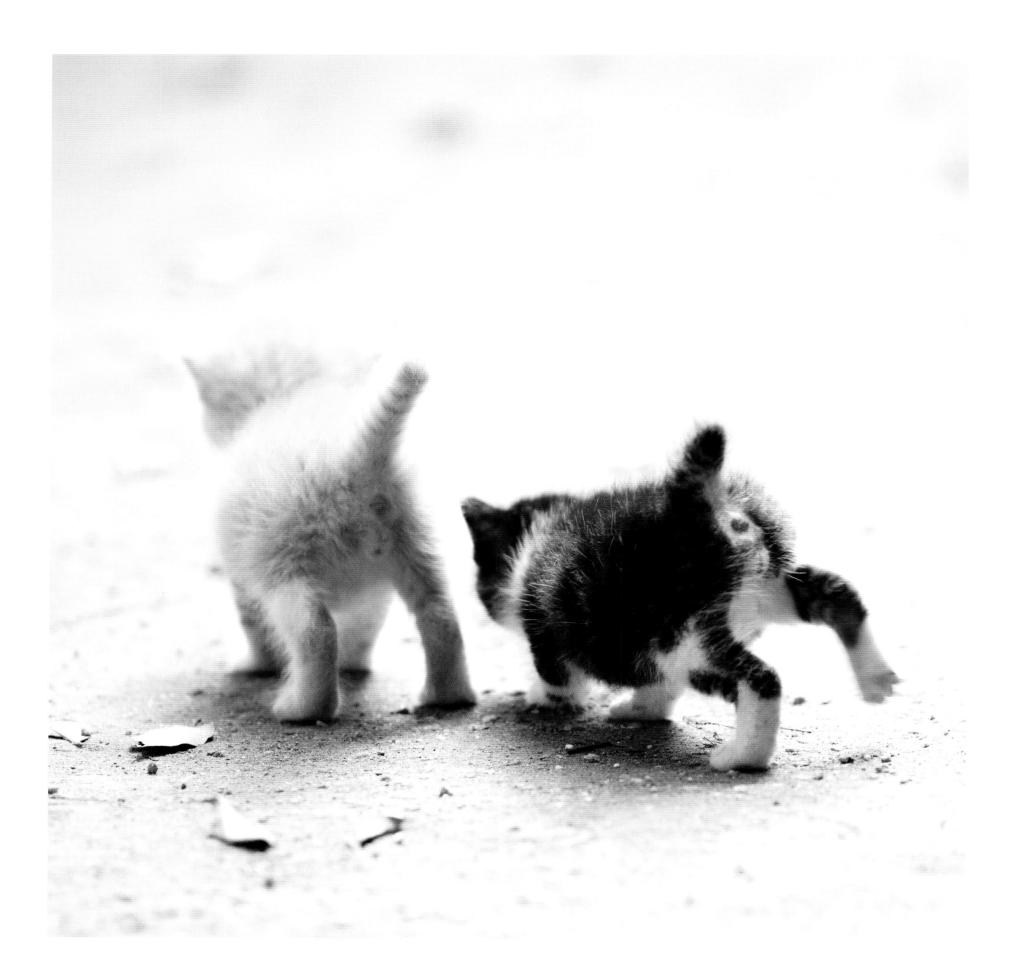

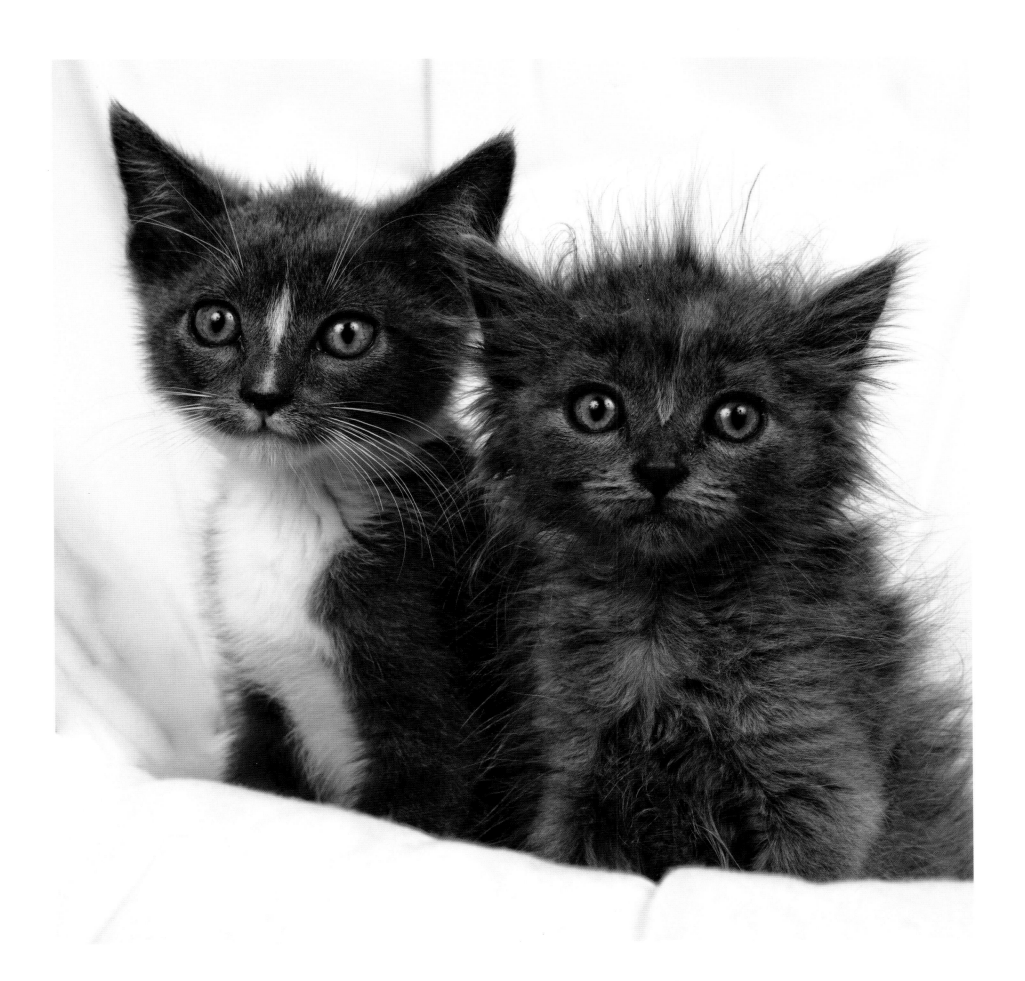

A kitten is so flexible that she is almost double;
the hind parts are equivalent to another kitten with
which the forepart plays. She does not discover
that her tail belongs to her until you tread on it.

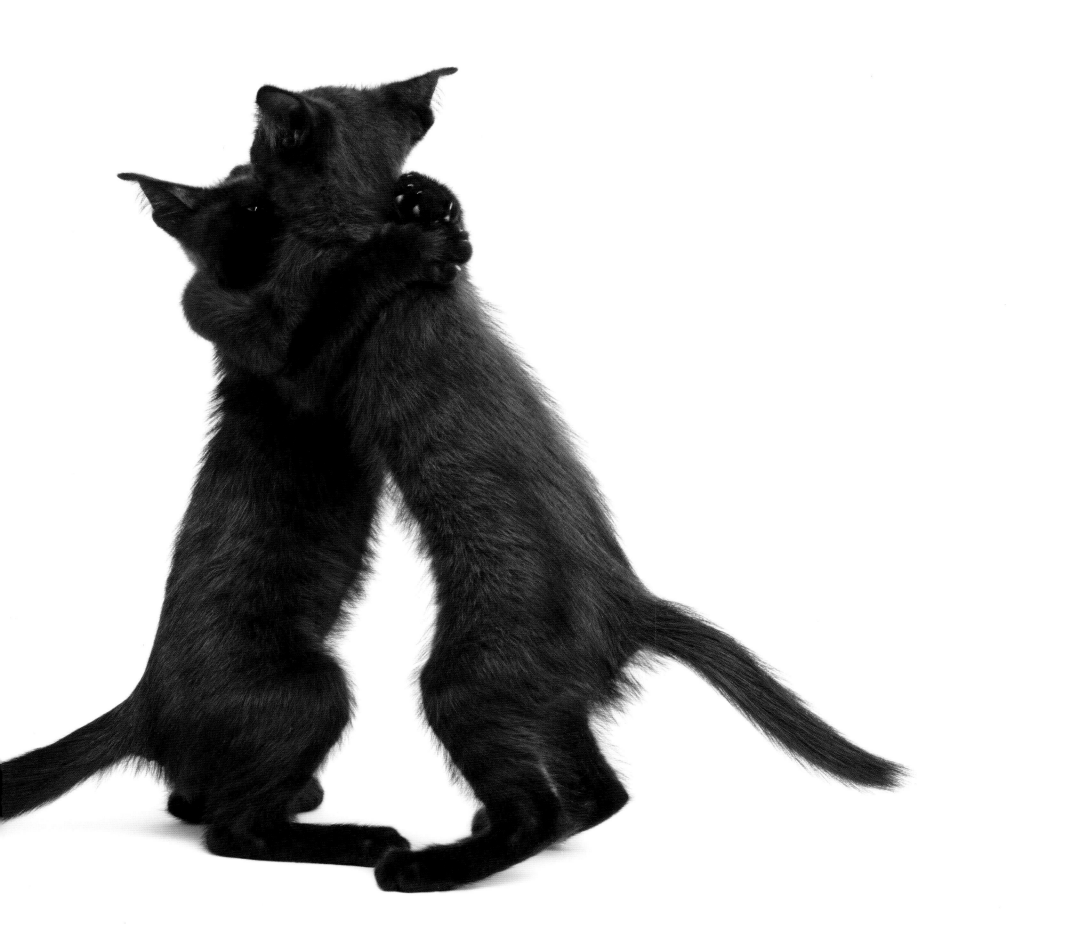

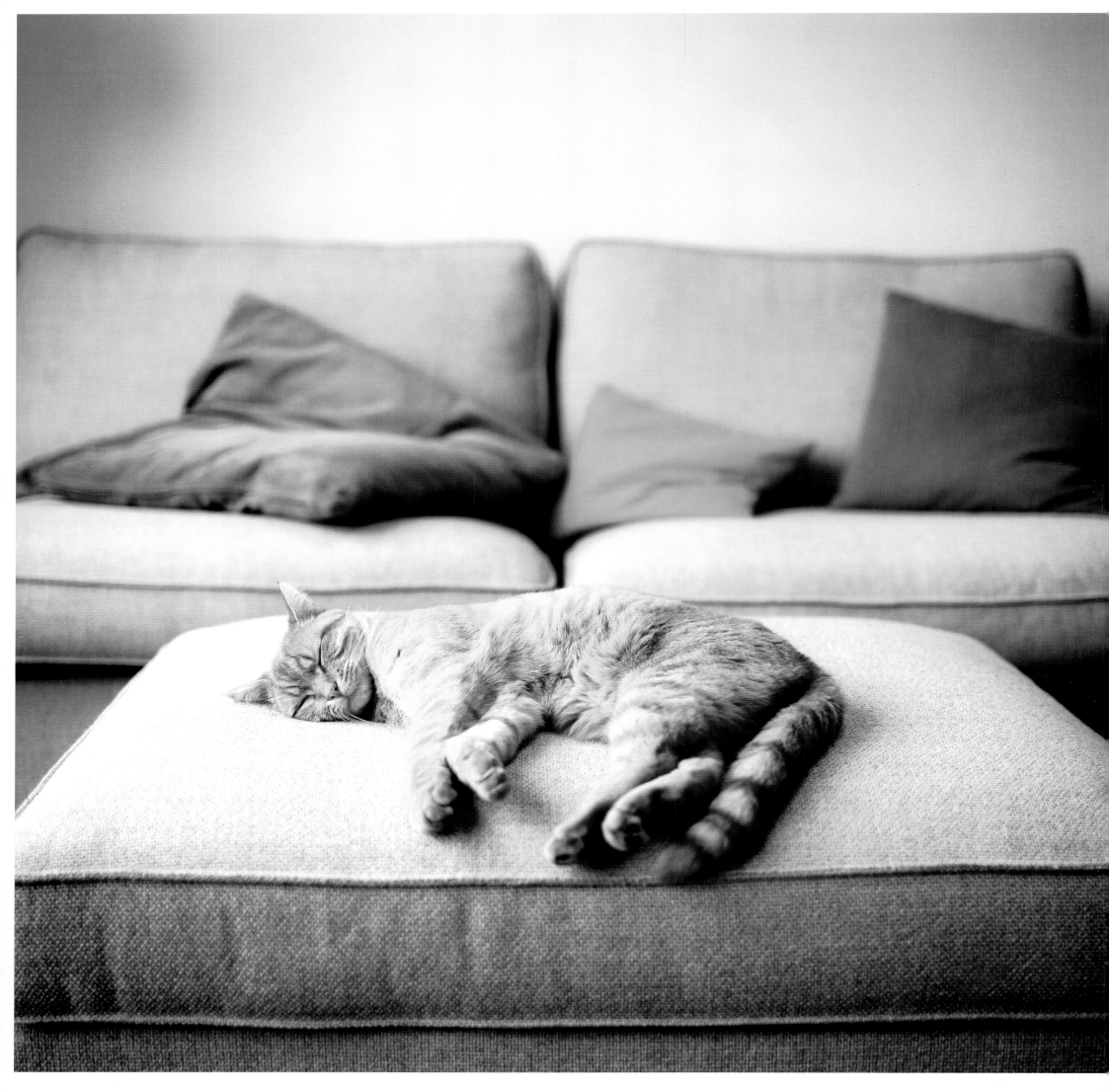

Dreaming is what cats do best.

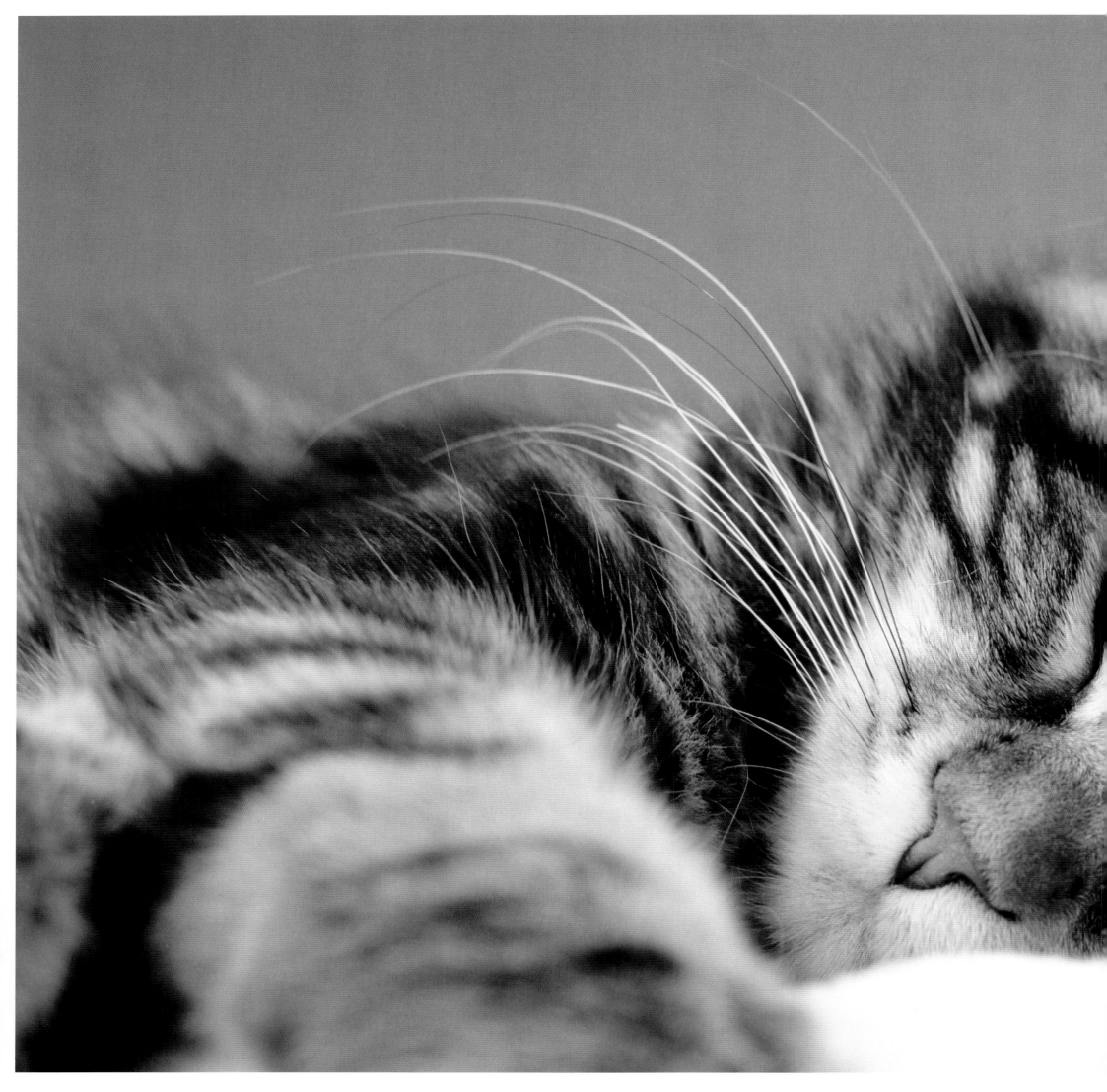

Cute

Here's a cat playing the piano. Not bad, if a little ambient. And here are a dozen kittens, perhaps more, sitting on a sofa moving in a synchronized way to a workout video. Oh, here are two grown cats actually doing a workout on a treadmill. Is that funny or cruel? Here's another two, brothers by the looks of it, playfighting to the perilous edge of eye-gouging injury, but not quite, and never giving up. Little tigers, don't we love 'em for their inner violence? Ah, but here's a ginger and a black cat who are pals, carefully grooming each other with a different kind of lick and showing great tenderness. And here are three young tabbies struggling to get into a tissue box. Bit boring that one. And now let's listen to two kittens cooing to each other in a trilling, purring twist. What could that mean—"This is the life!" or "I think it is your turn to groom me!"? And what about this one, perhaps the winner of our quick rundown of random cute cat videos, the ultimate super-fluffy kitten: a little gray ball of fur falling asleep to a nursery rhyme. Ahh. You can't beat that. Well, perhaps you can, with your own cat photos and videos, or by trawling deeper through the innumerable files that we now share across the world wide web of cuteness. Every day, another few thousand upload their cute cat moments: gestures that suggest we love our cats for their ability to melt our brains down into mush.

And why not? A doctor writes: "I'll be taking some time off . . ." Whaat! That's Dr. Cat, and I was just getting into his/her/its website of Dr. Cat stories and now they've stopped. That's the thing about cat cuteness: it's addictive, even when the cat is not a real cat (or a real doctor) but just a cartoon blog. On which theme (cartoon cats), I am reminded of the first television program I can ever remember. *Top Cat*, a Hanna-Barbera classic of animation, featured the coolest cat leading his gang around the bins of some Manhattan alley, always one step ahead of Officer Dibble, an NYPD policeman of little brain. The central character was a feckless chancer with unlimited style; a yellow alley cat who wore a waistcoat and hat and whose morality was never less than 100 percent self-serving. I wanted to be Top Cat! Still do, actually. Fortunately, I have since been house-trained and have learned to hide the more animal instincts behind a range of deceptive strategies . . . like most cats.

The thing about Top Cat (or T.C. as he was known to close friends, and I count myself among them) is that he was charming as well as a little monster. He was a tough version of cute. And that's the thing about almost all cats: even when tough, they can be cute, which doesn't apply to scary dogs. And we need cute in our lives, so that's why we have cats for the most part. We need them because we are all—at least all of us cat lovers—more than a little addicted to cuteness. What catnip is to cats, cute is to humans.

No, my brain has not turned to mush. At least not yet. We need cute and I will demonstrate this with a little science lesson. We are hardwired to appreciate cute. We can't help but love the cute kitty. If you see somebody who really doesn't "get" cute then you have to worry about their ability to love anybody. Our cute response is the thing that enables us to appreciate that we should look after defenseless little babies. As a species, we stand out for having offspring that are really desperately in need of support— unlike, say, elephants, whose period of gestation exceeds that of

humans, but who give birth to a baby that is soon ready to trot behind its parents. But we humans have infants that are totally unable to fend for themselves. As a result, our parenting instinct is for a high level of nurturing for a long time. It is also not a very discriminating instinct and seems able to transfer to other species with scarcely a glance at the detail. When we see big eyes, the large head-to-body ratio, the symmetry in the features . . . these things tell us, "give it some love, your destiny as a human race depends on it." Researchers have discovered that when these key cute elements are lined up, they act as triggers to the pleasure centers of our brain, creating a rush of positive feelings that ensures we then protect and help the infant. Our brains dope us up with the chemicals that pass for love.

But it is not only human babies that share infantile cute features: they exist across the animal kingdom. And so we receive that rush on a broader front . . . we are programmed to share the love a bit wider. And of course it wasn't long before scientific know-how turned cuteness into hard moneymaking. Now we are certain of the power of cuteness, and its strength is evident in areas like product design, aimed to seduce our senses and switch our buying preferences. Look at cars like the Mini, the Fiat 500, or the Nissan Micra . . . these are not designed to appeal to our sex drive, like vehicles for macho types in the past. Instead they appeal to the nurturing and more feminine drive in us, through their overload of cuteness, with bulbous headlights substituting for eyes and a windshield for the high forehead of the human infant.

Stepping into our need for cuteness, cats have it easy. They are tailor-made for the job. A kitten is just a bundle of cuteness, but, even as it grows up, a cat manages to keep more of its key cute features than most species. The baby-like, big, forward-facing eyes are typical also of grown cats, which have a much larger eye-to-head, and head-to-body ratio, than we humans do. Being soft and cuddly, and also being a little clumsy when young, just adds to that mind-melting factor.

Cuteness is separate from beauty. Some cats—such as Siamese— have a stronger claim on beauty, with their refined markings and more pointed ears, their sharp eyes, and accents of color. However, they do not retain as much cuteness as, say, the rounder-eyed appearance of the American shorthair, or even most non-pedigree cats. It is the consistent appeal to our subconscious respect for cuteness that secures a constant place for the cat in our affections, and that perhaps will shape the evolution of cat breeding.

It certainly has shaped the depiction of cats in mainstream media, where cute factors are often exaggerated, or at least made essential to the depictions of cats. This can be seen most notably, perhaps, in the features of the Japanese character Hello Kitty. An image that has become a mega-industry of cuteness, Hello Kitty is accompanied by a wealth of products built around a highly stylized, mouthless, symmetrical abstraction of a cat, always posed front-facing with a very rounded head and ears. So pervasive is Hello Kitty in Japan, that it can even be found in rugged manly environments, such as in a truck driver's cab. The theory is that the particular emphasis on

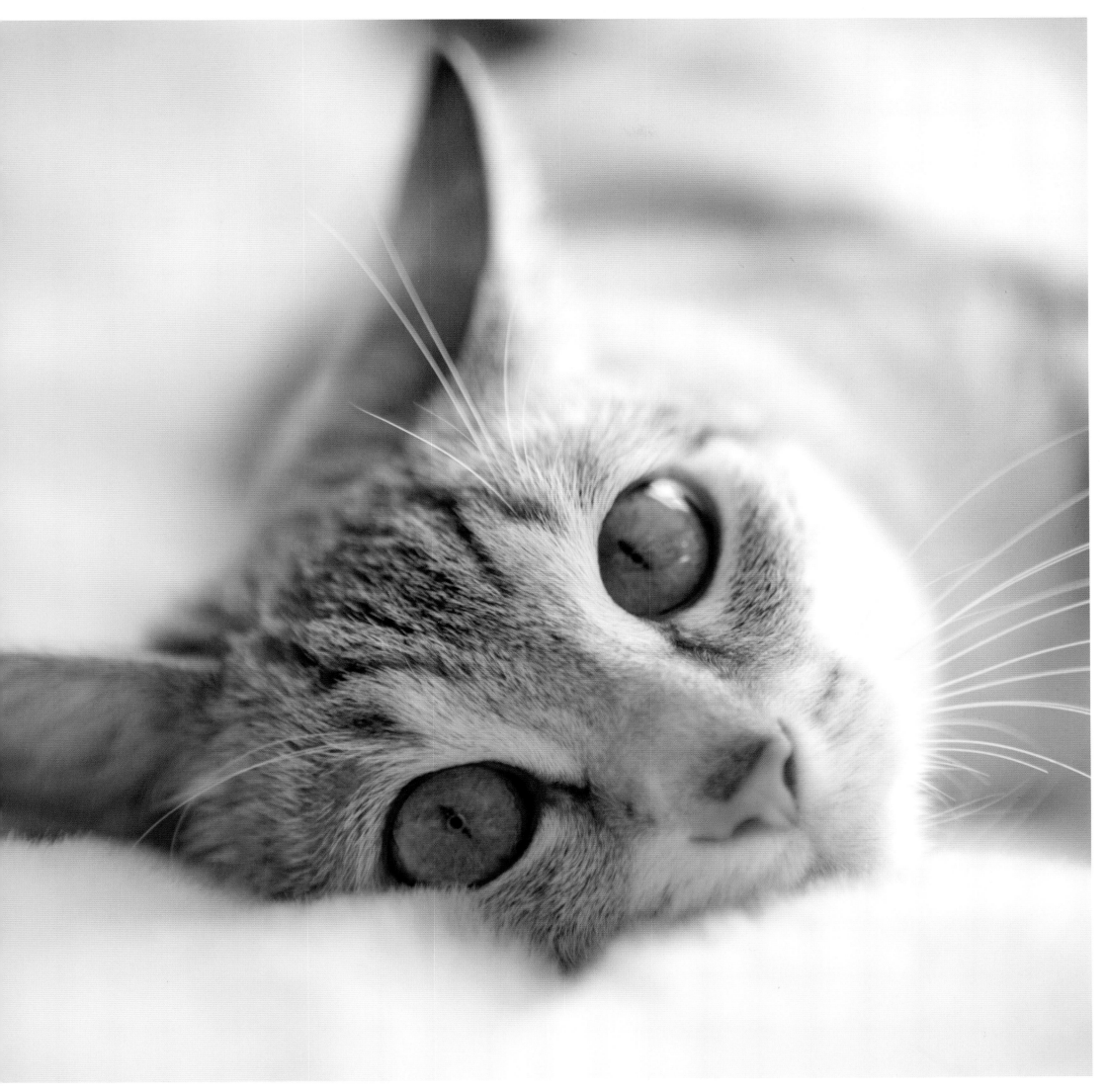

cuteness (or "kawaii" as it is called) as a display of love in Japanese culture helps generate harmony, avoid conflict, and soften the otherwise formal and authoritarian structures that still exist within society. And nothing does this better than the strange cat without a mouth. The big eyes are there, too, in the most famous Hanna-Barbera animation series, *Tom and Jerry*—with both cat and mouse as big-eyed, big-headed, and round-featured. Ker-ching! Cute!

The Japanese Maneki Neko, or Welcoming Cat—the figurine so often seen in shops in Japan and increasingly more internationally—also displays key cute aspects. Its features are very rounded, and mostly symmetrical. While this cat traditionally has one paw raised (a symbol that is supposed to intimate closeness to wealth, as well as a greeting), some cats have been made to make an even stronger statement of welcome by having two raised paws. This ups the cute factor by combining a suggestion of openness and defenselessness as well as achieving symmetry, which is an important element that we associate with baby features.

Of course, associating cuteness with commerce, or generally just immersing it in popular culture, can quickly lead to revulsion. We don't like being manipulated. Perhaps the success of cat characters in cute commerce is that we have such a strong bond with the cat as an everyday and real piece of cuteness in our lives, so the commercial manipulations slip a little more easily under our guard.

In a *New York Times* article from 2006, "The Cute Factor," that assessed the scientific evidence and tendencies of cuteness, Professor Denis Dutton commented: "Cute cuts through all layers of meaning and says, Let's not worry about complexities, just love me." But he warned: "That's where the sense of cheapness can come from, and the feeling of being manipulated or taken for a sucker that leads many to reject cuteness as low or shallow."

Undoubtedly there is something pretty shallow about the numerous websites committed to crowd-sourced videos of cats doing the cutest things. And yet the viewing and upload statistics, the general prevalence of shared videos around work communities and in families, and the thousands of forum notes appended to these viewings, show there is a very large market for basking in the shallow waters of cute.

All this does rather obscure, though, the powerful underlying knowledge that we are wired to respond to cuteness. This knowledge can help us to both understand our love for cats and be aware that we view them as objects for our nurturing instincts. Even though they are predators, little killing machines given half a chance, we view them as babies in need of our parenting. And because we provide that nurturing environment, they in turn step into a relationship in which they view us as an eternal mother, continuing to play kitten even as an adult cat. Especially at suppertime. Very lovable but, as with my old favorite Top Cat, don't forget that behind the charm there are some 100 percent self-serving motives. This may sound harsh, but I say it with love and delight in my feline friends. The writer William Burroughs captured this appealing selfishness of cats when he wrote: "The cat does not offer services. The cat offers itself. Of course he wants care and shelter. You don't buy love for nothing. Like all pure creatures, cats are practical."

When we strip away the pop culture and the commerce that surrounds our understanding of cute, when we train our vision on its true nature, we encounter a powerful force. There is a unique charm in how cats present themselves to us that is at the core of our relations with them. It works to make connections, avoid conflict, and achieve survival, and has enabled the domestic cat to thrive. When we look at their appeal for what it really is, we discover that cats have the same ruthless pull on our affections as babies—only they keep these qualities for life.

Stepping into our need for cuteness, cats have it easy. They are tailor-made for the job.

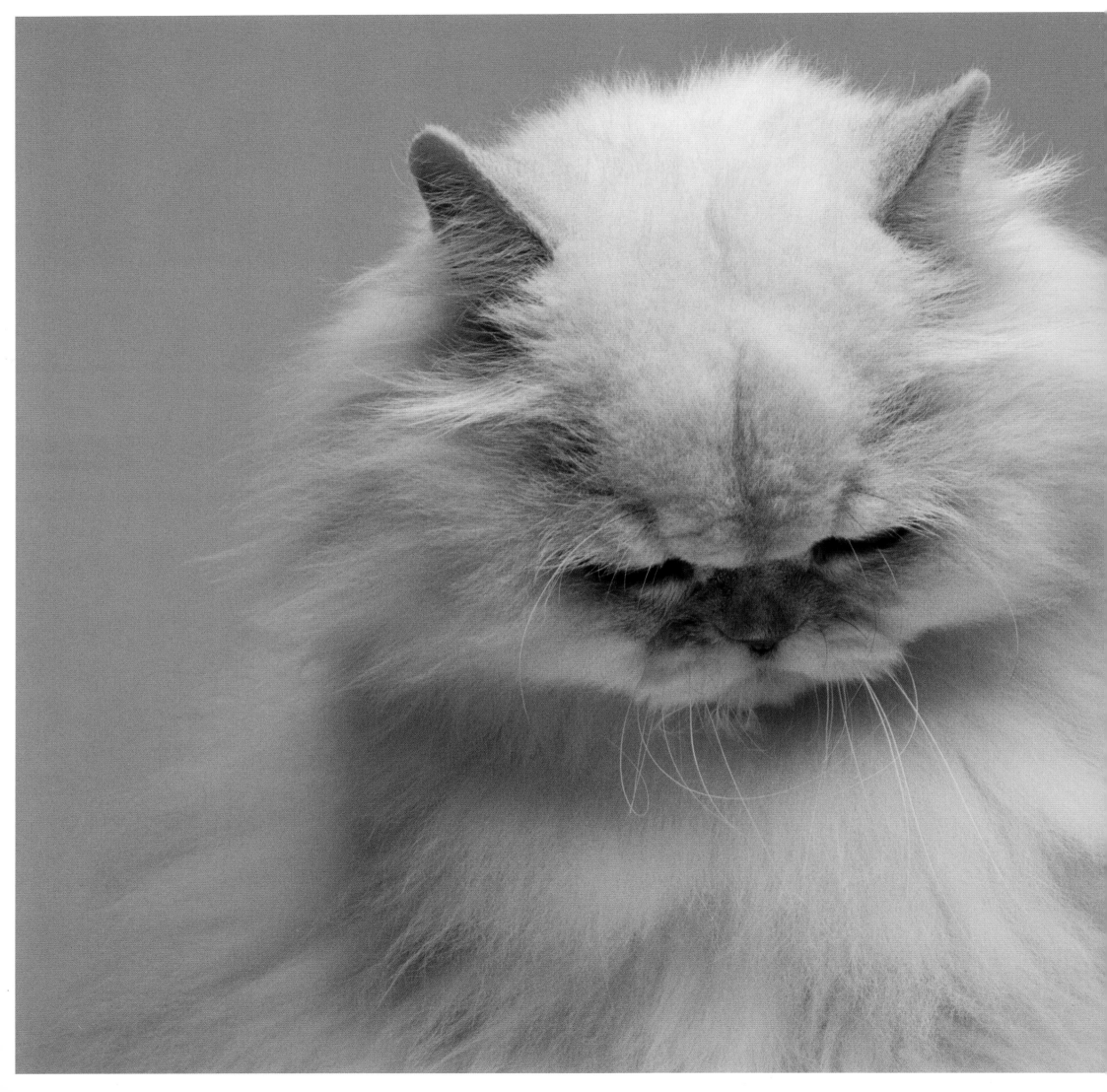

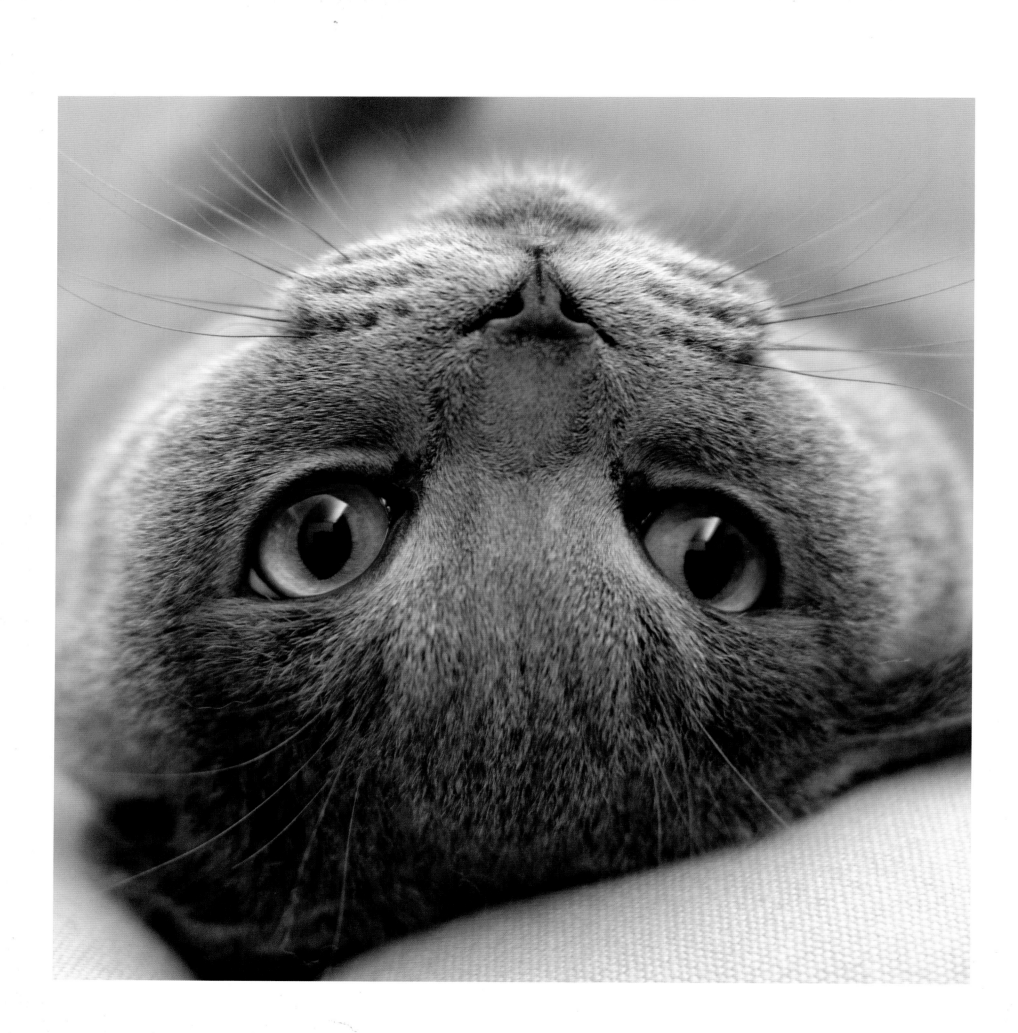

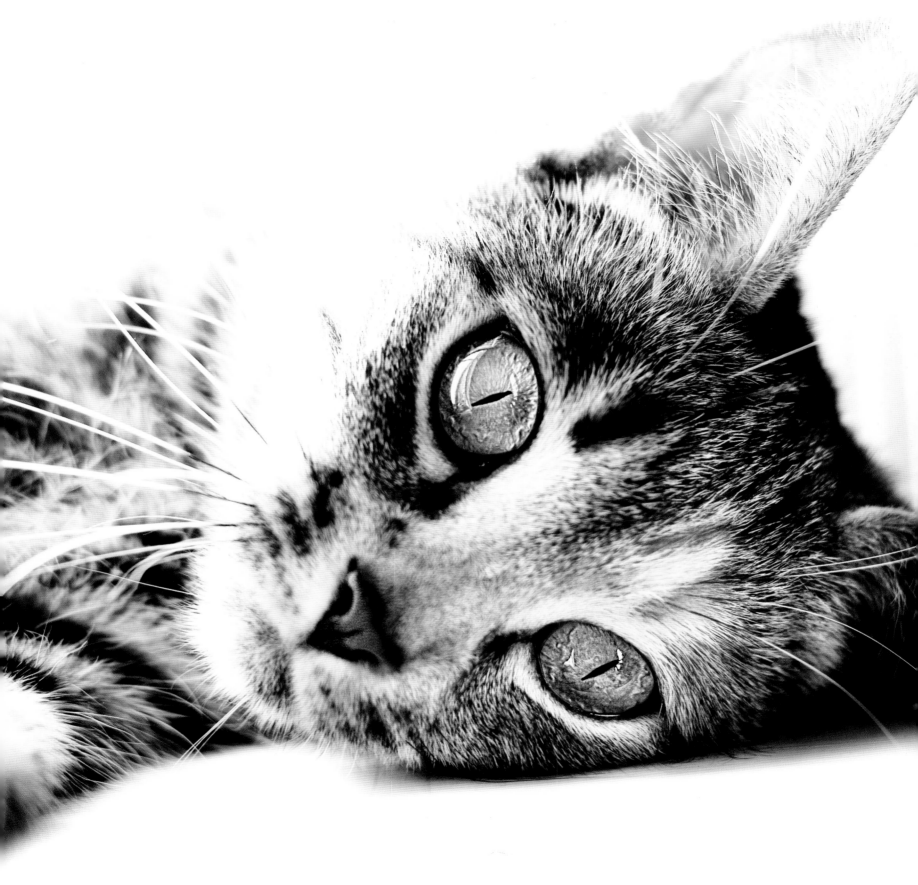

Who knows whether she is not amusing herself with me more than I with her.

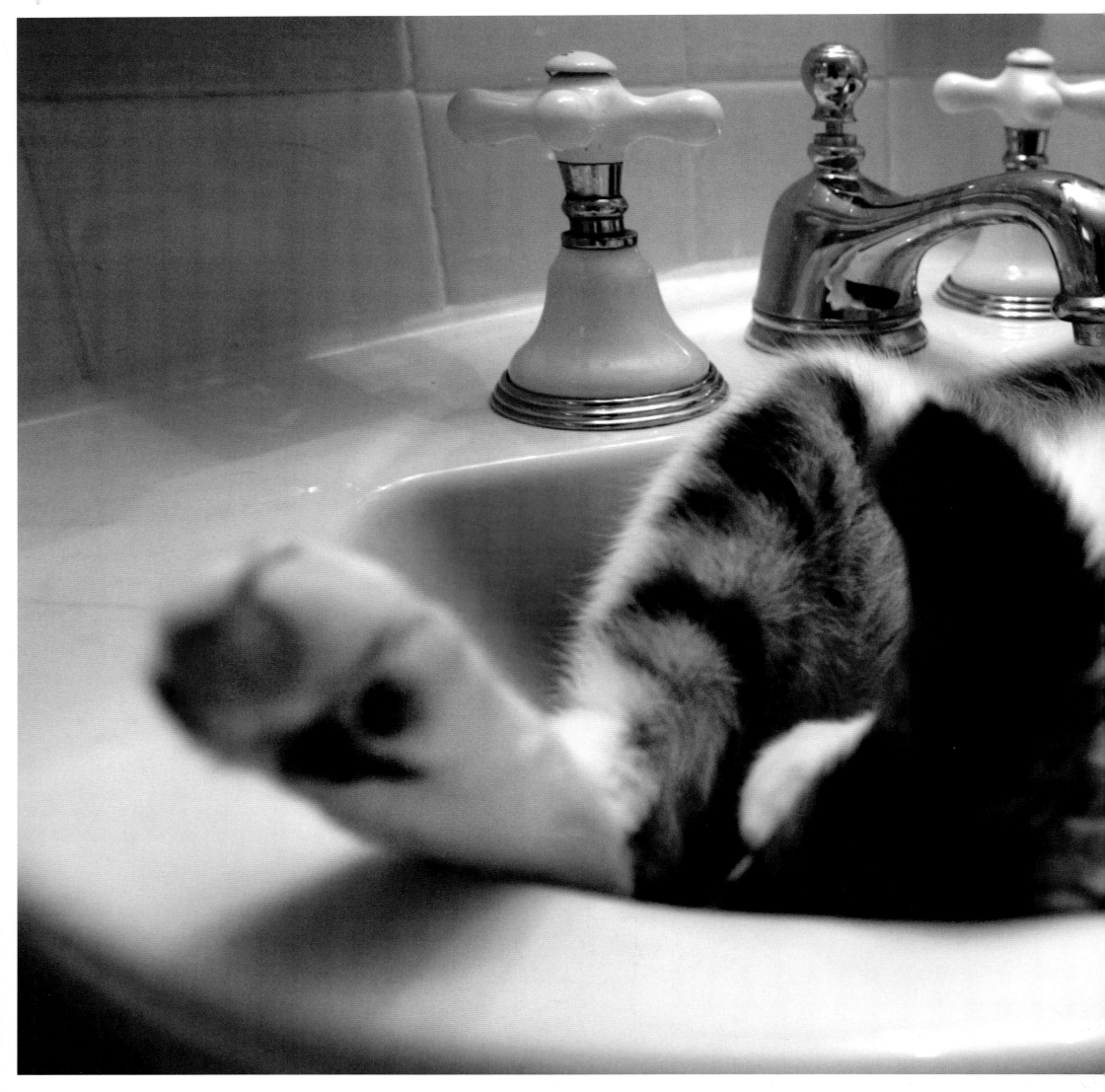

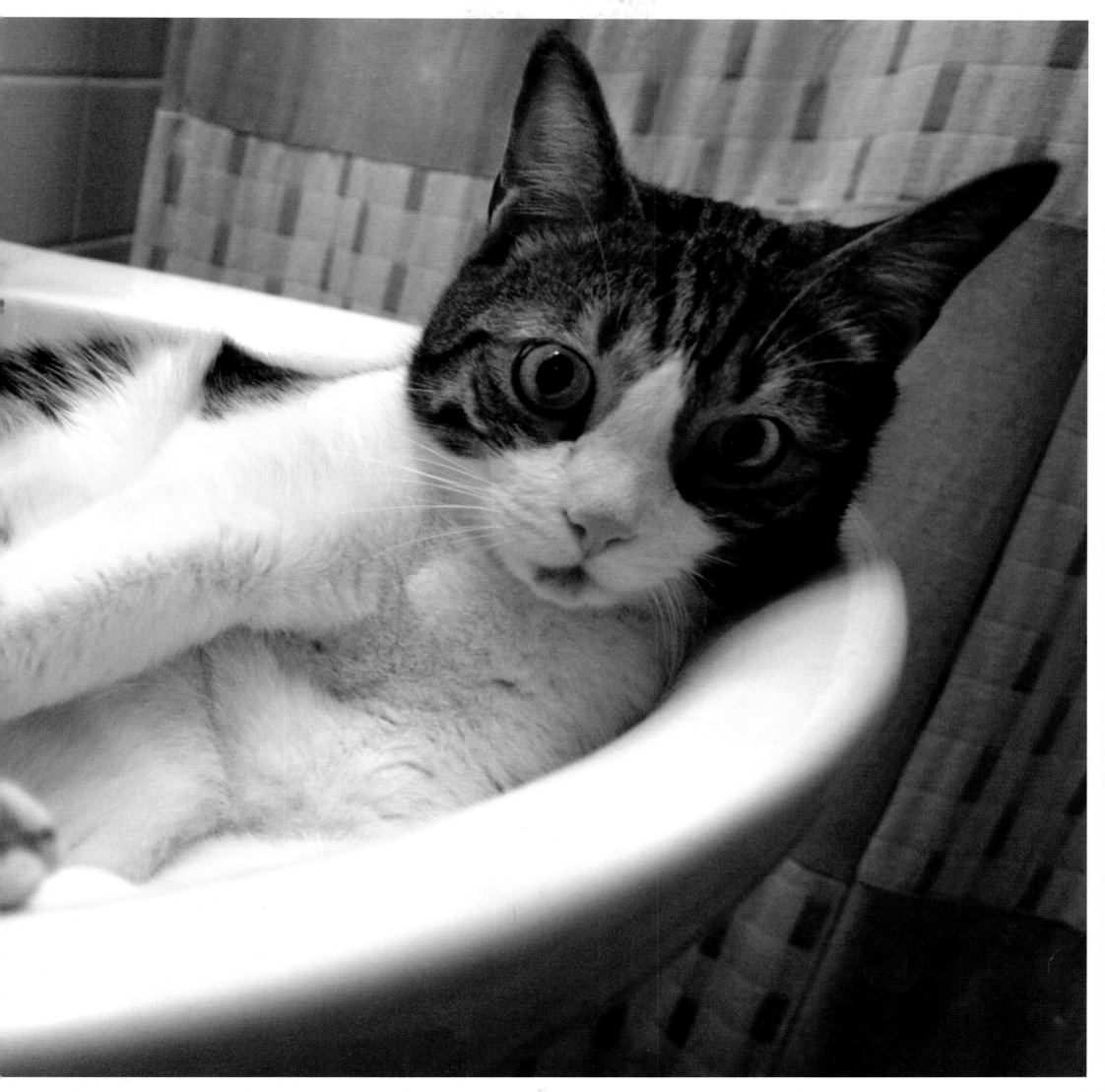

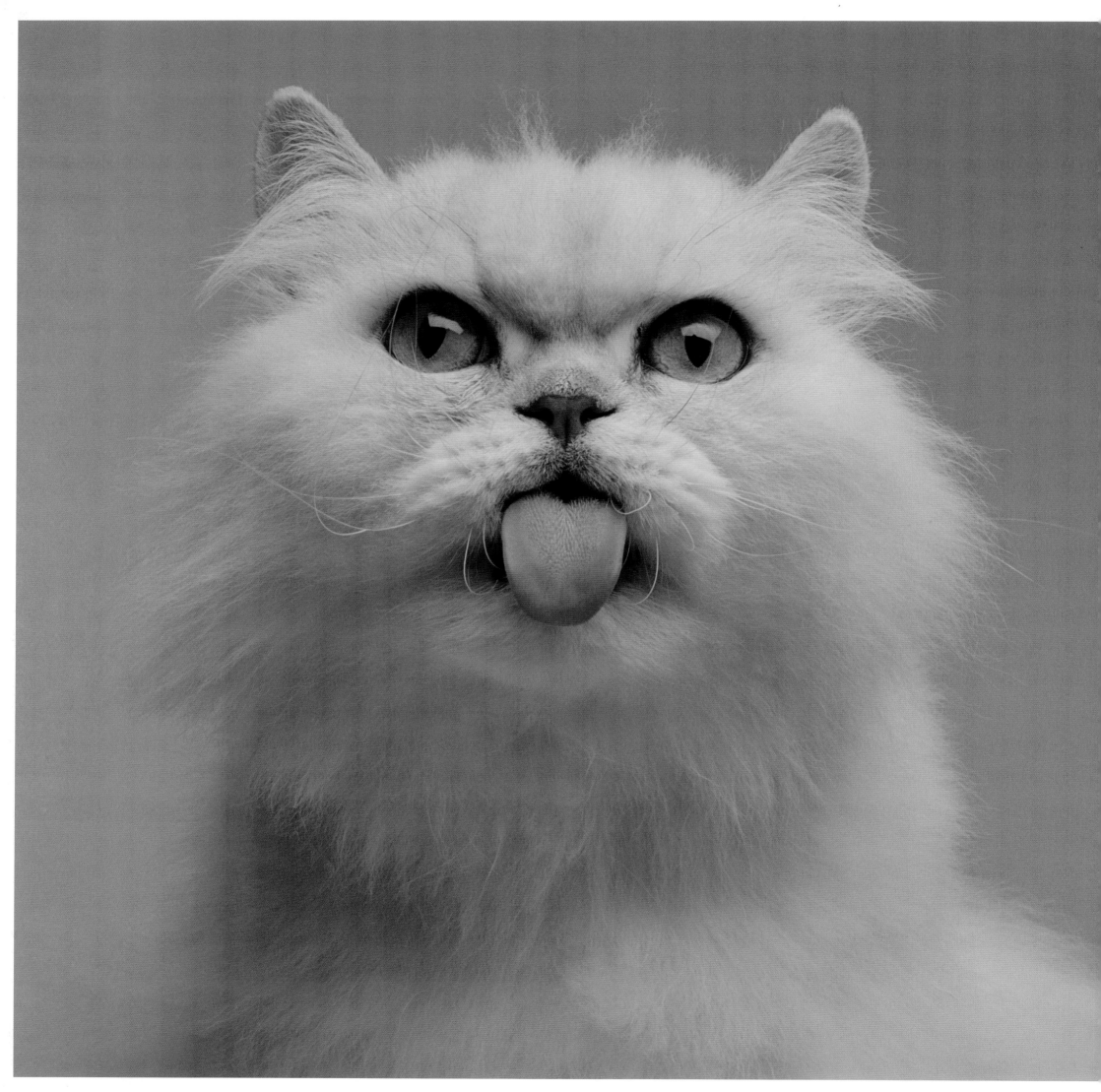

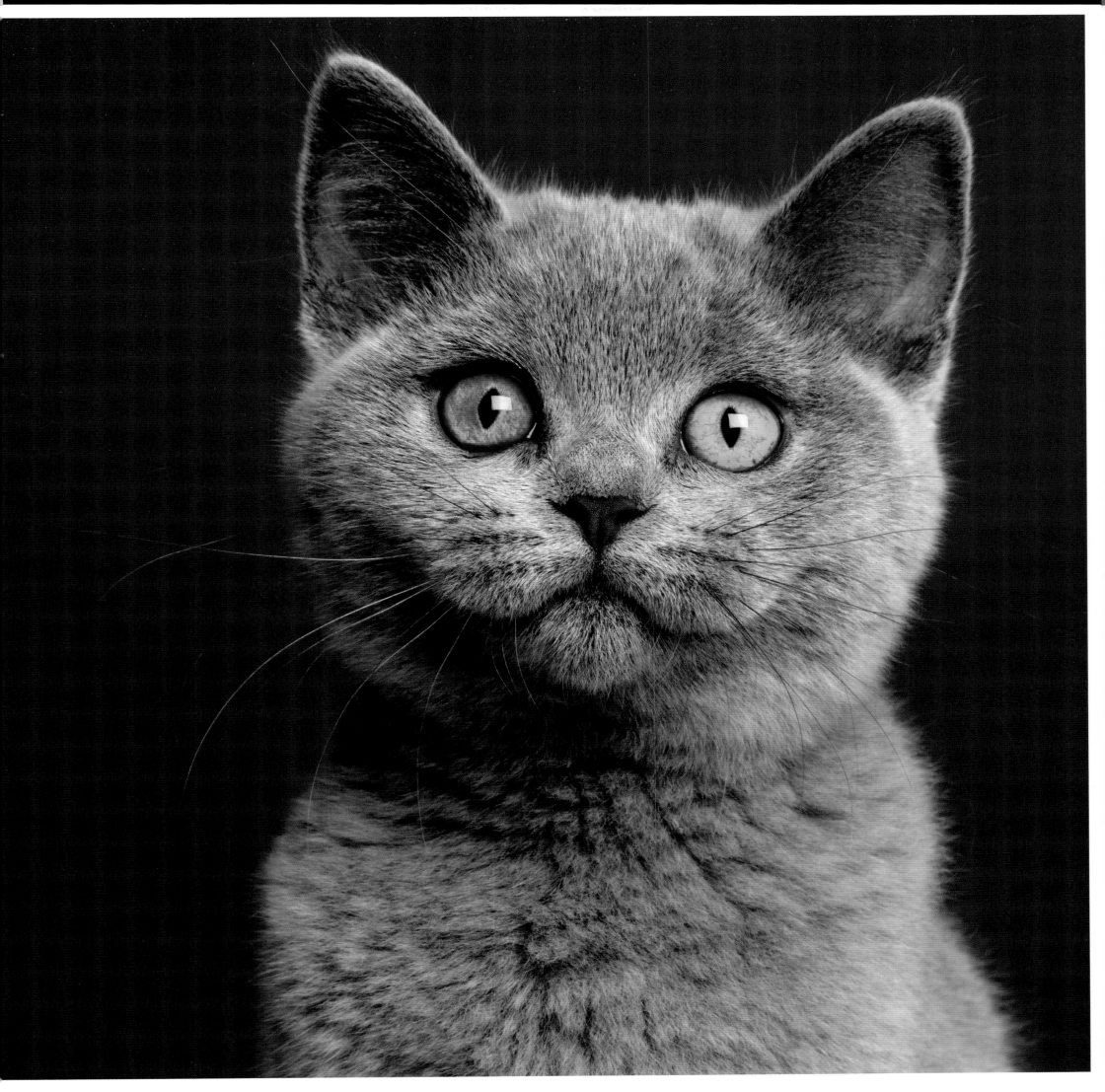

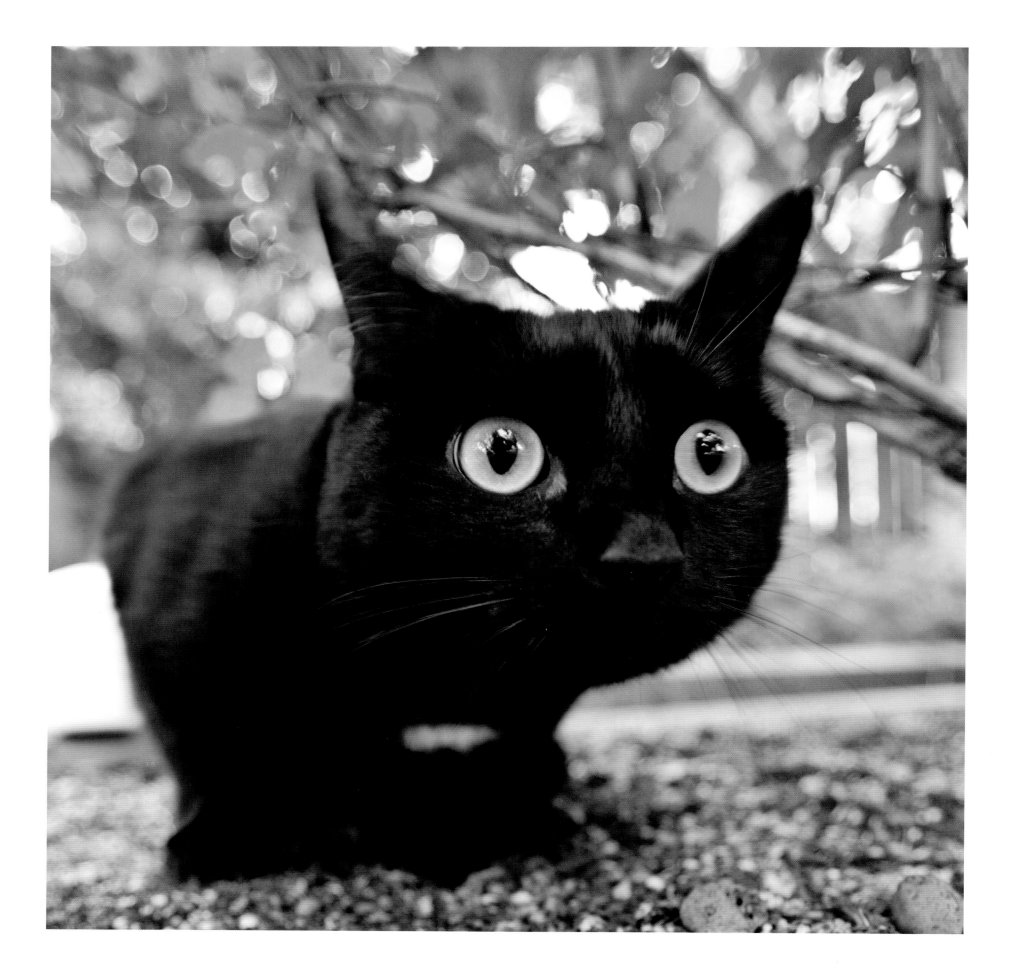

It is impossible for a lover of cats to banish these alert, gentle, and discriminating friends, who give us just enough of their regard and complaisance to make us hunger for more.

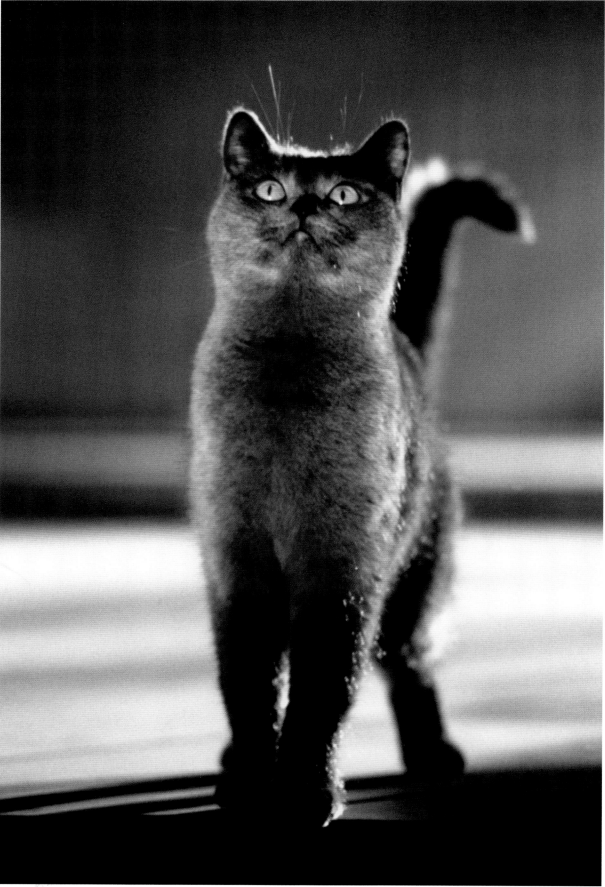

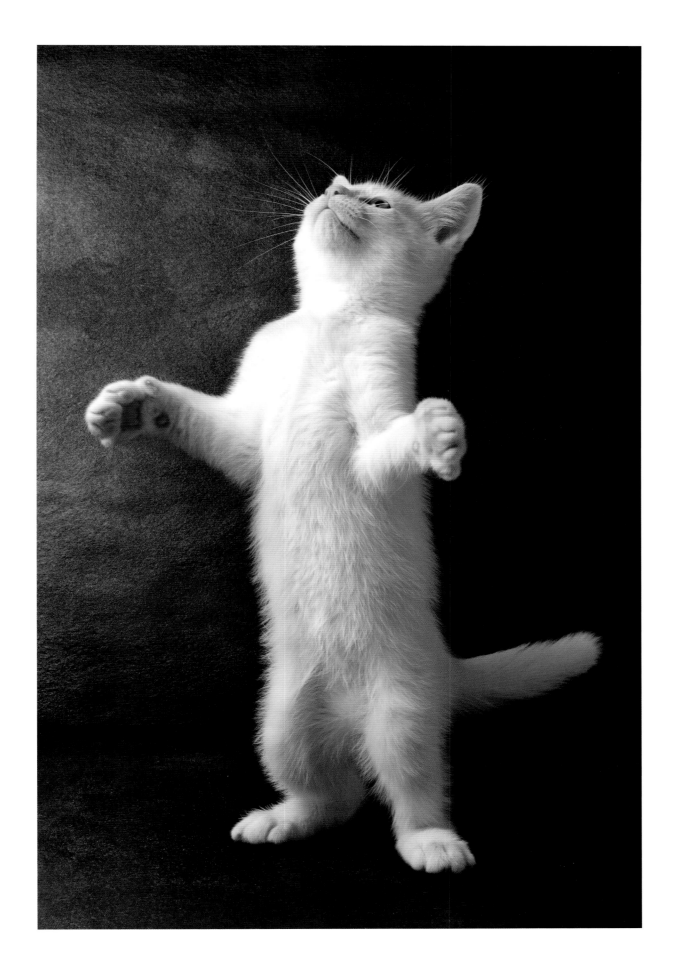

The cat is nature's Beauty.

Healing

Cats may not actually have nine lives but there is growing evidence that they may have life-extending powers. It seems that having a cat around allows owners to lead a healthier, happier, longer existence. Stories of the healing powers of cats range from citing their tendency to lower stress levels, to proclaiming them a remedy for everything from bone healing and pain relief, to joint mobility and heart problems.

So how can we distinguish cat fact from feline fantasy? Are the therapeutic qualities of our kitties just the product of wishful thinking on the part of their infatuated owners, or can we really credit our cats with the ability to enhance our physical and mental health?

The psychological effects of living with animal companions are well known. At least among those who choose to live with animals. Just having a pet has been demonstrated to lower stress levels, reduce the risk of depression, and relieve insomnia. And this is true for owners of cats, dogs, parakeets, and even rats (if you're susceptible to the romance of rodents—though they may not make the best siblings for one's cat). The evidence for these calm-inducing qualities is so impressive that pet ownership has been estimated to save the Australian health service about $880 million per year, while in Germany €6.6 billion per year is reputedly economized by dint of possessing a pet. These figures are based on research that found pet owners needed to make fewer visits to their doctor every year, had fewer sleeping problems, and were less likely to need medication for heart conditions.

But that's nothing compared to the apparent health benefits of having a cat. In 2008, researchers at the University of Minnesota's Stroke Research Center who studied a cross-section of around four and a half thousand adults aged between thirty and seventy-five, delivered the startling statistic that the risk of death from heart attack was 40 percent higher among those who had never owned a cat. During the course of the ten-year study, which adjusted to rule out other risk factors such as age, gender, blood pressure, and smoking habits, 3.4 percent of cat owners died from a heart attack, while the figure for the non-owners was 5.8 percent.

Professor Adnan Qureshi, who led the research, was motivated by widespread anecdotal evidence indicating reduced risk of heart disease among cat owners. He set out to investigate whether the possession of a cat could translate to a preventative effect, and presented his findings with a scientist's carefully balanced and rational approach. Qureshi was so impressed by his own results that he has been conducting further research into the relationship between cats and heart health. For him, it is the "most logical explanation" to posit a theory that cat ownership reduces stress and anxiety, thus reducing the risk of cardiovascular disease. That would be quite a payback for a few tins of cat food.

Until investigations can prove beyond doubt that owning a cat can reduce the risk of heart disease, Qureshi is reluctant to rule out the possibility that people who own cats are just the kind of personality types who are less prone to cardiovascular problems. But he is determined to get to the crux of the matter and is optimistic about a possible outcome. In the future it could be that instead of undergoing operations and medication, a patient might be prescribed cat ownership as a low-risk intervention, beating all the more sophisticated treatments in terms of safety and cost. If this ongoing research proves its proposition, it could benefit a vast number of patients, not to mention society as a whole in terms of the costs and risks attached to more expensive and dangerous treatments. Meanwhile, at least one cat already has been harnessed to the program: the professor's own cherished mixed breed, Ninja.

Over at the University of Warwick in England, the findings of health psychology researcher Dr. June McNicholas have highlighted how cat ownership has health benefits for both young children and the elderly. She found that living with pets boosted school attendance by 18 percent in her study of five- to eleven-year-olds: the children who lived in pet-owning families were less likely to have asthma or allergies, so lost fewer days off sick. She suggests that this is because the immune system develops in relation to what it is exposed to. So, rather than shielding children from contact with anything unusual, it is the early and regular contact with the complex substances on and around their pets that can help them to avoid asthma and other respiratory problems.

At the other end of the age scale, Dr. McNicholas looked at the role of pets in her study of almost 1,000 people aged from fifty-five to eighty. She found that cats helped their owners to feel younger and healthier by providing them with companionship, increased levels of activity, and—by acting as social catalysts—supporting better person-to-person interaction. The older the person, the more significant the cat's role appeared to become: they seemed to encourage their owners to maintain self-care routines. Maintaining an appropriate lifestyle for the cat encourages the owner to stick to regular meals, keep an adequate room temperature, and make shopping trips. The researchers also concluded that cats could provide valuable support following bereavement, providing a comforting presence and acting as a confidant at a time of great loneliness. Memories of a deceased spouse were often shared with the family cat, providing consolation to the bereaved.

Over 70 percent of Dr. McNicholas's subjects confided that their cats made them laugh every day, and that their tendency to attract the notice of passers-by, as well as create a need for trips to the vet and supermarket, generated valuable opportunities to meet people. These research findings were supported by the British Mental Health Foundation's chief executive, Andrew McCulloch, who declared that: "The bond between you and your pet can be as strong as between people . . . Looking after a pet can bring structure to your day and act as a link to others."

The Mental Health Foundation's assertion that caring for a pet may improve well-being indicates that the therapeutic effects of cat ownership have a profoundly beneficial influence on our physical health. The improvements to the immune system that cats can provide are well documented: numerous cat owners relate how their cats seem to know when they are ill, snuggling up and comforting them, which helps them to feel better while also boosting their immune system. But an understanding of the role that cats can play in helping children and adults suffering from mental health disorders

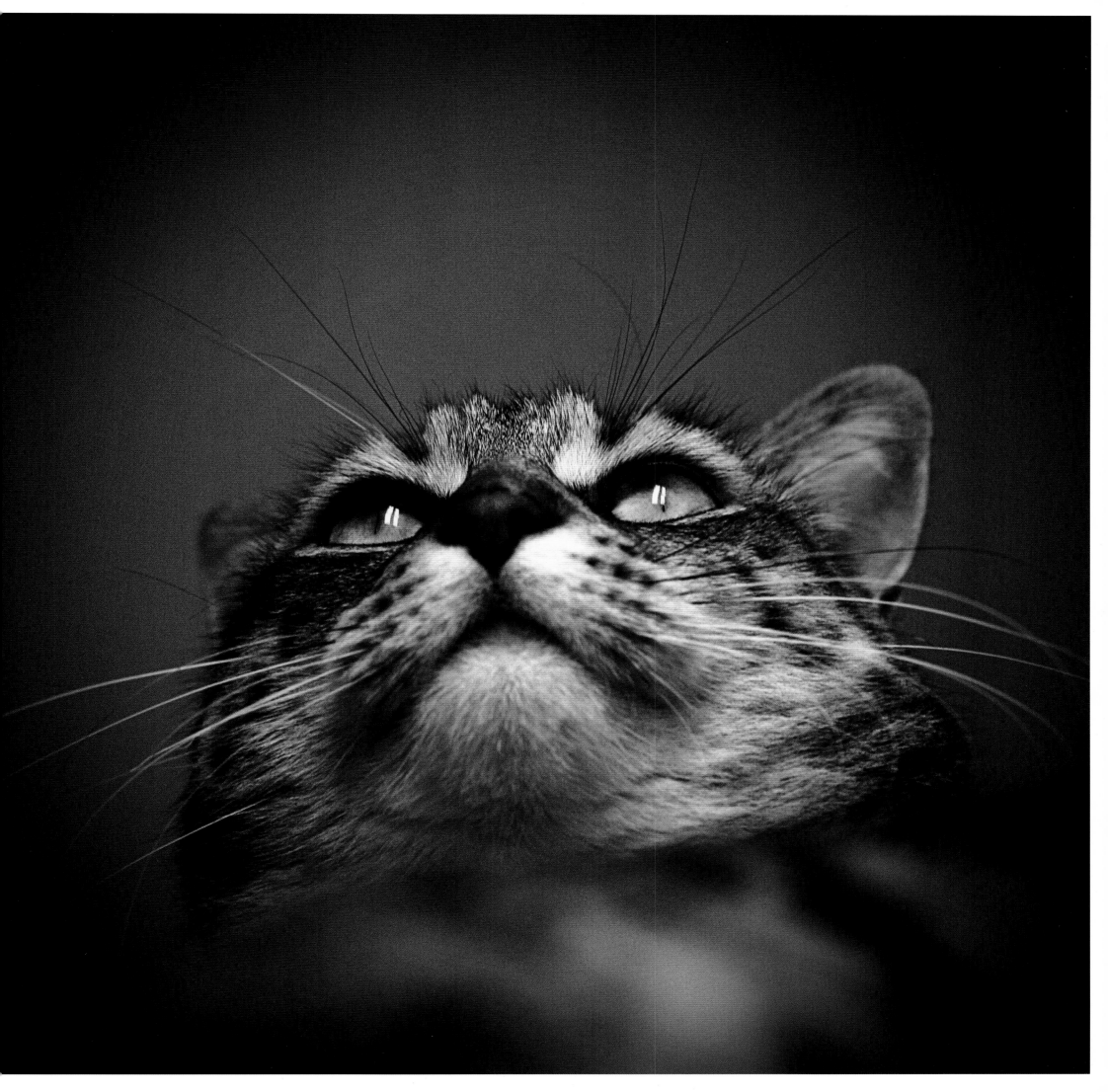

has only begun to emerge in the past decade. One of the most heartening stories was published by widowed father and neuroscience worker, J. Manerling.

When Manerling's wife passed away, his four-year-old autistic son, Richard, lost the motive to speak. Having heard of a girl who had been encouraged out of her inner world by horses, Manerling took Richard to numerous places where he could connect with animals. Richard was unresponsive until they visited the cats at the nearby animal shelter. There he was entranced by the sight of a black-and-white tuxedo cat: "Suddenly my non-verbal son pointed to the cage and said, 'Cat!' That was it," recalled Manerling. The family took the cat home, and Richard's nine-year-old sister worked with him to find an easily pronounced name—Clover.

Richard was soon overheard talking with Clover in private conversations. The transformational factor may have been that the cat appeared to have the patience to listen, and did not require him to explain himself and conform to normal language expectations. A second cat called Tigger (named by Richard) soon joined the family. Linus and Melody took Tigger's and Clover's place when they died during Richard's high school years. He then went on to college to study art and develop a wide circle of friends, living unashamed and largely unrestricted by his autism. Richard was able to articulate his feelings about autism: he found that his way of encountering the world, in which he had a sense of looking at everything and thinking about it, and only talking when he really had something to say, was similar to how a cat appears to interact with its surroundings.

His father concluded that, while he did not know exactly what had happened between his son, Clover, and gang: "I do know one thing . . . life has been a blessing since we discovered 'Cat!'"

Nowadays, we can find a mass of scientific and speculative evidence to underpin the notion of feline healing powers. But the concept of cats as healers stretches right back to ancient Egypt where Bastet, the cat goddess, was thought to have healing powers. Evidence of this belief has been found: a scarab engraved with a cat and inscribed "Bastet, the Nurse"; and various representations of Bastet striking a snake are interpreted as the cat destroying disease. The venomous snake is a symbol of the poisons that threaten our lives while the cat is a healer who, by destroying the serpent, expels these poisons. In Paraguay, even today, cats are kept as snake hunters, taking on rattlesnakes sometimes over a period of hours, striking them with a paw, then adroitly slipping to one side to avoid the potentially deadly response.

Bastet was not only revered for killing snakes and serpents: she was also believed to be especially successful in treating people who suffered from their poisonous bites and stings. But the goddess herself was not exempt from their venom. A stone slab exhibited in the Metropolitan Museum of Art in New York and now known as the Metternich Stela, was engraved in about 370 BCE with an image of Bastet being stung by a scorpion and saved from death only by Ra, who overcomes the poison with an incantation and the application of a tourniquet inscribed with a spell. The Metternich Stela, which also portrays a carving of Bastet's brother, Horus, was used as a

household talisman that was intended to bar entry to all poisonous creatures. A similar belief in cats as a protection against disease still endures in many parts of the world, where it is thought that a house deserted by cats will always have illness in it.

The association with healing attributed to Bastet and her feline successors has also inflicted suffering on cats in later times and locations, with parts of their anatomy being used in folk medicine. Cat fur, for example, has been used as a remedy for burns, while in the past, the Dutch believed that inflammation could be treated with the skin of a freshly killed cat. Meanwhile in the Rio Grande borders of the US and Mexico, cat flesh and blood were supposedly a cure for consumption. Elsewhere, cat skin has been used to treat sore throats and hives.

Perhaps unsurprisingly, in view of its reputation as a seer, the cat has often been exploited as a healer for blindness. Edward Topsell, the early seventeenth-century English cleric and author, best known for his 1607 bestiary, was responsible for a particularly gruesome remedy which nevertheless was used and approved by his contemporary physicians. His prescription for curing blindness recommended burning a solid black cat's head to ashes, which were then carefully blown into the eye three times a day. Less drastic was a supposed cure for apparent delusion, or mental blindness, in Scotland: "cast the cat over him" was the advice for restoring sanity to an afflicted person.

In rural England, milder optical problems such as sties were thought to be curable by rubbing them with a tomcat's tail; a Cornish spell involved stroking the eye with a cat's tail on the first night of a full moon. The tail has traditionally been the part of a cat's anatomy most widely used for healing, and was central to an elaborate old-English recipe to cure itches. This required a left-handed man to procure a black cat and swing it three times around his head. Then nine drops of blood from the cat's tail were mixed with the remains of nine roasted and ground barleycorns (the good news is that the cat need not die for this medicine—just be very shaken up). The ointment was finally applied with a gold wedding ring as the man walked three times around the patient, calling on the Holy Trinity to help out.

The cat's tail—a particularly sensitive part of the feline anatomy and an embodiment of its self-expression, with a language all of its own—was seen as the focus of the cat's healing power in many folk remedies. The Celts, for example, considered it to be especially potent and precious. They believed that anyone careless enough to tread on one would be avenged by a serpent, which would spring out from the tail and bite them. The tail of a black cat was handy for the rather modest task of remaining whitlows, just by threading the tail between different fingers on three successive nights, while the distasteful matter of warts could be resolved with the aid of the tail of a male tortoiseshell tom—but only in May. Perhaps the general folklore of burying a black cat's tail underneath the doorstep, reputed to protect the inhabitants against all sickness, should have been more widely applied.

Now we could—and indeed, I would—be scathing about the curative properties of a tail beneath the doorstep. But as we have seen in contemporary medical circles, a cat beyond the threshold

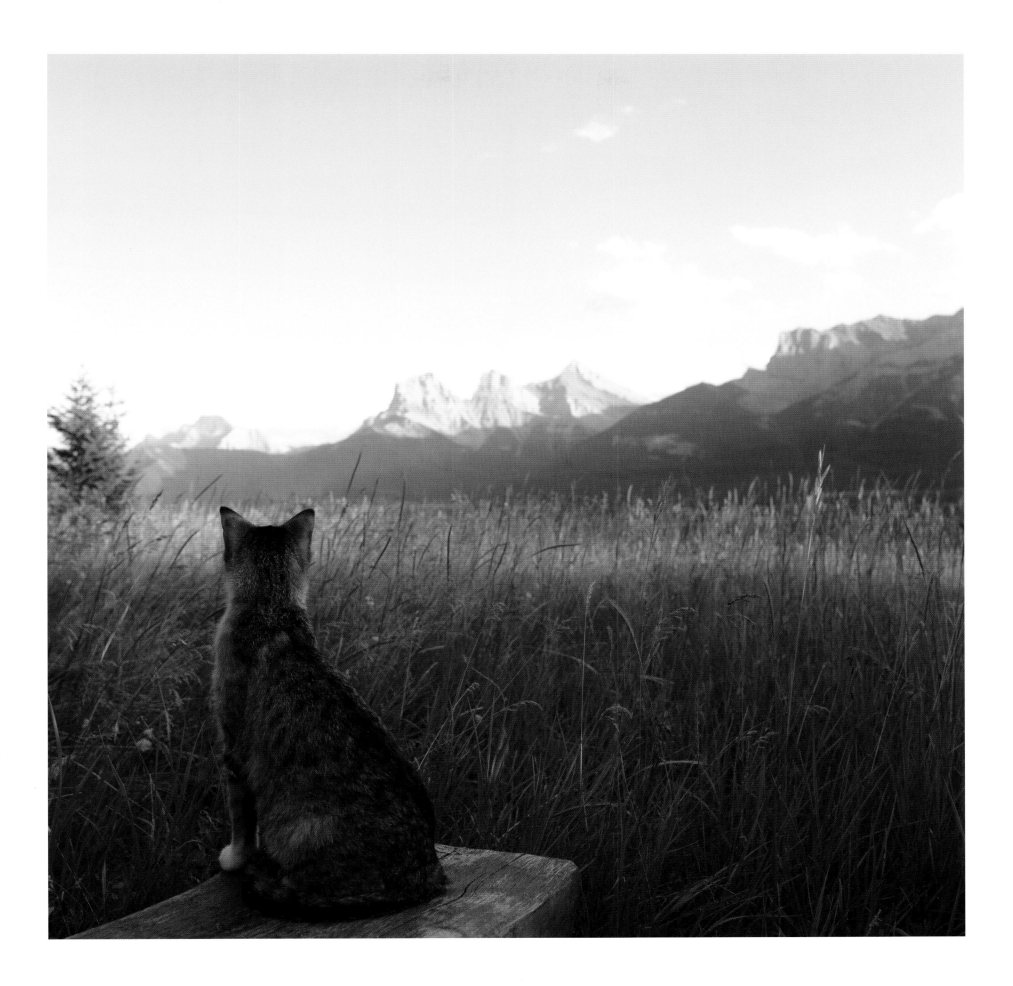

is widely accepted as having a significant role to play in preventative medicine. As is so often the case, some of the oddest mythological practices or pieces of distasteful folklore have some deep link with a scientific truth. As we have noted earlier, researchers across Europe and the United States are learning that pet cats can provide a range of therapies, from reducing blood pressure during periods of intense stress, to easing the pain of loneliness. It is not just random, but "it's an up and coming field," says Lana Kaiser, a physician and veterinarian who is professor of nursing at Michigan State University and was a key mover behind the Human-Animal Bond Initiative.

At the initiative's annual conferences, researchers come together to exchange information about their work. Here are some of their better news stories (which shouldn't require any medieval-style torturing of black cats, just the nurturing of any cats that come to hand): Scientists from the St. Louis University School of Medicine reported that the loneliness of residents in long-term health facilities can be significantly eased by just thirty minutes per week spent with a pet, which led to the adoption of "animal-assisted therapy" (AAT) by such centers nationwide; Karen Allen, a research scientist in the division of clinical pharmacology at NYU School of Medicine, conducted long-term experiments that demonstrated a dramatically lower rise in blood pressure at times of great stress when the subjects were pet owners; and a group of New York stockbrokers suffering from hypertension were given cats and dogs as pets and, a few months later, half of them were able to come off medication.

Dr. Marty Becker, resident veterinarian on ABC's *Good Morning America* and author of *The Healing Power of Pets*, said the act of petting a cat has been scientifically proven to ease chronic soreness by blocking the transmission of pain from the peripheral to the central nervous system. He also asserted that cats may be more dependable than spouses at helping to reduce stress levels and blood pressure. Call him a cynic, but he may have a point when he states that you will never arrive home to find a note from the cat saying "I don't love you any more, I have found someone else."

Then again, there are reports of cats disappearing down the road when they find a better place to be fed and housed . . . indeed, disloyalty—or shall we say dual loyalty—is something quite a few cats demonstrate as they collect sources of food and shelter at multiple locations. But let's not spoil the story.

None of this healing talk will come as any great surprise to cat owners. Virtually all of them have experienced the "power of purring": the soothing and calming effect of a contented cat who senses when they are sick or blue and snuggles up to them, its purr and warmth decreasing stress levels and conquering feelings of despair and loneliness. But now we are learning that there is a biological basis for what we have always intuitively known: our cats really do possess the power to help us heal—emotionally, physically, and mentally.

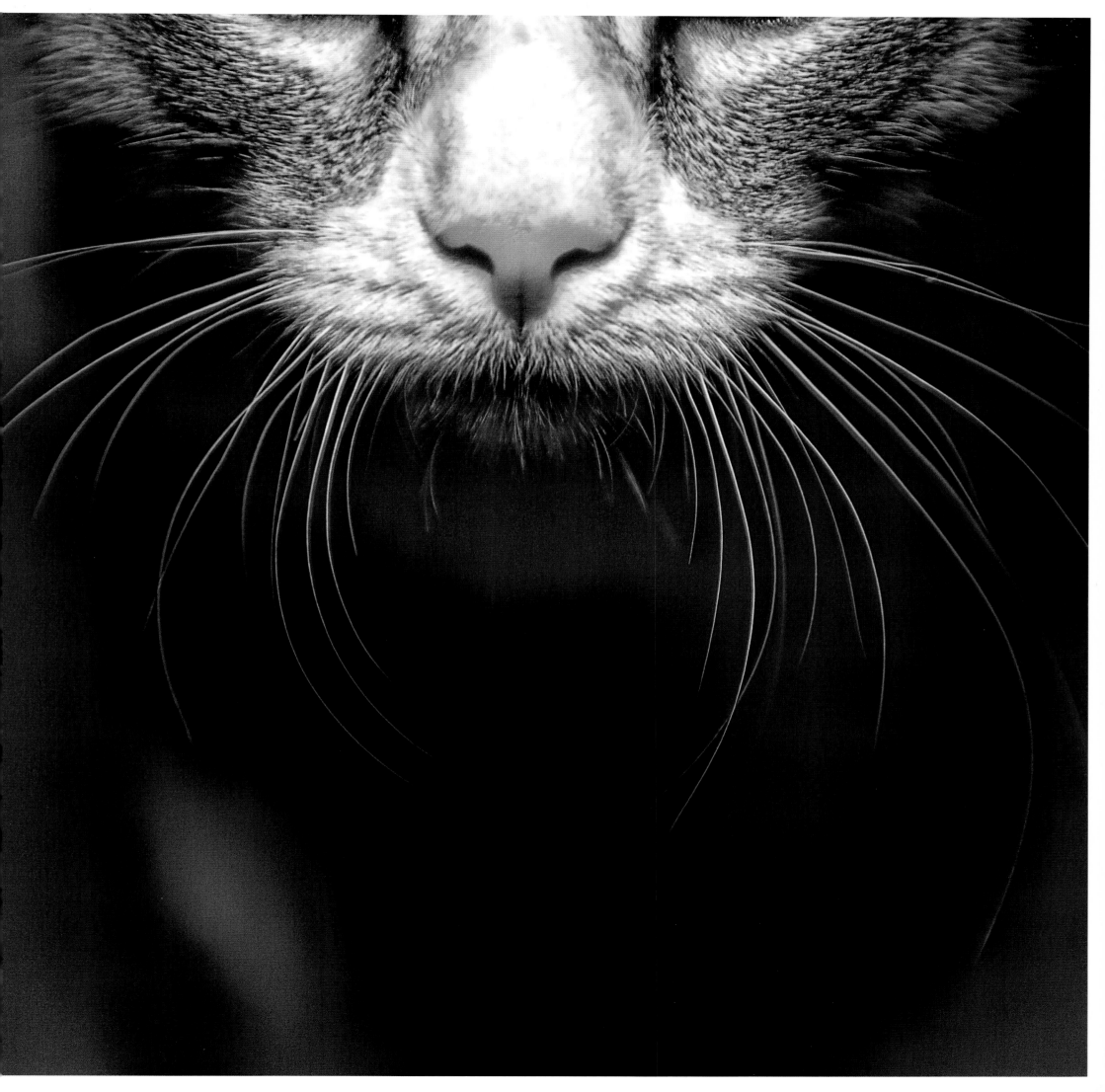

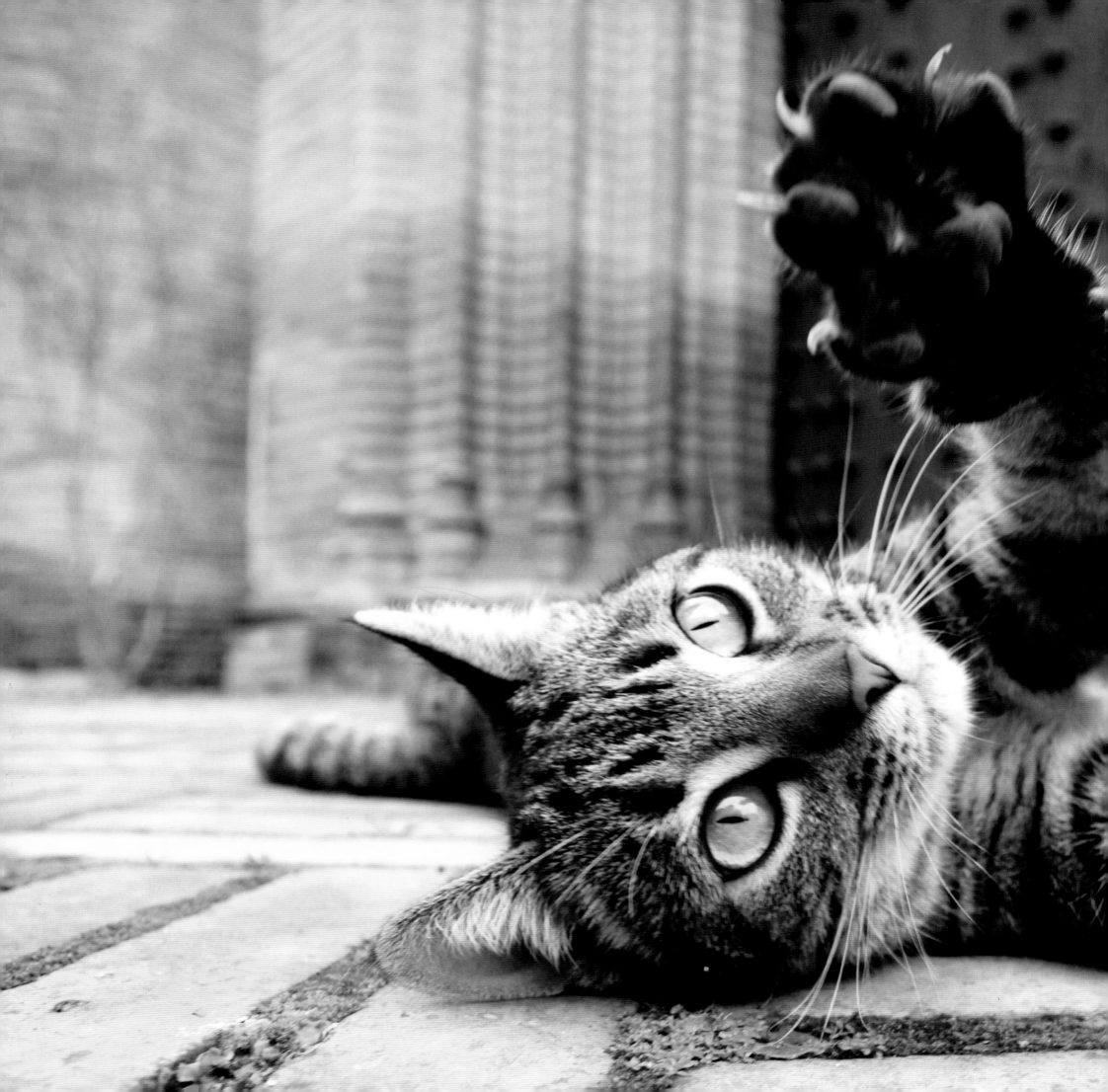

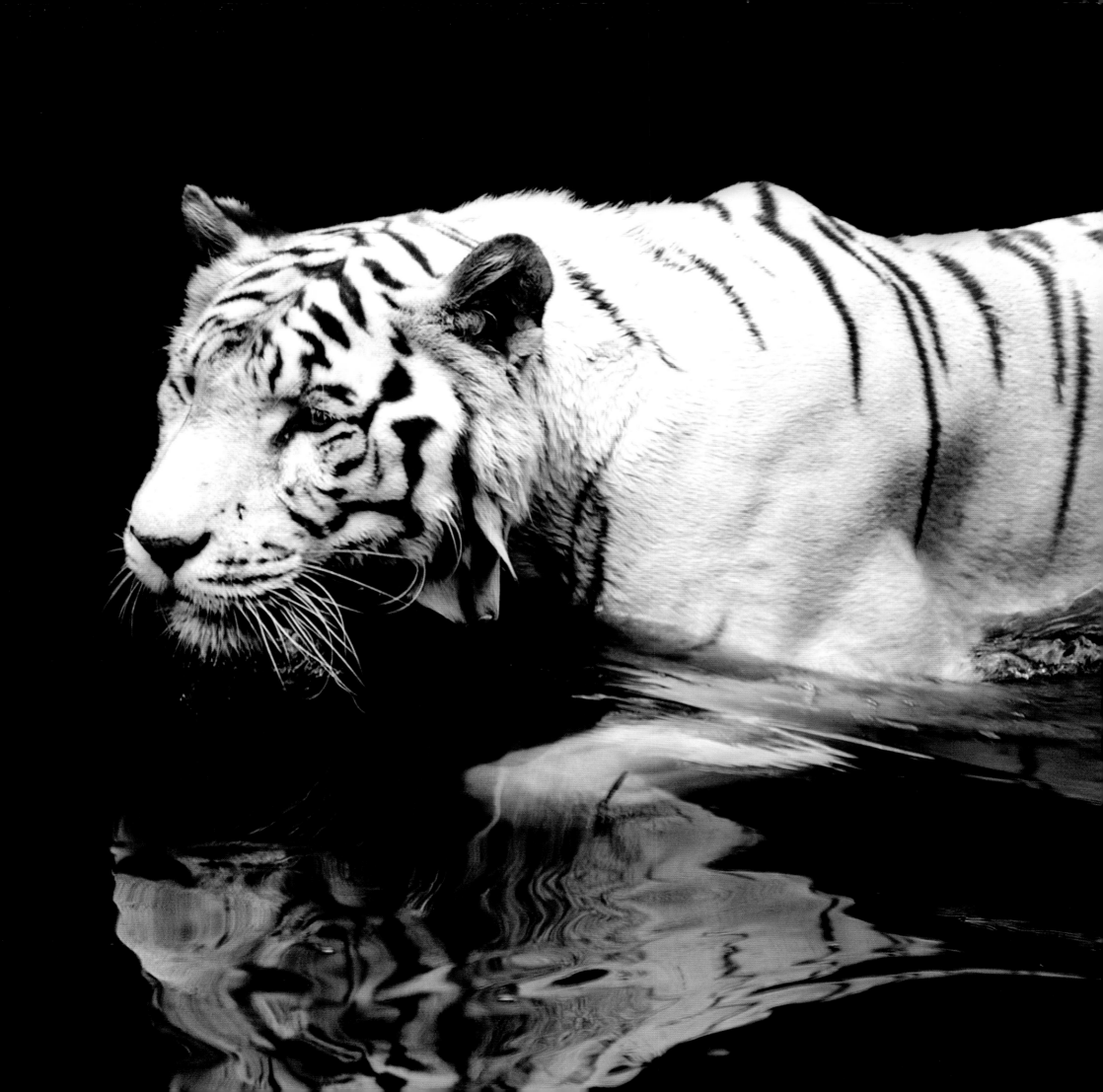

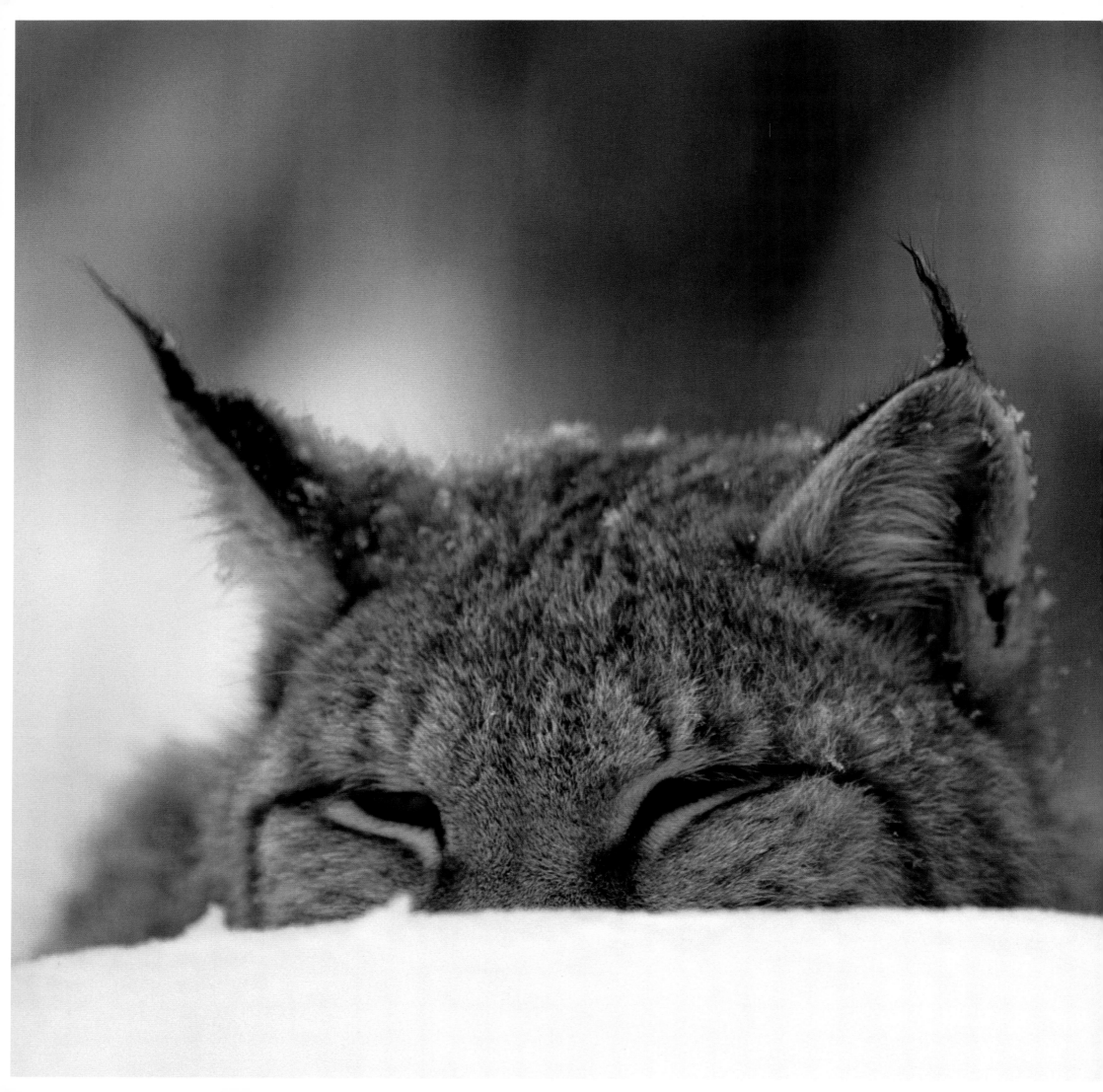

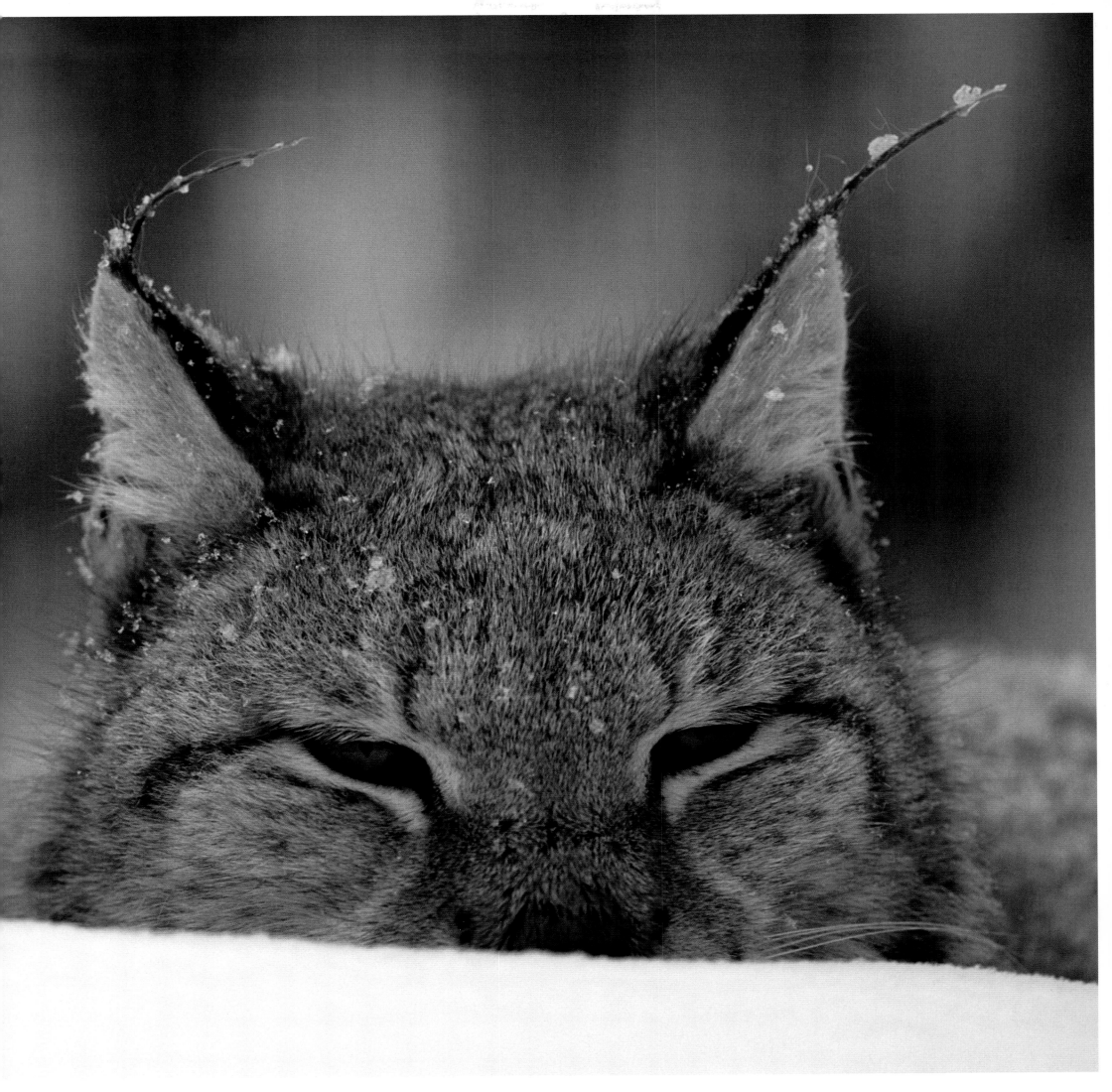

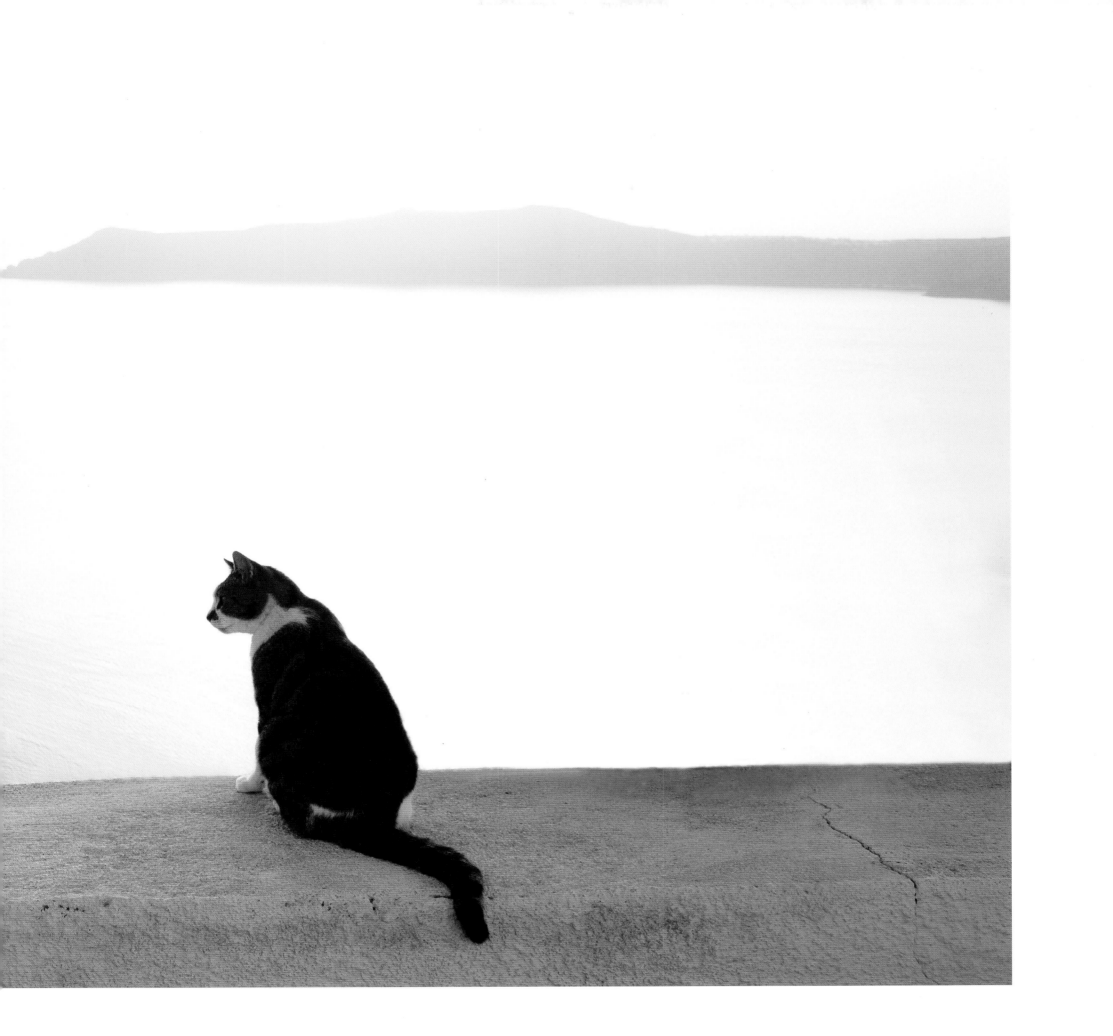

Cats, like cities, will reveal themselves at night.

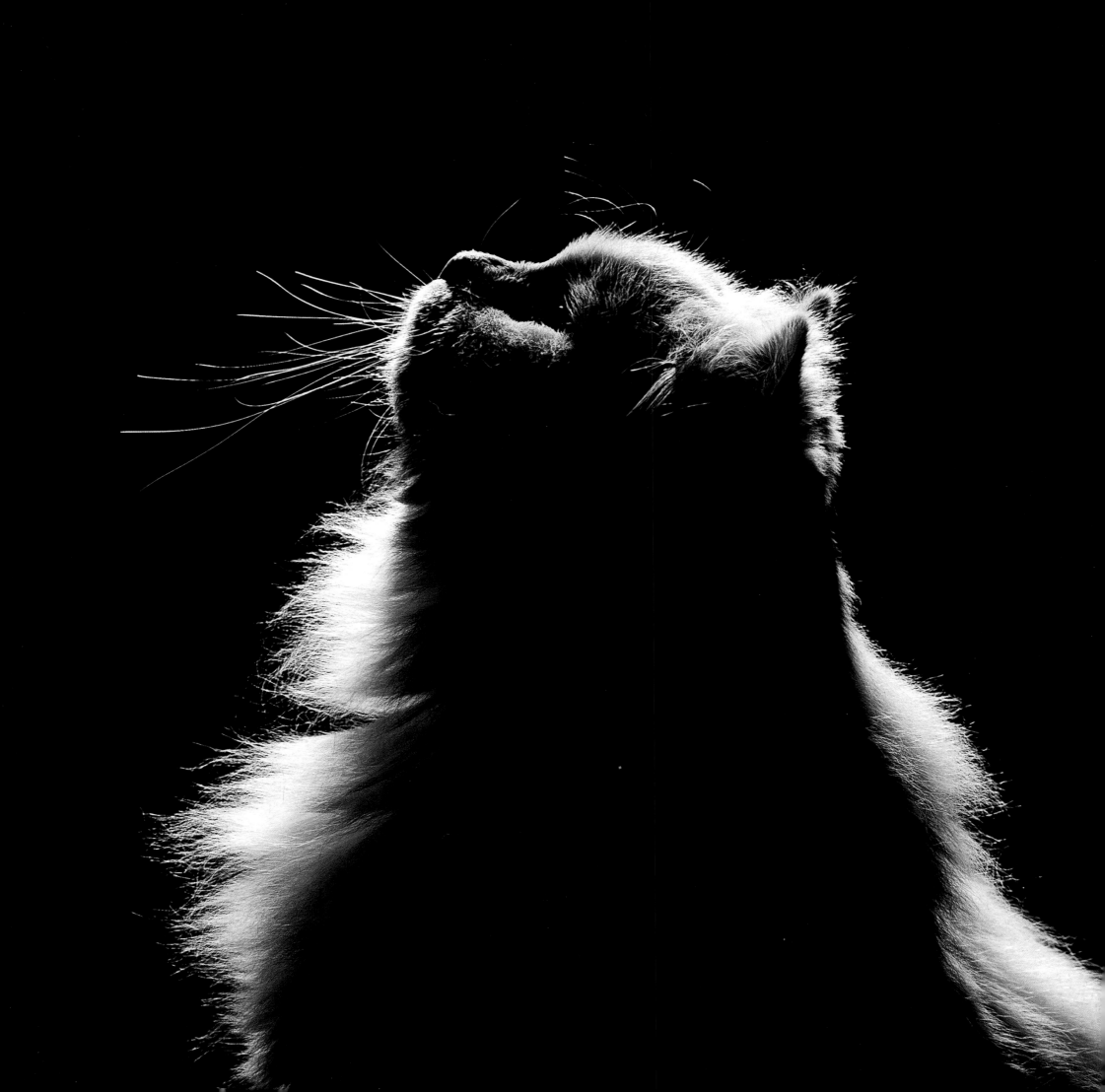

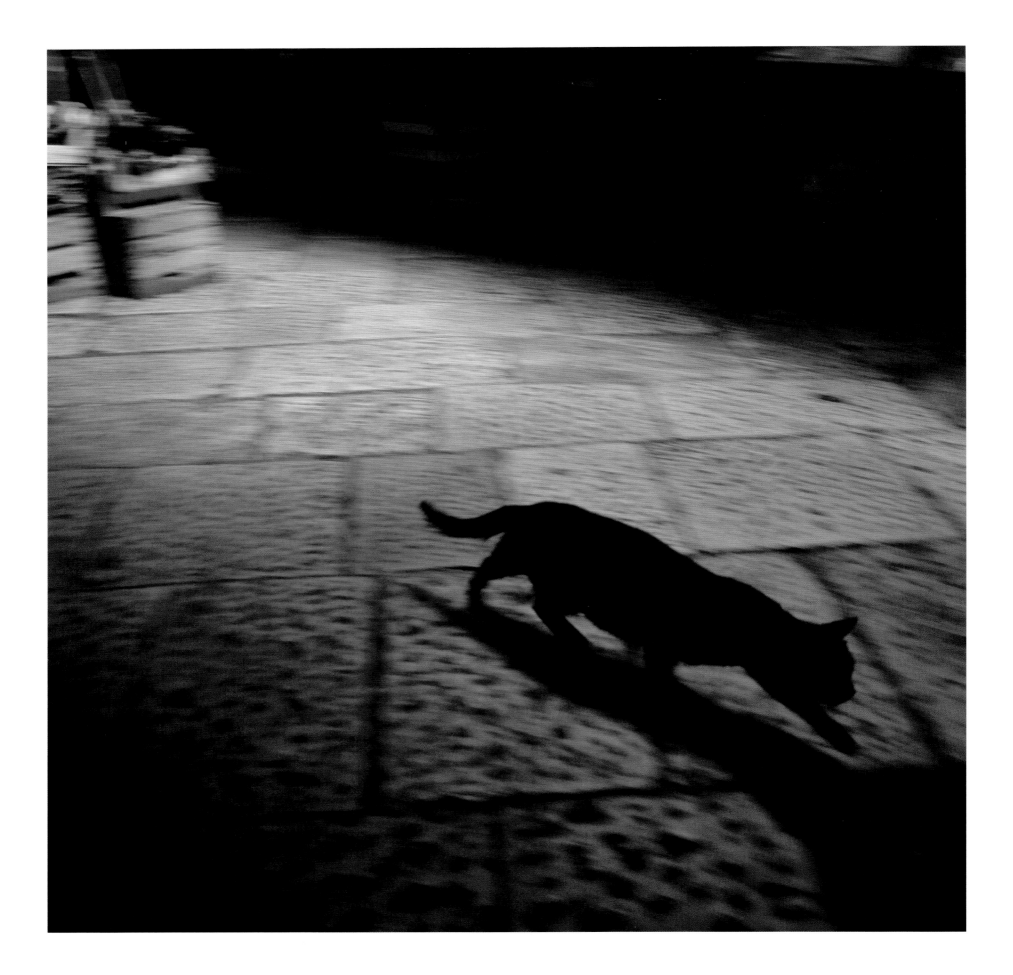

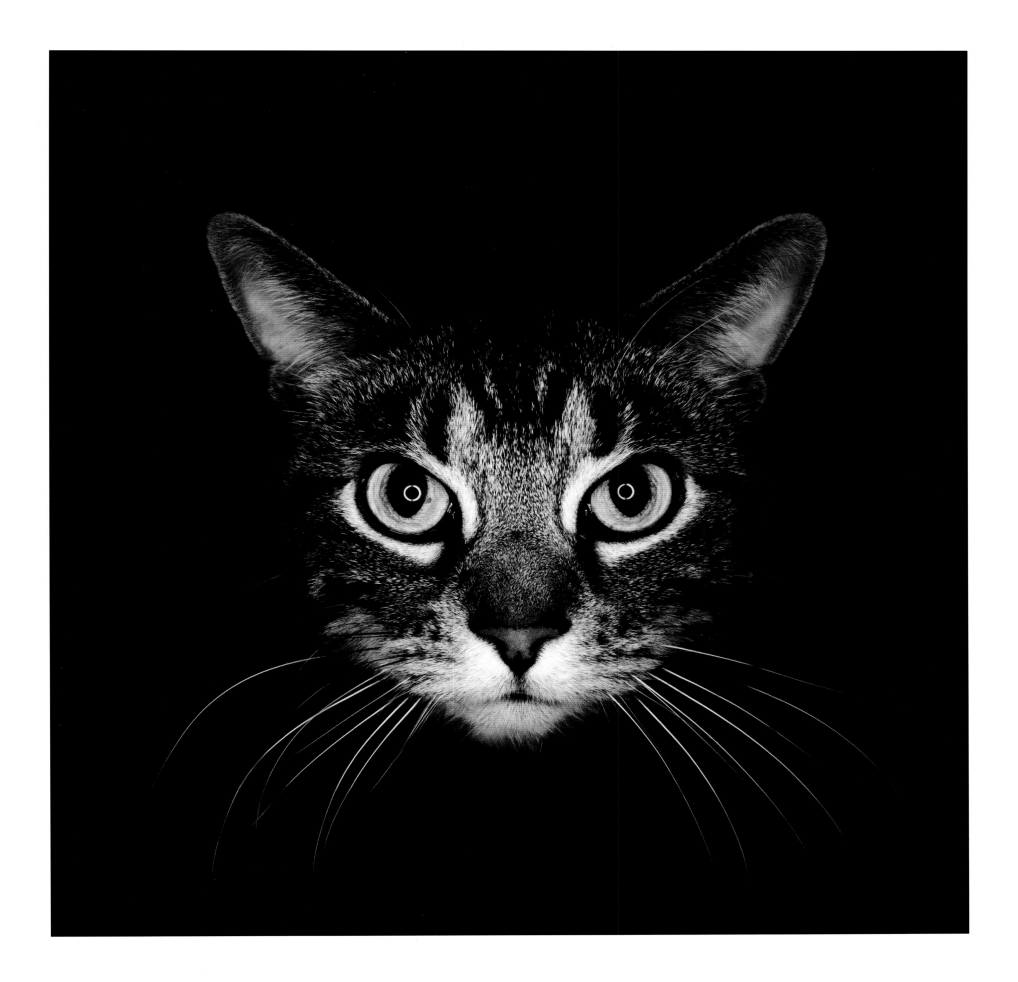

This is the victory of the cat . . . The animal which the Egyptians worshipped as divine, which the Romans venerated as a symbol of liberty, which Europeans in the ignorant Middle Ages anathemized as an agent of demonology, has displayed to all ages two closely blended characteristics—courage and self-respect.

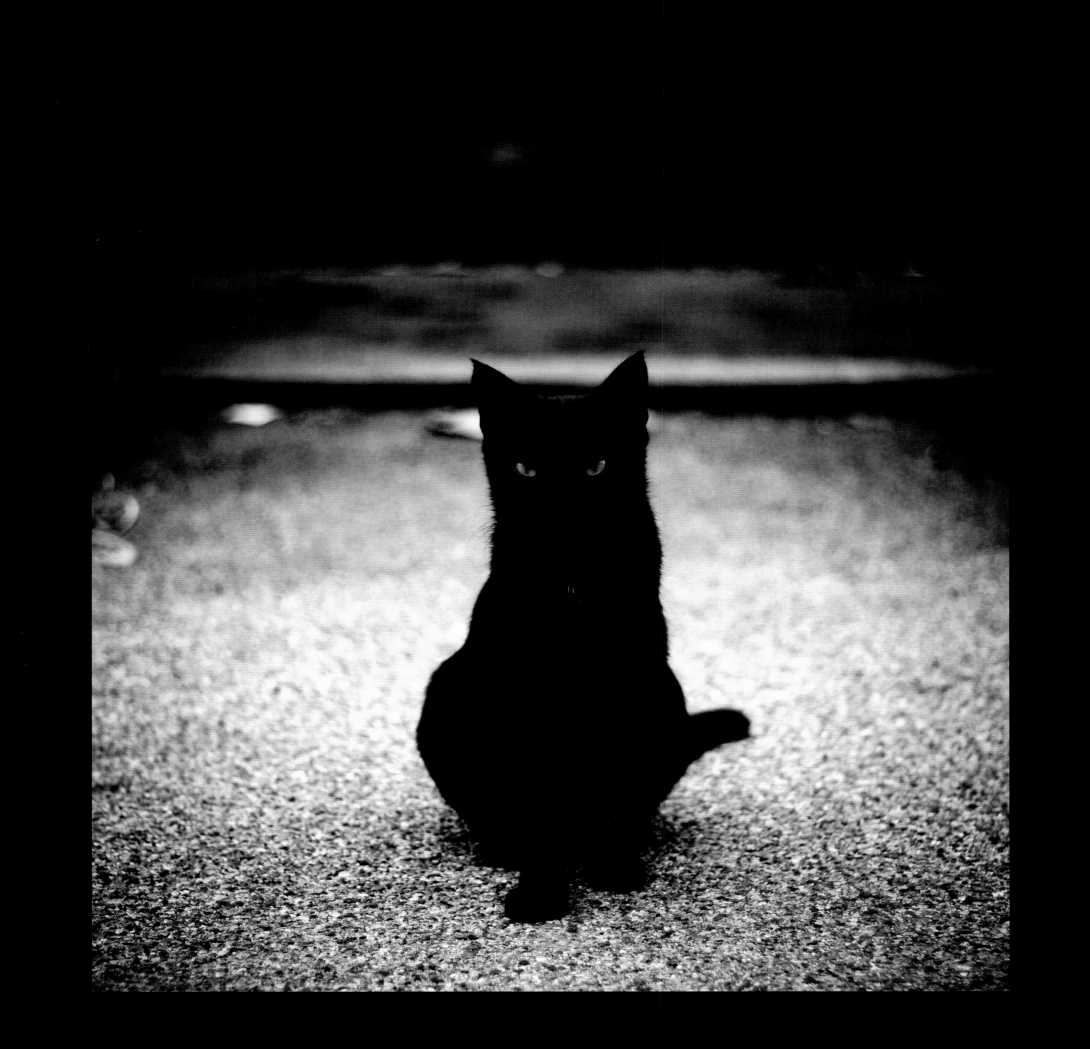

Black

Superstition encircles the history of the cat. Without human ignorance, suspicion, and crazed invention, the species would have had a much easier life. And no type of cat has suffered more from our wild fears and surmises than the commonplace and humble black cat.

The black cat needs our help. So much so that August 17 has been designated Black Cat Appreciation Day in the United States. On that occasion you are encouraged to put aside your prejudices and perhaps go so far as to adopt one of the many black cats found in animal shelters. They are often the last ones left un-adopted and are therefore most likely to be put down. The reasons why these cats end up in shelters are varied, but at root is the lingering—and, for some primitive minds, thriving—belief that black cats are harbingers of bad luck and even active incarnations of downright evil. We impose our superstitions, our fears, and stupidity on to these innocent creatures in the hope that this might relieve us of having to sort out our own problems. It is highly unlikely to work, but it certainly causes much misery for cats.

Bad publicity doesn't get much worse than being seen to carry out the work of the devil. For this you can get into serious trouble—and as far back as medieval times, the humble Blackie, Midnight, Sooty, and many thousands of other nameless black cats have had to watch out for unprovoked violence, torture, and murder. All this makes for a startling contrast to the elevated role that black cats once held. In Ancient Egypt, at the dawn of the domestic cat, it was the black cat that was most prized as an incarnation of the goddess Bastet (probably highly cherished because this was a particularly rare coloration at the time). Sadly, not much went right for it thereafter.

If you are reading this, there is a reasonable chance you may already know, like, and even own a black cat. It is unlikely that you perceive it to be anything other than a delightful creature that has much in common with other cats. You would no more think badly of the cat because of its color than you would think harmful thoughts of another human because of their color . . . oh, hang on—we are a crazy enough species to do that, too.

Roll back the clock to 1232–33, and we have the key point at which the bad image of black cats was formalized. In that year, Pope Gregory IX, alarmed by rising stories of devil worship, and perhaps even more annoyed by poor payment of tithes from the Lower Saxony area, set down in a Papal Bull the case against the specifics of heretical practice. The Catholic Church, understandably vigorous in defense of its own beliefs, described in some detail the evil ways of the supposedly powerful dangerous sect of Lucifer, which allegedly was emerging from German regions. (Whether there was a threat of devilry is unclear. What we do know is that public anger at the rapacious clergy was evident, and as many a leader has shown since, it is useful to direct opposition at real or potential opponents that can't fight back easily, in order to recruit support.) The new decree identified various practices that formed part of the evil-doers' initiation rites. One example was an after-dinner ritual that involved the passing around of a black cat to be kissed on its buttocks by all the heretics present. According to the decree, even more debauched behavior would then ensue.

Somewhere during these acts, apparently, a man with very hairy lower parts, also compared to a cat, would get involved in ways that further gave cats a bad image.

Now while all this cat buttock kissing would certainly make a change from passing chocolates or a bottle of port around the dinner table, it was no joke for felines. Across Europe in the Middle Ages the black cat was periodically hunted down and immolated in bonfires aimed at expunging witchcraft. Creeping association with superstition was given formal weight by Pope Gregory's papal document: over time it became a regular part of the Christian calendar to torture cats. Having once opposed such pagan-like rites, the Church and the Establishment later generally got behind them. In France, it was customary for the king to attend mass cat burnings; in 1648 Louis XIV attended the last of these midsummer ceremonies and personally lit the fire. The wave of attacks, which stretched beyond to the eighteenth and even nineteenth centuries, was directed at all types of house cat, but the stigmatization of black cats in particular remained the prime focus. The frisson of anxiety over *black* cemented the color as an on-brand trademark of the devil's work. And these sacrificial behaviors were soon not constrained to the doings only of Catholics.

The Pilgrim Fathers sought new freedoms in the New World, but did not escape old prejudices when it came to the black cat. The poor creature was associated with witchcraft once again—indeed, it was seen as a shape-shifting form assumed by cunning witches. The killing of black cats was taken up as one of the questionable cures for the casting out of evil; one superstition tackling another.

The oddity, though, is that while the black cat had such a terrible reputation in some cultures for bringing bad luck, it was also seen as bringing good luck. Often these two beliefs were held closely together, even within the same culture, but were simply delineated by different actions. At its extreme is the once popular belief in Germany that when a black cat crosses from right to left it is bad luck, but when crossing from left to right, it is good luck. Got that? This notion of bad luck being caused by a cat crossing one's path later influenced nineteenth- and twentieth-century anarchists, who adopted the black cat symbol as a threatening mark against evil capitalists. They were to beware the black cat crossing their path, blowing up their factories, overturning their despotic rule! Even today, a range of black cat graphics are still used by anarchist groups from time to time.

Pirates had another variation on this superstition: if a black cat walked toward you it was bad luck, but if it walked away from you, it was good luck. So what happens if you are moving past the cat when you notice it . . . do you run ahead of it on the deck, or back up fast in order to ensure the cat's passage is lucky? It is unclear whether the pirates ever cracked that one. It seems that assigning any property of luck to the cat, though, is fraught. What if the cat dies on you? This happened to Charles I of England, who lamented his luck had gone with the passing of his favorite black cat. Apparently, the very next day he was arrested and charged with treason, and was executed shortly after. The moral of that story is: perhaps you need to have two black cats, always keeping some luck in reserve.

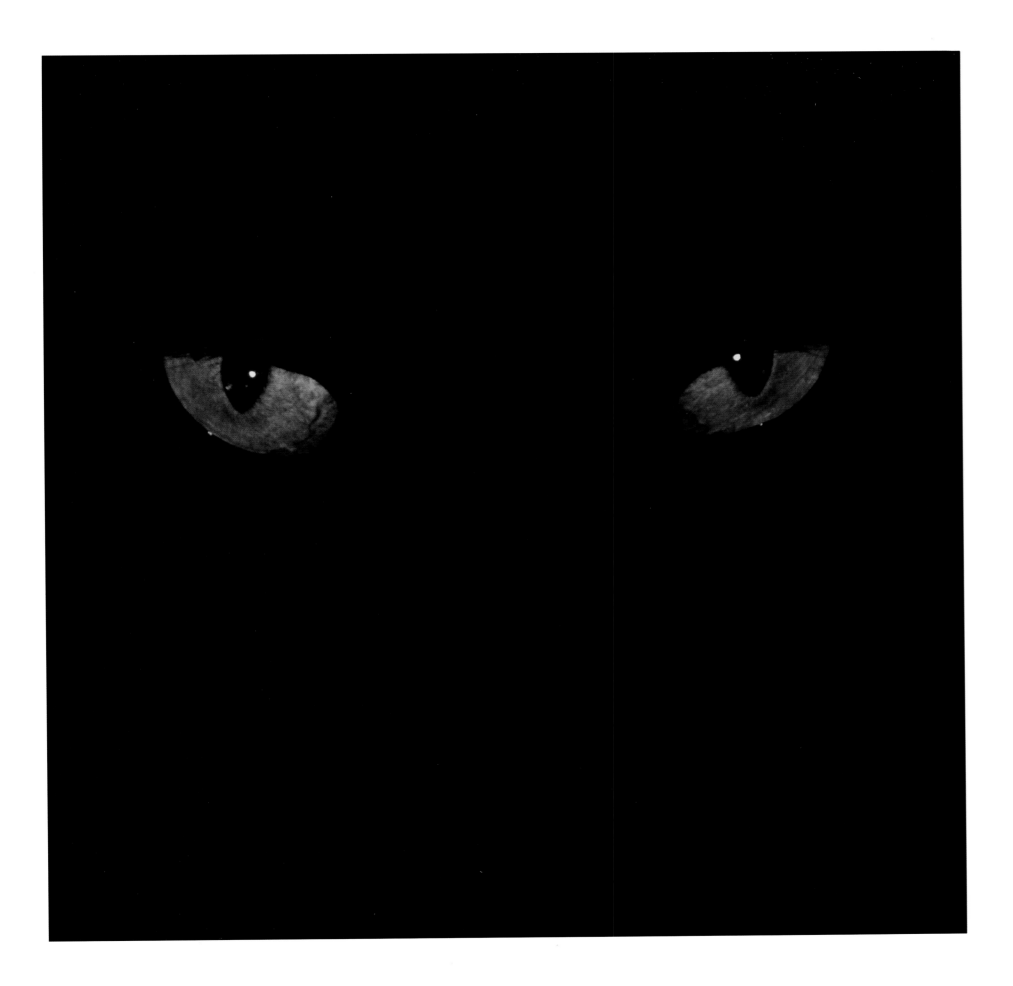

Almost inevitably, gamblers will have a particular take on black cats. After all, luck is everything to them. If a black cat crosses their path, they feel that it's a bad omen. Of course, that's if they notice. What happens if you don't notice the cat—do its actions still count? Does a bad run at the roulette table mean you should avoid any possibility of seeing a cat, or should you take extra vigilance to spot all cats, and avoid gambling on days when you encounter black ones? As ever, the rulebook of superstition is almost as vague, if not entirely random, as the beliefs themselves.

There may be no country that has not developed some variant of the belief in the fortune attached to cats, for good or bad. They are often contradictory. In the United States, folklore from the Ozark Mountains held—or perhaps holds—the belief that a black cat visiting the home means good luck, but that, if it stays, then bad luck will follow. (This belief may have stemmed from the fact that a cat is more likely to stay if he detects a plentiful supply of vermin, which is indeed unfortunate.) Alternately, Sicilians avoid a black cat visiting in the first place and will chase it out, fearing it brings with it the "evil eye."

There has been many a story of a grisly or ghostly character that features black cats, but few have attained the success and chill-factor of Edgar Allan Poe's "The Black Cat." Published in 1843, it has been much anthologized ever since (although to no great value for its author, who died young and never earned much from his work). In this classic story, the increasingly deranged narrator first brutally assaults and then hangs a treasured black cat; he is then goaded by another cat that mysteriously encourages him to kill his wife with an axe. He walls up the wife's body in the cellar and is bemused to note that the cat has disappeared. Later, while being investigated by the police, it is the howling of the cat (he has accidentally entombed it with the body of his wife) that gives the narrator away to the police. He tells us the story shortly before facing the gallows for his crime.

Why this story resonates still is because it goes beyond cheap effect or retelling of superstition, to actually engage with the absurdity of the belief. The narrator brings all the misery on himself and others, due to his alcoholism and related violent behavior. The role of the cats is as victims, and yet they take on a spooky power—as if they are representatives of some higher judgment and fate.

It works because something in our mind is prey to this superstition. We are teased into half believing the cats have some kind of super-power, when in fact there is a perfectly logical explanation of what happens—even if it depends on a bit of coincidence.

The common tendency to believe in supernatural luck and fates is, I suspect, not so far from the irrational weaknesses that lead to all kinds of prejudices—against fellow humans as well as animals. Whether it is religious or racial intolerance, or merely harmless superstition such as knocking on wood, we have brains that are prone to weird primitivism. The black cat has somehow endured—rarely enjoyed—being a part of this. If you have any doubt that it persists, note that some cat shelters specifically avoid allowing black cat adoptions around Halloween for fear of very bad motives lying behind the acquisition of the cat. Right now there are people out there who can believe an innocent creature to be connected with evil because of the color of its fur.

Black Cat Syndrome, as it is now formally called, has been apparent in many ages and many cultures. It still survives strongly enough to suppress demand for this color and to cause fears as to the safety of black strays. It is, of course, closely related to the Black Dog Syndrome—where again superstition has led to dog shelters having a surfeit of black dogs over other varieties. But the greater mystery that surrounds a cat makes for a greater cause for alarm at the persistence of superstition.

It is the nature of irrational traditional beliefs that they don't wear with time, or go out of fashion, but grow in strength unless cut down by the power of reason and good society. The problem may be that the very thing that charms us about cats—their reserve and emotional distance, their unpredictability, that sense of otherness, and yet their apparent tolerance and interest in us—leaves them more exposed than other creatures to the dark superstitions concocted around them. As long as we are enchanted enough to love cats, so some of us can be misled into fear and hatred, which is a kind of flip side for the disturbed human mind, misreading the positive emotions our cats can more happily stimulate.

The simple fact is that it is not the black cat that is lucky or unlucky for us; it is our own exposure to cruel fate that we are trying to offload, explain, and escape.

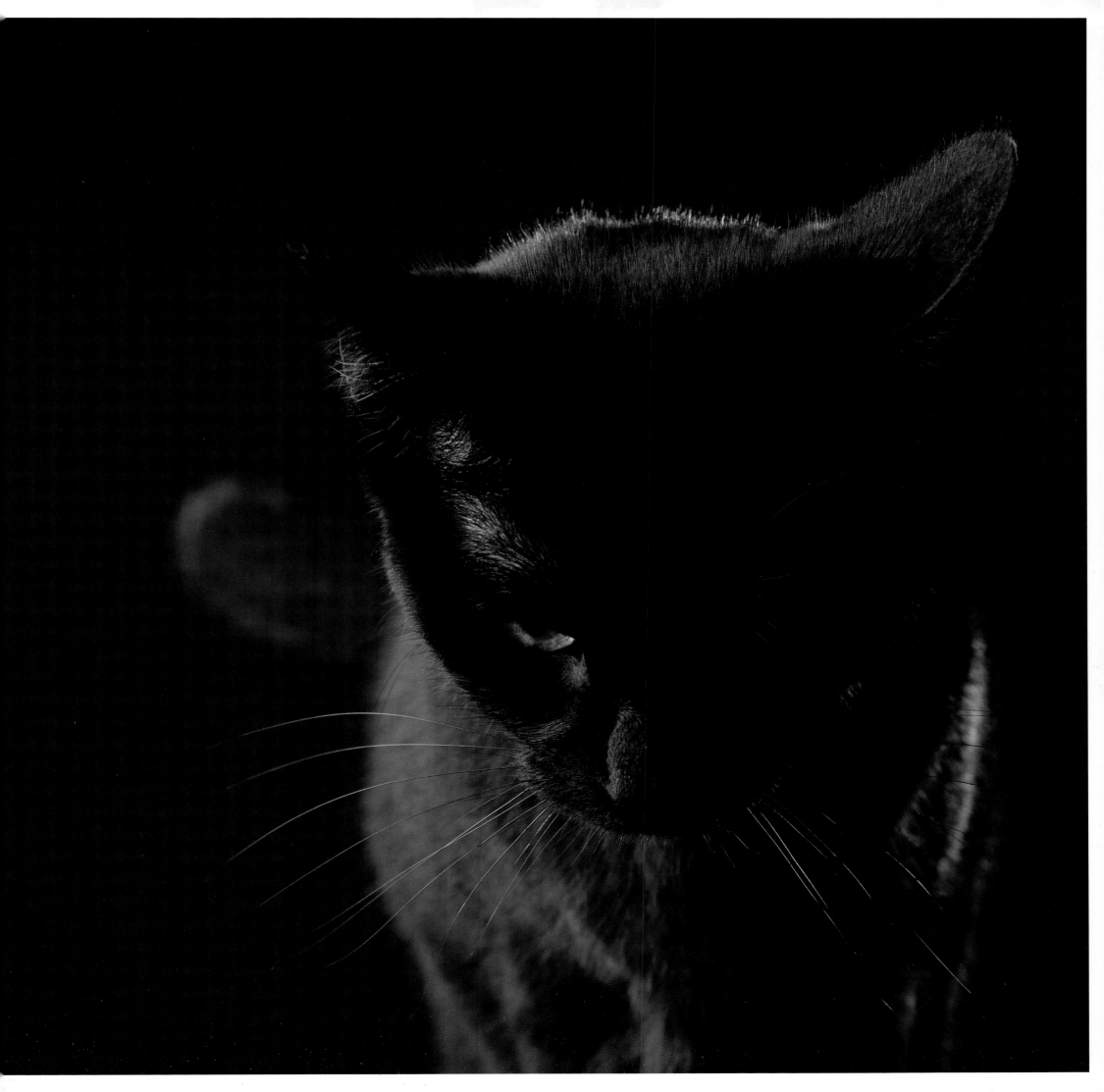

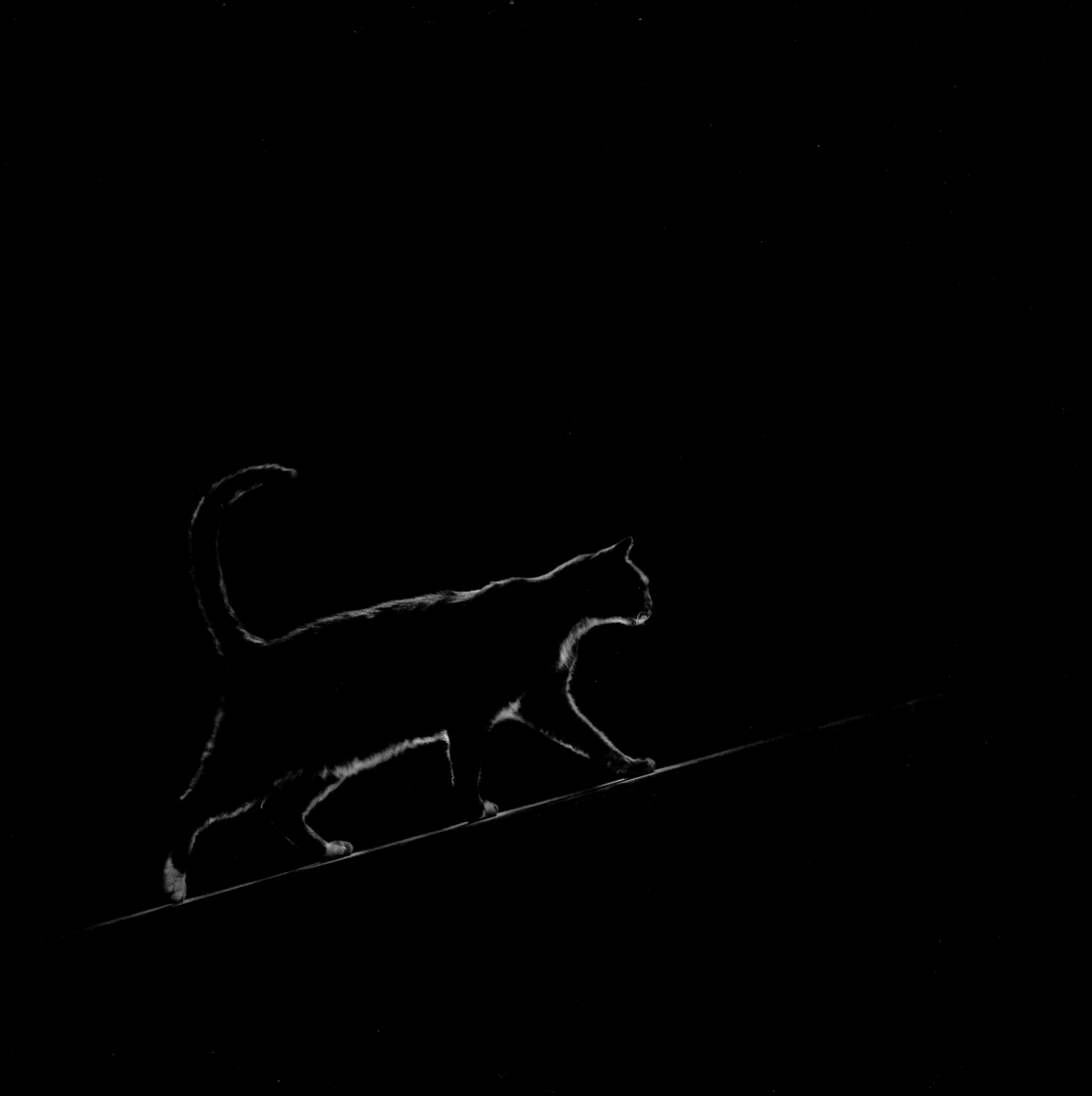

If a black cat walks towards you it is bad luck, but if it walks away from you, it is good luck.

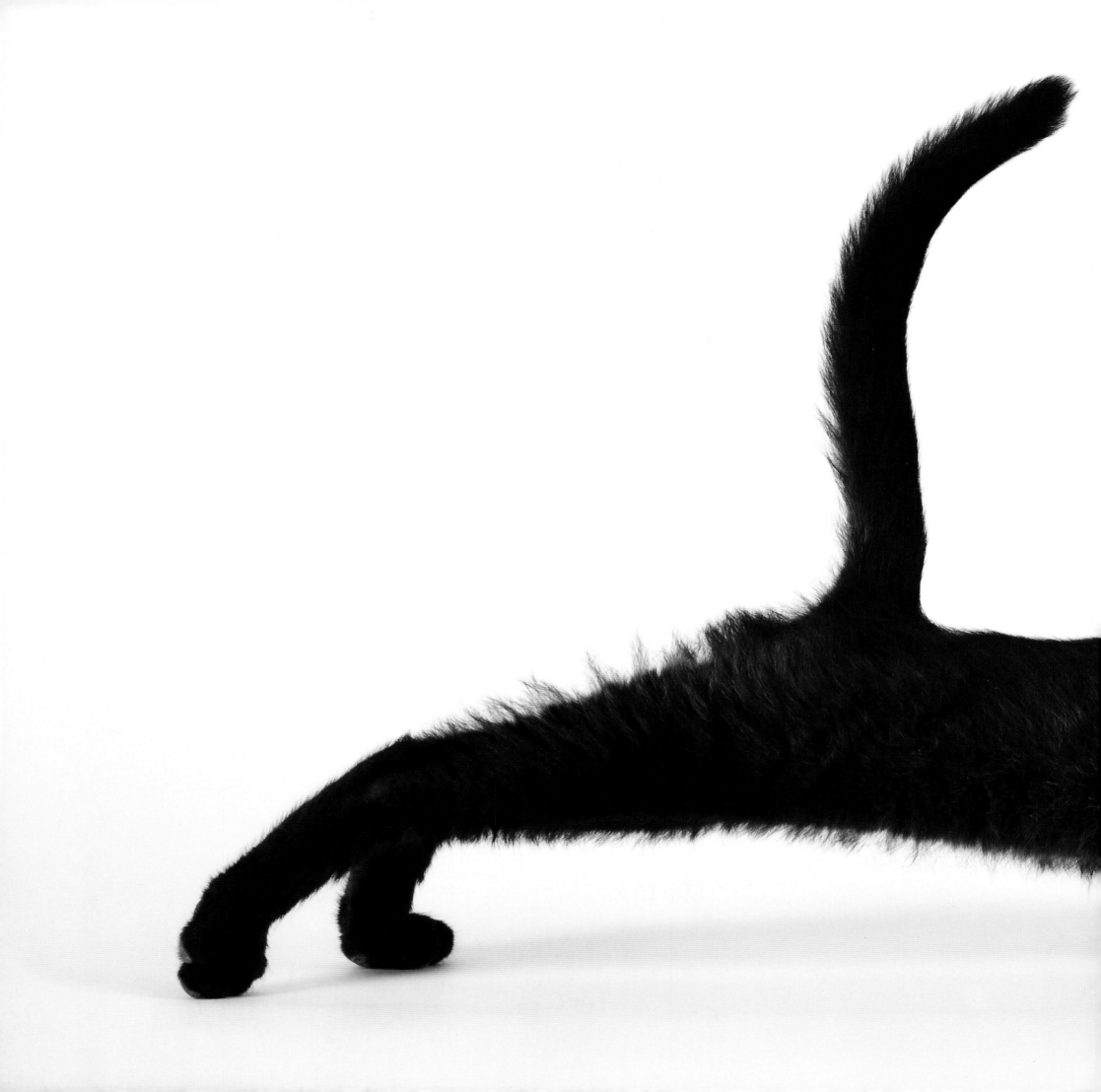

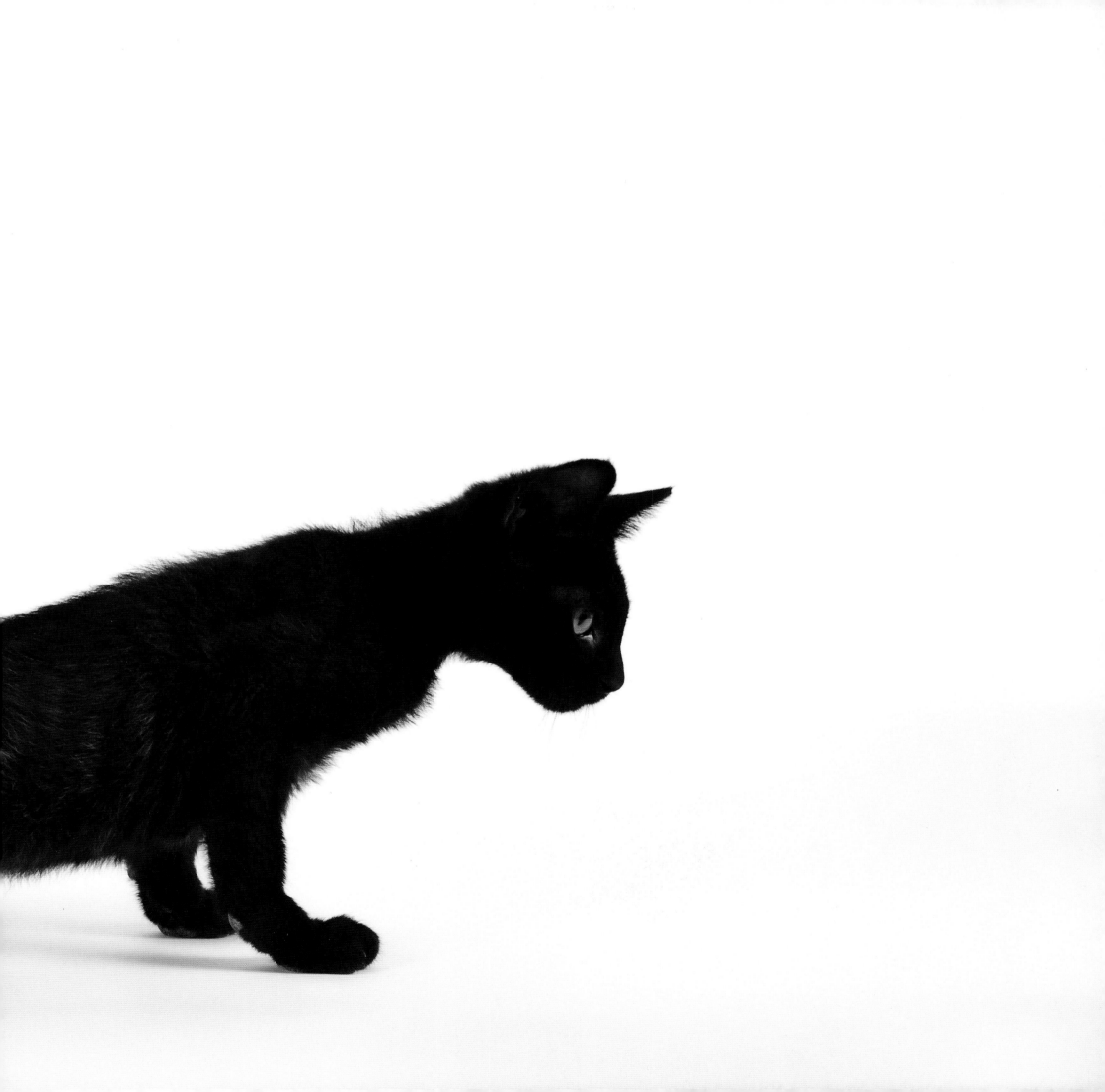

Eternal

Almost since humans first walked the earth, they have formed bonds with animals—especially horses, dogs, and cats—as the earliest cave paintings and archaeological finds will testify. Horse owners often describe a special one-to-one relationship with their animal. Dog owners, of course, consider their pet "man's best friend"—practically human itself in the way it relates to them. Only the cat retains its mystery, even for the most affectionate owner with no reason to doubt that their cats appreciate and return their fondness. For thousands of years, this element of mystery has been evident. It has lent intensity to the human-feline love affair: however tame, sociable, and dependent our cats may appear to be for most of the time, they can also be aloof, secretive, and unpredictable. We can never know what they are thinking—as people claim to be able to do with dogs—and that enigmatic nature is the source of the wonder, reverence, suspicion, and superstition that cats have long inspired.

In recent years, scientists have dispelled some of the mystery with their research into feline biology and genetics. Much of this has benefited humans suffering from certain diseases, such as hemophilia, leukemia, and diabetes—diseases that also afflict cats. But when it comes to psychological and sociological studies, there have been fewer revelations. Although wildcats are unusually solitary creatures, domestic cats can be extremely social, both with humans and each other, and are indeed reliant on humans for their survival. Unlike truly domesticated dogs, horses, and cattle, however, these gregarious "house cats" have never developed into a genetically distinct species. Of course, they have adapted and changed and found a place in our homes, and our hearts, with astonishing ease. But no matter how biddable and affectionate toward their owners, our cats continue to retain their freedom and involvement in the wider cat world beyond the four walls of their "family home." And in that world, there is no place for humans, except as occasional honorary members.

The knowledge that our cats, however tamable, are never truly domesticated, lends a frisson to our relationship with them. It may also increase our respect for their apparent ability to survive beyond the confines of our mutual habitats. Those of us who allow our cats to wander outdoors—around half the cat owners in urban areas (and more in rural parts)—suspect they might mingle with the large population of free-roaming strays: those abandoned, "neighborhood," and feral cats that exist in every town and city. Sometimes our hunch becomes certainty when we are introduced to the delightful newborn offspring of such liaisons. But we may often wonder how our pampered puss—who is used to having her meals prepared and served in her personal platter, and her basket lined with a favorite blanket—can cope amid the rough and tumble of these feline recreation areas beyond our garden fence. She doesn't appear to have much in common with these scruffy, skinny, cool-rather-than-cuddly, Top Cat-style nomads who survive on their wits rather than the generosity of doting owners. But clearly she survives—and probably thrives—on these forays into the feline badlands: that's because, unlike domesticated dogs, it's essentially nurture rather than nature that separates our pets from their wilder kin.

In former times, those same back-alley vagabonds discouraged schemes to destroy them by being so efficient at keeping rat and mice levels down. Today, humans have taken over these cats' pest-control function through large-scale poisoning, but constant influxes of new strays usually foil attempts at eradicating the cats themselves. Nevertheless, many of these feline urchins live on the borderline of survival and their resilience is astonishing: a direct consequence of the enduring similarity between their physical and mental makeup and that of their wild forebears and cousins. Sadly, however, the fact of their being able to survive when abandoned has made it easier for heartless humans to inflict such cruelty upon them: "It'll be okay," such brutes might say, "everybody knows cats have nine lives."

Probably the single most widely used phrase in relation to cats, there are several variations of this ancient epithet. In some Spanish-speaking regions, cats reputedly have just seven lives, while in certain Turkish and Arabic areas, it goes down to six. There is no definitive evidence to pinpoint when the phrase was first used but there are strong reasons to connect our story back once again to the cat-worshipping society of ancient Egypt, the first community to keep cats as household pets.

Atum-Ra, the sun god and principal Egyptian deity, took the form of "The Great Tomcat" on his frequent visits to the underworld, where he confronted and killed his great enemy, the snake-demon Apophis. He and his descendants (including the gods of earth, air, moisture, and sky) were known as Ennead—The Nine—and Atum-Ra was revered as the embodiment of nine lives in one creator. A hymn of the fourth century BCE refers to this origin in its address: "O sacred cat, your mouth is the mouth of the god Atum the lord of life who has saved you from all taint." The "nine lives" idea thus combines Atum's courage and luck in feline form with the number of his progeny. But alternative explanations have been proposed, most frequently the idea that nine was considered a uniquely lucky number, often invoked in ancient religion and folklore because it represented a "trinity of trinities" and was thus appropriate to describe the lucky life of cats. In China, too, nine has always been thought a number signifying good fortune.

The nine lives attribution has since become an established idiom, ubiquitous in language and literature. Inevitably that includes Shakespeare, who, in his play *Romeo and Juliet*, had Mercutio respond to Tybalt's "What wouldst thou have of me?" with: "Good king of cats, nothing but one of your nine lives." A rather less eminent poet described the cat's life cycle: "For the first three, they play. For the next three, they stray. And for the last three, they stay." A list of references to the nine lives could extend indefinitely. But there is a definitive scientific explanation for the concept that cats are able to survive experiences that would almost certainly end the lives of virtually any other mammals.

Unusually lucky people are sometimes described as "always landing on their feet," and the cat's luck is often a consequence of their actually doing so. Some of the earliest documented proof of this dates from the Middle Ages, when, as discussed in the previous chapter, the mystery of the cat inspired not adulation or worship but suspicion and torture. Rather like witches (often perhaps women whose unique abilities were interpreted as malevolent perversions), cats as their familiars were seen as having fearful, mystical powers that must be extinguished.

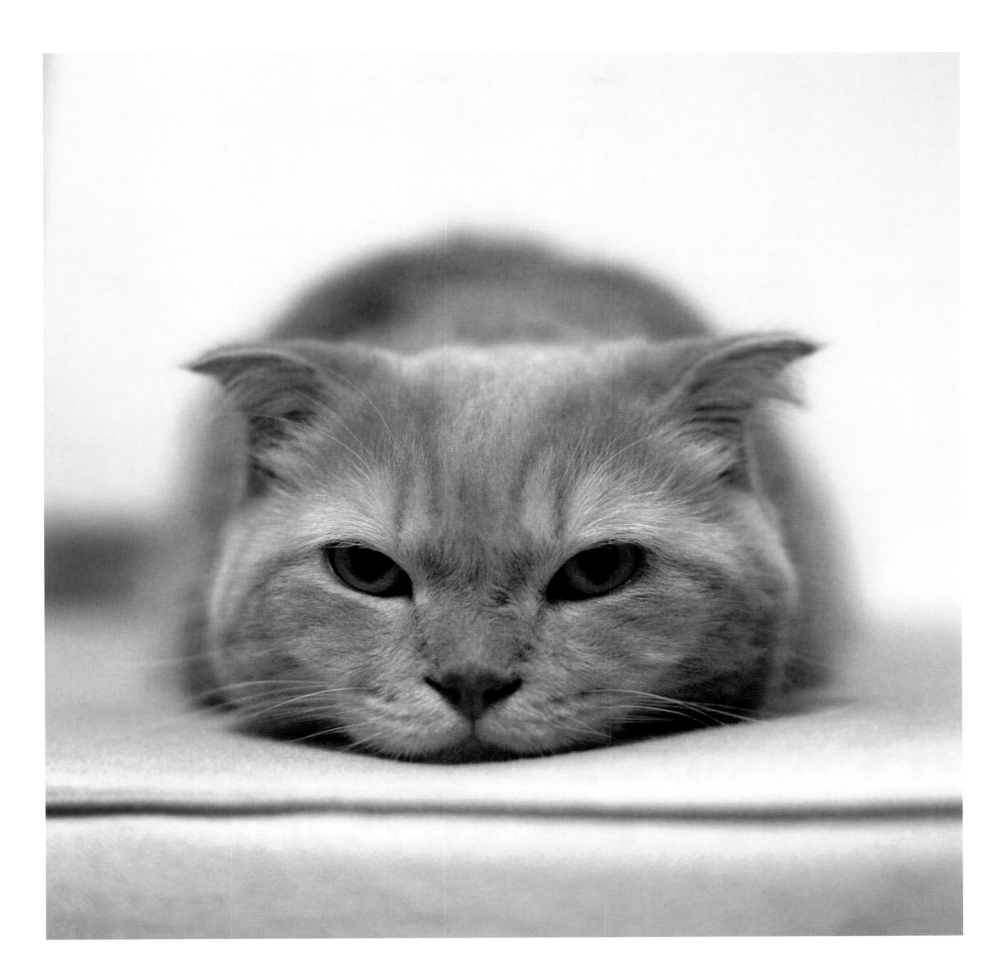

Cats provide us with models of meditation . . .

deep in thoughts we can never fathom.

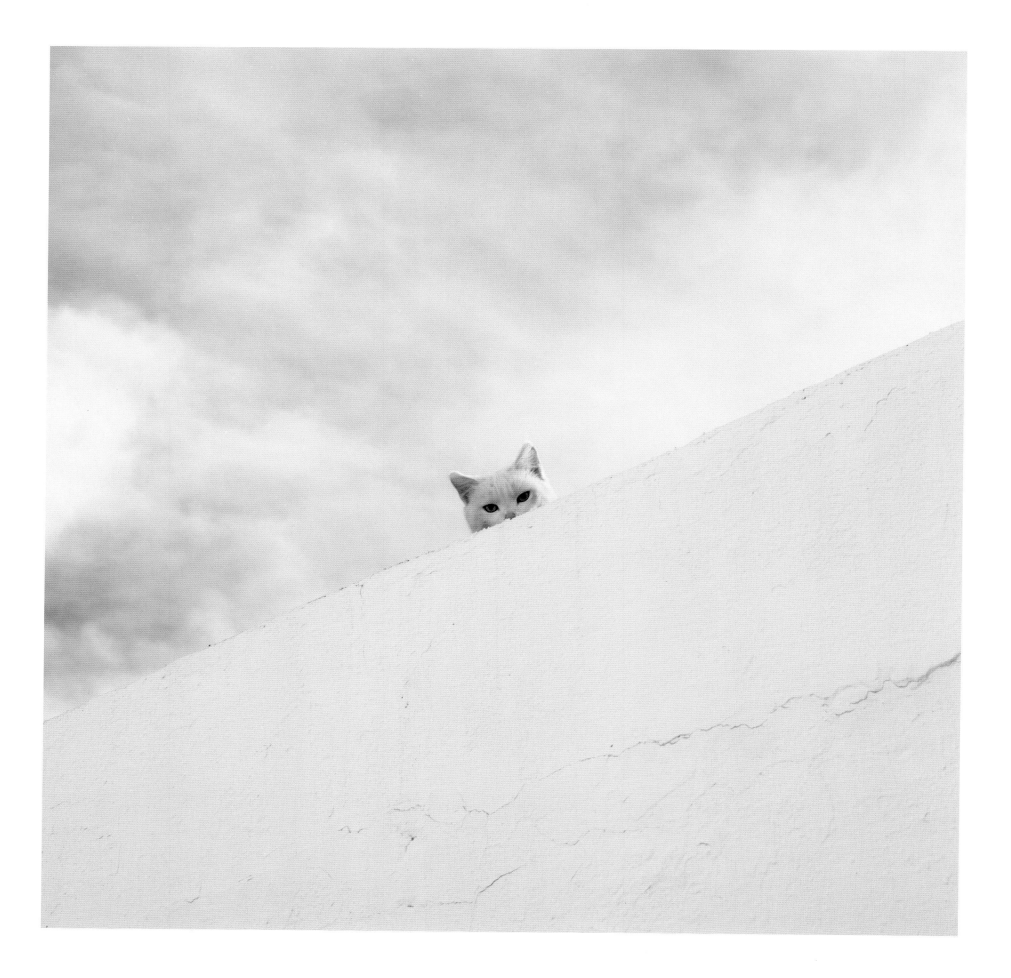

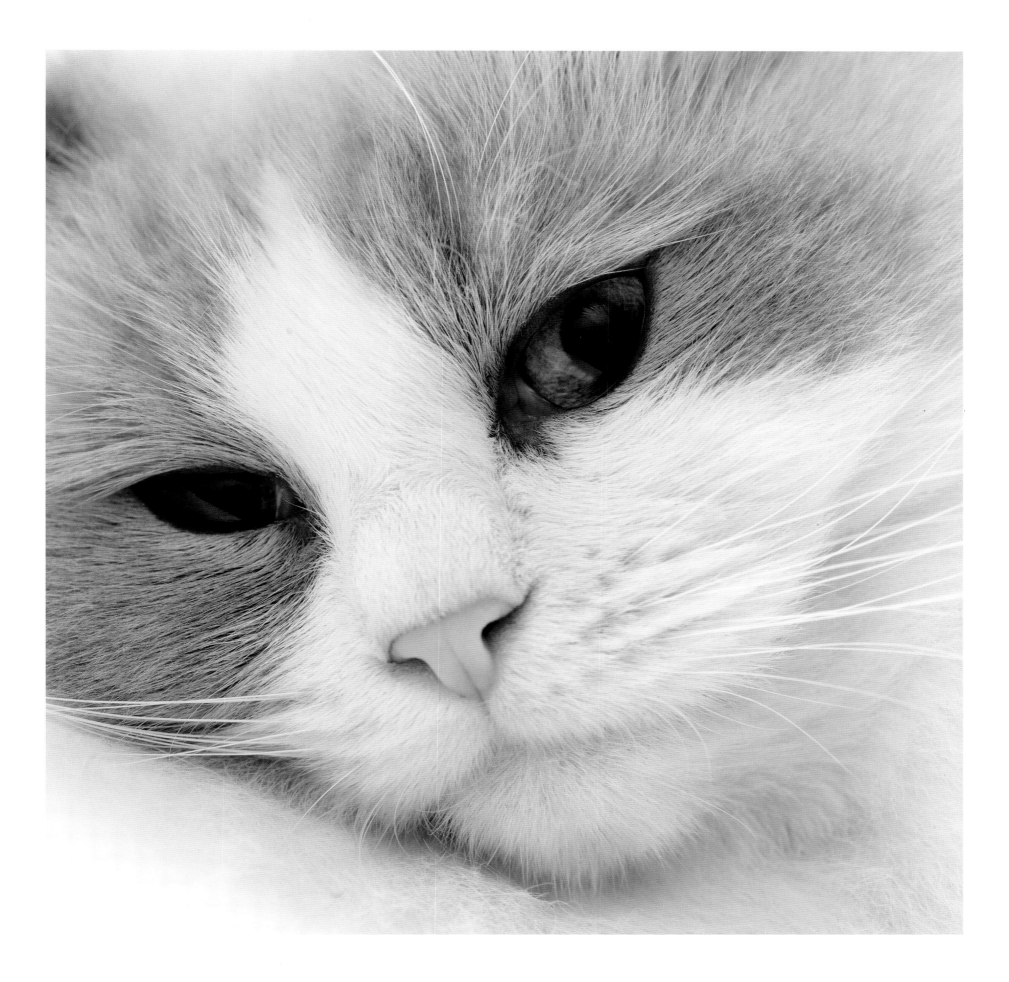

And, indeed, the torture they were subjected to did on occasion reveal one "power" that might have underpinned the idea of the extra lives—namely, the ability of cats to survive great falls.

Because cats had been associated with early pagan rituals, there was a basis for a bad reputation to grow; for some they became seen as the evil agents of Satan, a creature that must be subjected to pain, suffering, and death. Once sacred, now they were damned: flayed, crucified, and often burned alive on Christian feast days. In one variation of these cruel rituals, carried out in medieval Belgium, Baldwin III, Count of Ypres, threw cats from a tower, inspiring an annual purge when cats were thrown from the top of the 230-foot Cloth Hall tower. The annual "cat festival" continues with toy cats today, but live animals were used until 1817, when the town keeper declared: "In spite of the height of the fall, the animal ran off quickly so that it might never be caught again in a similar ceremony."

This may have been the first public declaration of the "landing on its feet" phenomenon. It is now noted somewhere every day, mostly by stunned but relieved cat owners whose treasured pets have launched themselves through high windows—then padded upstairs or emerged from the elevator, apparently unharmed by their escapade. But what medieval spectators perceived as a miracle (or curse), unique to cats, is now understood as the fortunate consequence of feline anatomy—or even the cat's intuitive understanding of physics. In 1894, French physiologist Etienne-Jules Marey, decided to investigate the cat's remarkable ability to survive a fall and, with a camera that took sixty images per second, filmed a cat falling through the air. The resulting film demonstrated how the falling cat began to twist in the air, maneuvering its head, back, and legs to lessen the impact and land on its paws. At the same time, the cat's tail stiffened and turned like a propeller, thus acting as a counterbalancing device. Of course, all this happened so quickly that it is only with the slow-motion film that the secret of the cat's unique righting response was revealed.

Cats are vitally aided in this major element of their "nine lives" reputation by their physiology. In being relatively small and light they are able to soften the impact of a fall while their highly sensitive inner ear is crucial to their outstanding sense of balance. This is critical to enabling them to land on their feet and allows them in a split second to instinctively calculate and recalculate their position in the air and readjust to landing upright. Any impact from the fall is further ameliorated by being absorbed through all four paws and a natural splaying of the legs.

As innumerable astonished witnesses have testified over many years, cats can survive falls from the loftiest heights relatively unscathed. In fact, as discovered in a study by a team of New York veterinarians: in cats they treated, there was a greater survival rate of falls from higher, rather than lower buildings: 10 percent of the cats in their study who fell from heights of two to six stories died, but only 5 percent of those who fell from seven to thirty-two stories were fatally injured. This may be explained by the laws of physics, which determine that when falling bodies reach terminal velocity, their friction with the air acts as a brake: at this point, cats seem to become aware that they have stopped accelerating and spread their legs, like an umbrella opening, increasing the area which the air has to push against, and further slowing their fall while allowing them to recover their sense of balance. This would, in turn, buy them more time to maneuver their body for landing on all fours.

Of course, many cats do suffer bruises, fractures, damaged noses, and even brain damage from such falls, so it is advisable to keep upper-story windows closed. And in spite of their nine lives, cats do not live forever: their current average life expectancy is twelve to fourteen years for male cats and perhaps one or two more years for females. But one famous exception was Creme Puff, the world's oldest recorded cat who died at home in Austin, Texas, in 2005, aged thirty-eight years and three days. Her owner, Jake Perry, had another pet cat, Granpa, who passed on at the age of thirty-four years and two months in 1998. Perry claimed to pamper his cats with their favorite meals of bacon and eggs, and asparagus and broccoli, a diet almost as idiosyncratic as that of English writer Barbara Pym's cat, Minerva, who lived to the ripe old age of seventeen, largely on a preferred menu of fried tomato skins and custard. But there is no guarantee of this diet adding years to a cat's life.

Longevity and even eternal life were, however, assured for the mystical cats who were present in both the physical and spiritual worlds in the ancient mythology and folklore of almost every part of the world. Many of these tales feature half-human, half-feline creatures who linger in a spiritual dimension, representing the souls of dead ancestors. The sacred Siamese cat, for example, was one who was treated as if a part of the royal family, living with special privileges in the palace. When a king died, his soul was said to pass on to this cat so that he could stick around long enough to see the coronation of the next king before moving on to heaven. The Birman breed from the nearby region of Burma are said to originate from their famous ancestor, Sinh, who took on the soul of his master, head priest in the temple of Lao-Tsun.

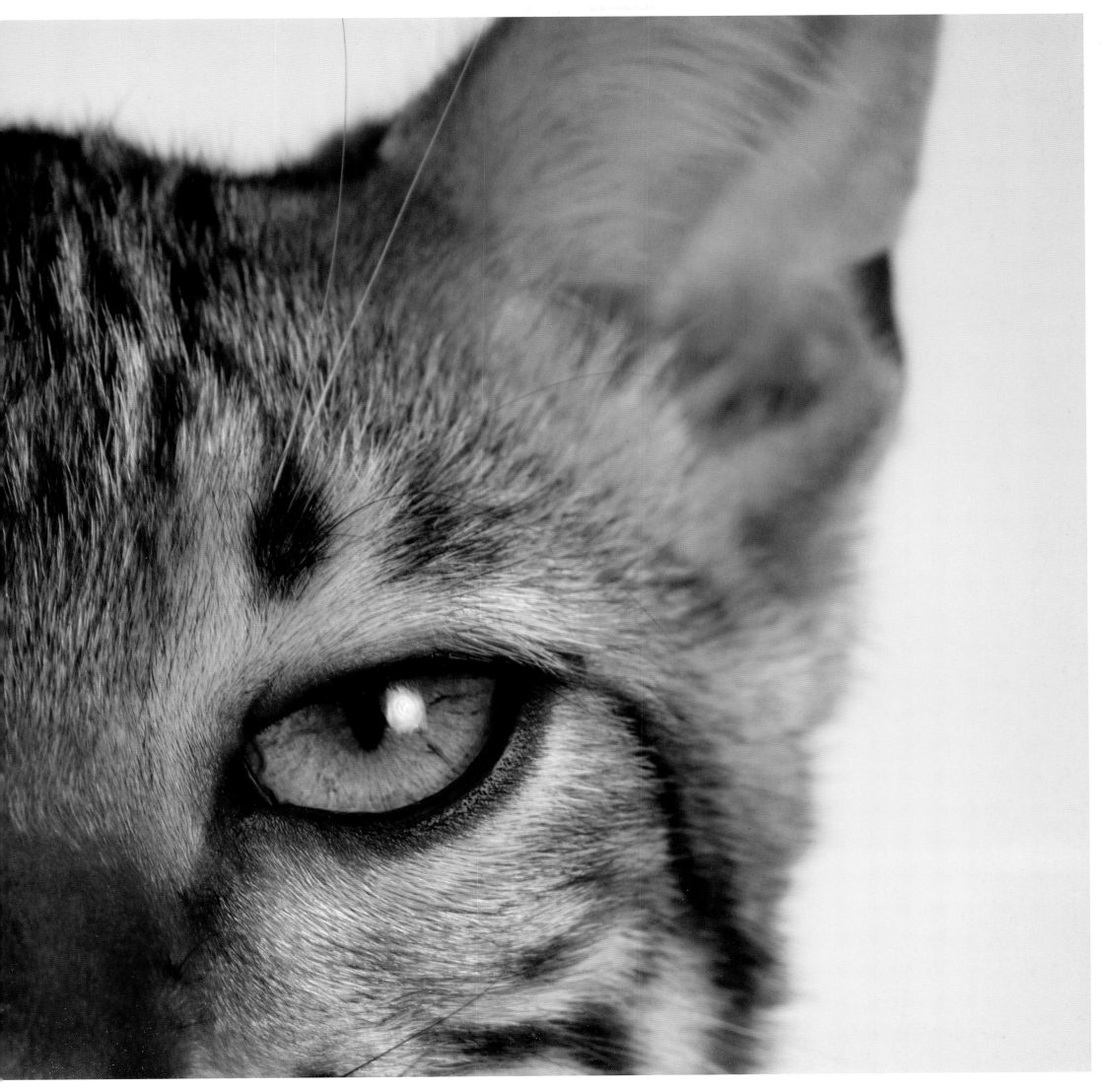

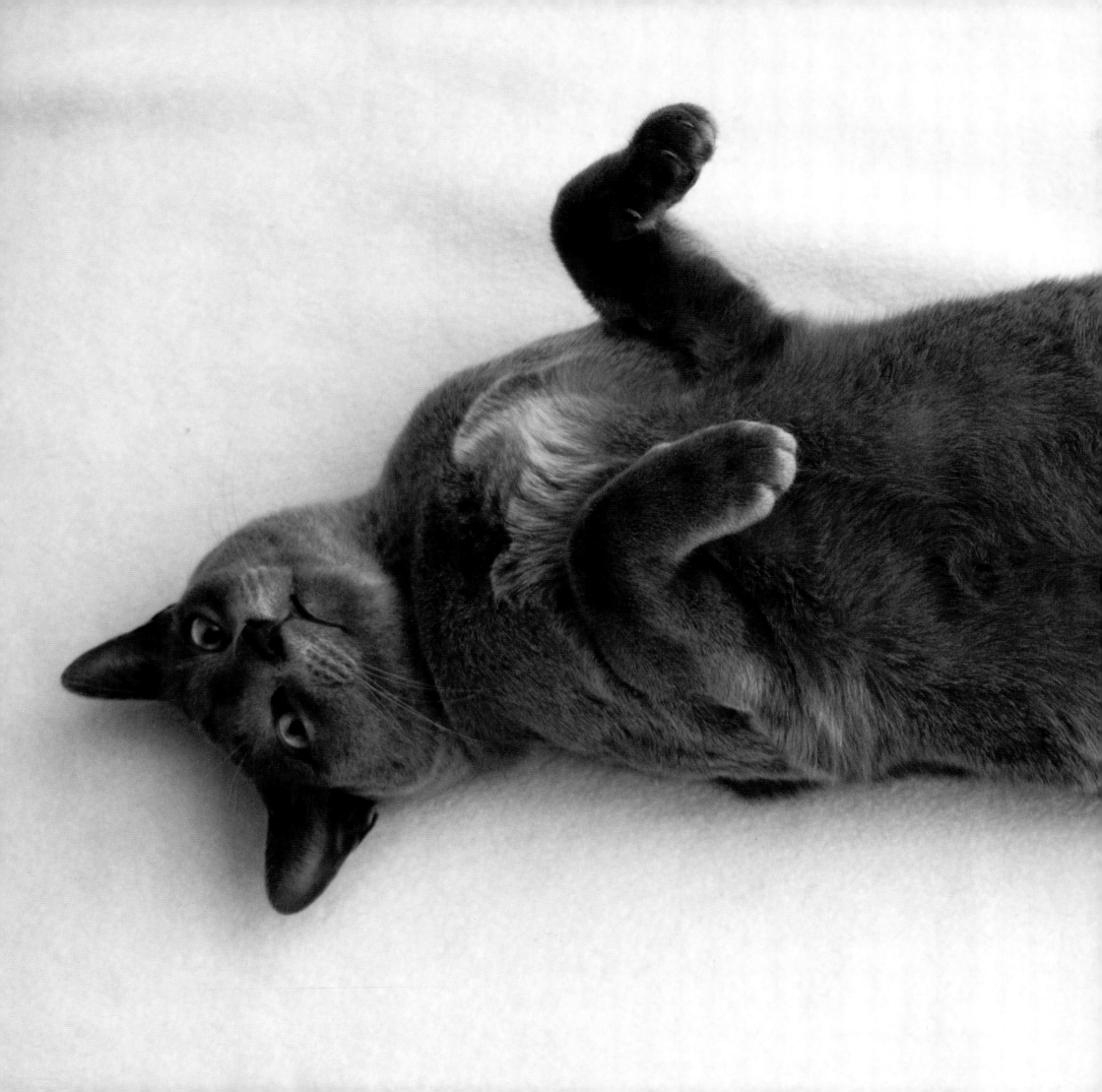

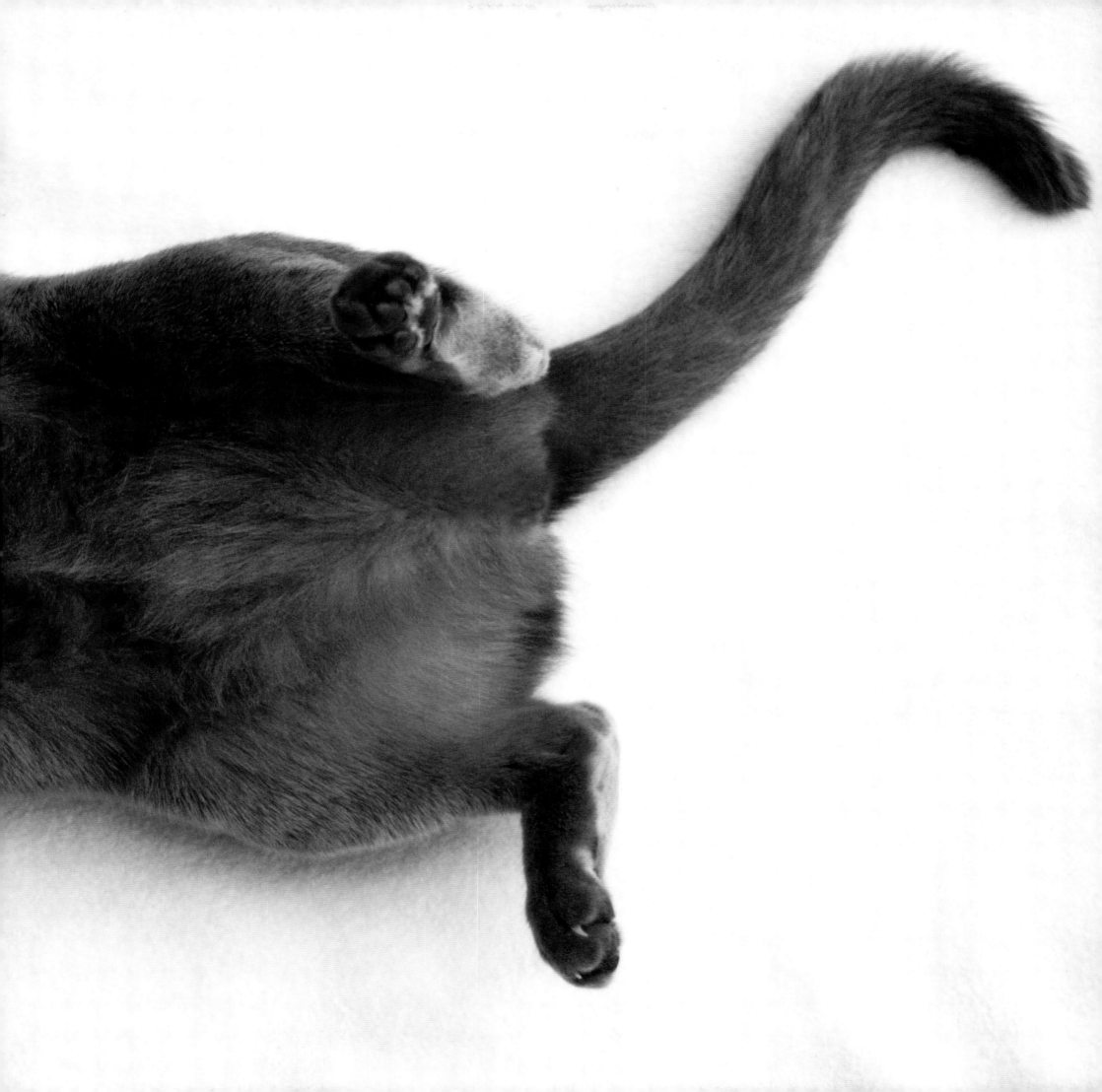

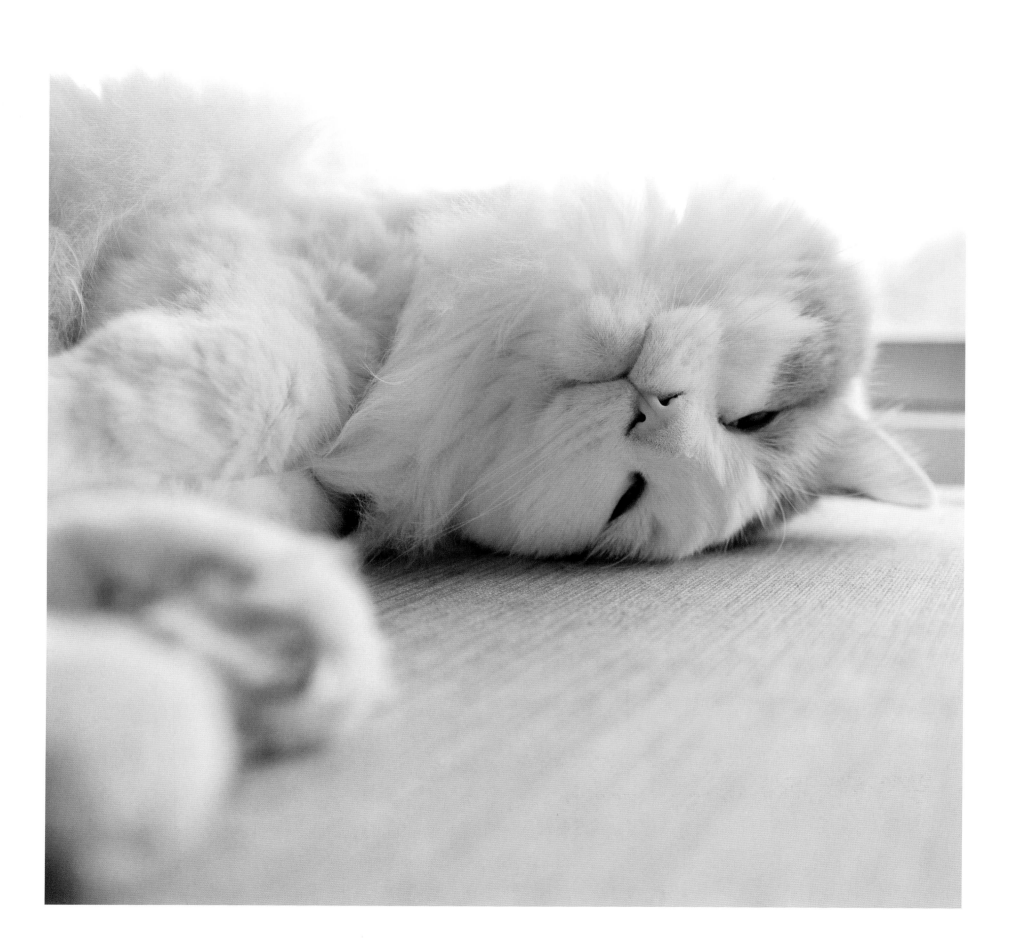

When the priest was murdered by Siamese invaders, Sinh carried his master's soul to the goddess Tsun Kyan-Kse, who rewarded it with nirvana. Even today when a monk dies, he is said to be reincarnated as a Birman cat before going on to attain nirvana.

While we may not believe in our cats as the keepers of immortal souls, there is one sense in which our cats are assured eternal life. Most of us who have lived with and loved a cat retain vivid memories of their characters and habits. We cherish recollections of incidents involving our cats. The wealth of feline literature, in poetry and prose, ensures that myriad cats, with all their quirks and qualities, will never die—at least in the minds of writers and readers. In one way or another, most cats contrive to be unforgettable—even those who have not always inspired unconditional love in their owners. Generations of cat owners have found their memories revived when encountering the fine beast at the heart of William Brighty Rands's much-loved children's poem, "The Cat of Cats":

I am the cat of cats. I am
The everlasting cat!
Cunning, and old, and sleek as jam,
The everlasting cat!

I hunt vermin in the night—
The everlasting cat!
For I see best without the light—
The everlasting cat!

All our cats are eternal and we cannot imagine life without one—even if it cannot be the same one forever. As Albert Schweitzer said, "There are two means of refuge from the miseries of life: music and cats." Russian writer Anton Chekhov believed that "the soul of another is a mystery, and a cat's soul is even more so." And Sir Walter Scott, the great Scottish novelist, declared: "Cats are a mysterious kind of folk. There is more passing in their minds than we are aware of." No cat lover would see any absurdity in this and most would concur with Gavin Ewart's unsentimental but admiring lines in his sonnet "Cat Logic":

One morning a cat wakes up, and doesn't feel
disposed to eat or wash or walk. It doesn't panic
or scream: "My last hour has come!" It
simply fades. Cats never go grey at the edges
like us, they don't even look old. Peter Pans,
insouciant. No wonder people identify with cats.

And no wonder, too, that we form the closest of bonds with them. But while we love our cats for seeming so much like ourselves, it is their eternal mystery that we love most of all.

The quotes

My favorite cat cartoon is from the *New Yorker*, and is drawn by Mick Stevens. It depicts a man sitting in an armchair reading a newspaper; in front of him is a cat asking "Can I get you anything?" The caption below reads: "New, Improved Cat." It's in the spirit of similarly engaging, if less unbelievable, juxtapositions that we have threaded a series of telling quotes throughout this book. Some are from famous writers who have a passion for or, at least, a view on, cats. Other comments are from the less famous, who are perhaps best known for these very observations. And then there are the anonymous maxims, the proverbs or folk sayings, that indicate just how embedded the ways of the cat have become in our lives. At times we can't speak, or even think, without drawing on cats . . .

pp. 9, 11, and 12

Cats have nine lives: For the first three, they play. For the next three, they stray. And for the last three, they stay.

English proverb. This old saying, which exists in various forms, contains commonplace wisdom about cat behavior compressed into the myth of why cats have nine lives. While none of this wisdom is literally true—indeed is quite untrue for most cats—it provides a seductive framework for understanding the stages of a cat's life. It also contains enough truth in its easily memorized form to have been handed down for, most likely, hundreds of years.

pp. 20–21

In ancient times cats were worshipped as gods. They have not forgotten this.

This comment is often attributed to the English fantasy writer Terry Pratchett (1948–), sometimes to the even more prolific Anonymous. It is also close to a quote from the comic writer P. G. Wodehouse (1881–1975), who wrote: "Cats as a class have never completely got over the snootiness caused by that fact that in Ancient Egypt they were worshipped as gods."

p. 30

It is as if we want to produce the equivalent of a paint specification chart, but one made up of all the possible variants of cat form, color, and markings.

From *The Life & Love of Cats*

pp. 34–35

Cats sleep anywhere, any table, any chair.
Top of piano, window-ledge, in the middle, on the edge.

From the poem "Cats Sleep Anywhere" by Eleanor Farjeon (1881–1965), an English author of stories and poetry, who had great success writing for children. The Eleanor Farjeon Award, a leading honor for contributions to children's literature, is awarded annually in her memory.

pp. 42–43

The cat is domestic only as far as suits its own ends.

For the short story writer Hector Hugh Munro (1870–1916), better known as Saki or H. H. Munro, cats were a motif of mystery and an element in his creation of dark, suspenseful stories. This line is from a longer quote, "The cat is domestic only as far as suits its own ends; it will not be kennelled or harnessed nor suffer any dictation as to its goings out or comings in." Saki was born in Burma and grew up in England. Asian strangeness lights up his stories, which subtly and humorously undermine establishment values. One of his most famous tales, "Tobermory," is named after a cat that is taught to speak—only for people to realize that a speaking cat has secrets we would rather were not shared.

pp. 54–55

They are wild at heart, with a veneer of domestication that helps them live alongside us.

From *The Life & Love of Cats*

p. 59

Usually you can tell when a cat is up a tree. You can tell by the distraught children, anxious owners, sympathetic neighbors, and excited dogs who surround the tree.

From the article "The Science of Getting a Cat out of a Tree," *Kiplinger's Personal Finance*, May 1980, 60.

pp. 68–69

The truth is that it is the mix of the wild with the tame that we find appealing.

From *The Life & Love of Cats*

pp. 76–77

It always gives me a shiver when I see a cat seeing what I can't see.
Eleanor Farjeon, see entry for pp. 34–35.

p. 83

It is practically impossible for a cat lover to meet a stray feline on the street without stopping to pass the time of day with him.

By Carl Van Vechten (1880–1964), a wide-ranging American writer and photographer, whose output included two books celebrating cats, *The Tiger in the House* (1920) and *Lords of the Housetops* (1921). Van Vechten photographed many artists and writers of the 1930s and became the executor of the estate of his friend, the writer and dog lover Gertrude Stein.

p. 93

The cat wants nothing more than to be a cat, and every cat is pure cat, from its whiskers to its tail . . .

From "Ode to the Cat" by Pablo Neruda (1904–1973). Famed for his love of poetry, the Chilean writer was also a diplomat and politician. His popular works include a series of odes to everyday things . . . among which appears the cat. He spent several years in exile, before returning to Chile in 1952. He won the Nobel Prize in Literature in 1971.

p. 102

I do not think the cat can be overestimated. He suggests so much grace, power, beauty, motion, mysticism.

Carl Van Vechten, see entry for p. 83.

p. 111

If a cat does something, we call it instinct; if we do the same thing, for the same reason, we call it intelligence.

A typically concise witticism from the American humorist and critic Will Cuppy (1884–1949). His writing style in part derived from a technique involving setting down his thoughts on numerous index cards before shuffling them into a form that could be the basis for the finished text. He was something of a recluse, who often preferred the company of animals to humans.

p. 115

One can pick a cat to fit almost any kind of decor, color scheme, income, personality, mood. But under the fur, whatever color it may be, there still lies, essentially unchanged, one of the world's free souls.

From *How to Live with a Calculating Cat*, by the award-winning cartoonist and illustrator Eric Gurney (1910–1992).

pp. 124–125

The smallest feline is a masterpiece.

Leonardo da Vinci (1452–1519) not only said this but also demonstrated the sensibility in the many magnificent sketches of cats that he made. Some were in preparation for a work called *Virgin and Child with a Cat*, which features the Madonna showing a kitten to the infant Christ. The final painting was thought to have been destroyed, but a recent version has been discovered that may be the original in a poor state or a copy.

p. 129

There is no more intrepid explorer than a kitten.

The French critic and novelist Jules François Felix Fleury-Husson (1820–1889), known as Champfleury, wrote perhaps the first major book on cats, in his series of essays published as *Les Chats* (1870).

p. 136

A kitten is so flexible that she is almost double; the hind parts are equivalent to another kitten with which the forepart plays. She does not discover that her tail belongs to her until you tread on it.

A detailed and somewhat curious observation—considering theproposed behavior—from the journal entry of February 15, 1861, by the American writer, philosopher, and pioneer conservationist Henry David Thoreau (1817–1862). He is best known for his work *Walden; or, Life in the Woods* (on living the simple and natural life in his cabin by Walden Pond, Massachusetts) and his essay "Civil Disobedience."

p. 139

Dreaming is what cats do best.

From *Writing with Cats* (2003) by Gerald J. Schiffhorst, an emeritus professor of English in Florida, whose insights into composition include the useful advice that a cat is more important to the serious writer than a computer.

p. 149

Stepping into our need for cuteness, cats have it easy. They are tailor-made for the job.

From *The Life & Love of Cats*

p. 157

Who knows whether she is not amusing herself with me more than I with her.

A loose translation of one of the most famous of all quotes about cats, part of the philosophical speculation of Michel de Montaigne (1533–1592), from one of the texts in which he effectively invented the idea of the personal essay. The original is: *"Quand je me joue à ma chatte, qui sçait si elle passe son temps de moy plus que je ne fay d'elle?"* or "When I play with my cat, who knows if I am not a pastime for her more than she is for me?"

p. 163

It is impossible for a lover of cats to banish these alert, gentle, and discriminating friends, who give us just enough of their regard and complaisance to make us hunger for more.

Agnes Repplier (1855–1950), now somewhat forgotten, became famous for the many essays published over her long lifetime. She was a contemporary of Edith Wharton and Willa Cather, and earned the unofficial title of the "American Austen," which compared her dry wit with that of Jane Austen. Her works included a volume called *The Cat* (1912).

p. 166
The cat is nature's Beauty.
French proverb.

p. 182
Cats, like cities, will reveal themselves at night.
A mysterious observation made in a letter by Rupert Brooke (1887–1915), a poet and soldier, who was one of the rising generation of poets killed in the First World War. He was also described as "the handsomest young man in England" by W. B. Yeats.

p. 186
This is the victory of the cat. . . . The animal which the Egyptians worshipped as divine, which the Romans venerated as a symbol of liberty, which Europeans in the ignorant Middle Ages anathemized as an agent of demonology, has displayed to all ages two closely blended characteristics—courage and self-respect.
Saki or H. H. Munro; see entry for pp. 42–43.

p. 193
If a black cat walks toward you it is bad luck, but if it walks away from you, it is good luck.
English proverb

pp. 198–199
Cats provide us with models of meditation . . . deep in thoughts we can never fathom.
From Gerald J. Schiffhorst; see entry for p. 139. The full quotation this is extracted from reads:
What we easily overlook is that cats provide us with models of meditation. Since their very way of being is purely contemplative, it is easy to assume that cats staring into space are doing nothing when, in fact, they are deep in thoughts we can never fathom.

The breeds

The cats in this book come from all walks of life: from domestic short- and longhairs, to pedigrees, to wildcats, and even big cats. We have sought to display the spirit and behaviors of the cat, rather than be descriptive of types. In many cases, the precise type or breed shown cannot be reliably identified. However, for those interested in particular breeds, what follows is a list of the pages on which some of the breeds that feature in this book are mentioned (image page numbers are bold):

Further reading and notes

Enter "cat website" into a search engine and you may be offered more than a billion links of information purporting to be feline friendly. Retreat to the more edited world of books, and the choice is still never-ending. What sits in this introductory list is the product of fine sifting around the more promising key sources. So if you liked the preceding pages, then the below could well extend the pleasure. Remember, all reading should ideally be done with a cat on the lap or nearby.

Inspiring Reads

Aberconway, Christabel. *A Dictionary of Cat Lovers.* London: Michael Joseph, 1949.

Boylan, Clare, ed. *The Literary Companion to Cats.* London: Sinclair-Stevenson, 1994.

Budiansky, Stephen. *The Character of Cats.* London: Weidenfeld & Nicolson, 2002.

Eliot, T. S. *Old Possum's Book of Practical Cats.* London: Faber and Faber, 1939.

Kirk, Mildred. *The Everlasting Cat.* London: Faber and Faber, 1977.

Lessing, Doris. *On Cats.* New York: Harper Perennial, 2008.

Mery, Fernand. *The Life, History, and Magic of the Cat.* Translated by Emma Street. New York: Grosset and Dunlap, 1968.

Poe, Edgar Allen. "The Black Cat" (included in numerous editions of Poe's and other short stories, first published in *The Saturday Evening Post*, August 19, 1843).

Rogers, Katharine M. *Cat.* London: Reaktion Books, 2006.

Rogers, Katharine M. *The Cat and the Human Imagination.* Ann Arbor: University of Michigan Press, 1998.

Sacquin, Michele. *The Well-Read Cat.* Paris: Bibliothèque Nationale de France, 2010.

Saki (H. H. Munro). "Tobermory." From *The Chronicles of Clovis.* London: Penguin Classics, 1995.

Dr. Seuss. *The Cat in the Hat.* Boston: Houghton Mifflin, 1957.

Wheen, Francis, ed. *The Chatto Book of Cats.* London: Chatto & Windus, 1993.

Useful Guides

Champfleury. *Les Chats.* Paris: J. Rothschild, 1868.

Morris, Desmond. *Catwatching.* London: Jonathan Cape, 1986.

Tabor, Roger. *Understanding Cat Behaviour.* Newton Abbot, UK: David & Charles, 2003.

Taylor, David. *The Cat Directory: Profiles of Every Cat Breed.* London: Hamlyn, 2010.

Weir, Harrison. *Our Cats and All About Them: Their Varieties, Habits, and Management;* and *For Show, the Standard of Excellence and Beauty.* Tunbridge Wells, UK: R. Clements & Co, 1889.

Special Thanks

I am very fortunate in having had the wonderful resources of the London Library and the British Library available for my immersion in the literature and depiction of cats. I am also fortunate in having memories of Joe, and the ongoing support of Jan and Caledonia, to whom the book is dedicated.

Notable References and Websites

Introduction

Michel de Montaigne's essay of 1576 in which he speculates on whether it is he or his cat that is playing with the other has been separately and widely published as *An Apology for Raymond Sebond* (London: Penguin, 2006). It is sometimes seen as his greatest work, a masterpiece of skepticism.

Sense

More on cat's tongues and other feline information from Sandra Toney can be found at http://tinyurl.com/6pcvoam.

Healing

A useful aggregation of healing stories were found in Susie Bachman's article "The Lore of the Cat," retrieved from the website Pawprints and Purrs, http://tinyurl.com/6u6tgvc (website no longer live at time of publication).

D.r Valeriy Ilyichev's article "Cat Sense Organs: Smell and Taste" can be read in translation at http://tinyurl.com/7crnqt6.

The story of Oscar the cat with a sixth sense can be read at CBS News: http://tinyurl.com/ysv9ot.

The economic benefit of cats is drawn in particular from a paper "Contribution of the Pet Care Industry to the Australian Economy, ACAC, 2010": http://tinyurl.com/6w546pk.

Links between mental health and pet keeping are referenced from Mental Health Foundation research at http://tinyurl.com/7nxff24.

J. Manerling's story on cats and autism can be read in full at http://tinyurl.com/crthtn.

Lana Kaiser's comments on how cats help keep people healthy can be referenced at ABC News: http://tinyurl.com/7vsap3q.

Cute

Natalie Angier's article in the *New York Times*, 3 January 2006, "The Cute Factor," is at http://tinyurl.com/d7vc4.

Eternal

On the origin of the cats' nine lives: http://tinyurl.com/82pbvc9.

On the Kattenstoet, Festival of the Cat, in Ypres: http://tinyurl.com/487gn86.

William Brighty Rands (1823–1882), writer of "I am the cat of cats," was sometimes known as the "Laureate of the Nursery." The complete poem can be read at http://tinyurl.com/6rea7q8.

The extract from Gavin Ewart's "Sonnet: Cat Logic" is from *Selected Poems 1933–1988* (New York: New Directions, 1988). Ewart (1916–1995) was an English poet of darkly comic and poignant verse, much admired by other writers and deserving republication. Read more about Ewart in his obituary published in *The Independent*, October 24, 1995: http://tinyurl.com/7w8jaz4.

Editor: Laura Dozier
Book Designer: Helene Dehmer
Production Manager: Erin Vandeveer

Cataloging-in-Publication Data has been applied for and may
be obtained from the Library of Congress.
ISBN: 978-1-4197-0404-8

First edition published in 2012 by Abrams
Concept and design copyright © 2012 PQ Blackwell Limited
Text copyright © 2012 Lewis Blackwell

The publisher is grateful for literary permissions to reproduce items
subject to copyright. Every effort has been made to trace the
copyright holders and the publisher apologizes for any unintentional
omission. We would be pleased to hear from any not acknowledged
here and undertake to make all reasonable efforts to include the
appropriate acknowledgment in any subsequent editions:
pp. 34–35: Eleanor Farjeon in *Blackbird Has Spoken* (Macmillan:
1999); p. 59: "The Science of Getting a Cat out of a Tree"
Kiplinger's Personal Finance (May 1980, p. 60); pp. 76–77:
Eleanor Farjeon in "Spooner" from *Roger Caras Treasury
of Great Cat Stories* (Galahad Books: 1993); pp. 198–199:
Gerald Schiffhorst in *Writing with Cats: An Inspirational and
Practical Guide for Writers* (Butler House Publications: 2003).

Printed by 1010 Printing International Limited

Printed and bound in China
10 9 8 7 6 5 4 3 2 1

Abrams books are available at special discounts when purchased
in quantity for premiums and promotions as well as fundraising
or educational use. Special editions can also be created to
specification. For details, contact specialsales@abramsbooks.com
or the address below.

ABRAMS
THE ART OF BOOKS SINCE 1949
115 West 18th Street
New York, NY 10011
www.abramsbooks.com

Image Credits

Our thanks to the many photographers—past, present and
future—who explore and shape our vision of the wonderful and
mysterious relationship we have with cats. Many thousands of
images were reviewed during the writing and editing of this book,
and they influenced our thinking in incalculable ways as well as
making for immensely entertaining study. But our specific thanks
go of course to the photographers and collections whose images
are included:

Front cover, p. 87: Daniele Carotenuto; facing pp. 1, 2, 4–5, 64,
194–195, 216–facing: Michael Kloth; p. 8: Diane Collins and
Jordan Hollender; p. 10: Don Klumpp; pp. 13, 27, 30 (middle),
31 (right), 121, 128, 137, 161: Life On White; p. 15: Ibai Acevedo;
p. 17: Bhawika Nana; pp. 18, 108–109: Josef Timar; pp. 22–23:
Jennie Clutterbuck; pp. 25, 67: Dan Burn-Forti; p. 28: Ryan McVay;
p. 29: B. Holland; p. 30 (left): Renaud Visage, (right): Jon Boyes;
p. 31 (left): Dirk Freder, (middle): Max Oppenheim; pp. 33, 72,
72–73, 92, 119, 122–123, 203: GK Hart/Vikki Hart; pp. 36–37:
Jimmy LL Tsang; pp. 38, 39: Lottie Davies; pp. 40–41: Neo Vision;
pp. 44–45: Press and Arts; pp. 47: Glowimages; pp. 49, 197:
LeoCH Studio; pp. 50–51: Julie McInnes; p. 52: T. Kruesselmann;
p. 53: Michelle Kelley; p. 56: Ngoc Minh Ngo; p. 57: Alex Barlow;
p. 58: Anna Kern; pp. 60–61: Karen Desjardin; pp. 63, 65, 97,
104–105, 105: Michael Duva; p. 70: Dave King; p. 71: Tim Platt;
pp. 74, 134, 201: Ultra.F; pp. 78–79: Lori Lee Miller; pp. 80–81:
Ruy Barbosa Pinto; p. 82: Victoria J. Baxter; pp. 84–85:
Brad Wilson; p. 86: Lisa Stirling; p. 89: Goran Patlejch; p. 91:
Tatiane Noviski Fornel; pp. 94, 95: Sharon Dominick; pp. 98–99:
Alan & Sandy Carey; pp. 100–101, 148: junku; p. 106: Anja Hild;
p. 107: Cindy Loughridge; p. 109: Babur Saglam; p. 113:
Barros & Barros; p. 114: Patrick Matte; p. 116: Yasuhide Fumoto;
p. 120: Christopher Kontoes; pp. 126–127: Jane Burton; p. 130:
Duncan Smith; pp. 131, 132–133: Gandee Vasan; p. 135:
Geri Lavrov; p. 138: Marcel ter Bekke; pp. 140–141: Taubenberger;
pp. 142–143: Carl Pendle; p. 145: Marcy Maloy; p. 147, 169:
Louise LeGresley; pp. 150–151: Mixa; pp. 152–153, 160:
Daniel Day; p. 154: Sam Lee; p. 155: John Koinberg; pp. 158–159:
Bruce R. Bennett; p. 162: Peeter Viisimaa; p. 164: Pinto; p. 165:
Anthony Bradshaw; p. 171: Philip and Karen Smith; p. 173:
Travis Payne; pp. 174–175: Felipe Rodriguez; p. 177: Carlina Teteris;
pp. 178–179: Peter Lilja; pp. 180–181: Hiroshi Higuchi; p. 183:
Martin Rogers; p. 184: William A. Allard; p. 185: Jonathan Fife;
p. 187: Gianluca Fabrizio; p. 189: Nikographer [Jon]; p. 191:
Dougal Waters; p. 192: Sigthor Markusson; p. 200: Tim Robberts;
pp. 204–205: Howard Kingsnorth; p. 206: Brantlea Newbery.

Images on pages 1, 2, 4, 58, 64, 164, 197, and 216 are used with
permission from copyright © Corbis Images; all other images are
with permission from copyright © Getty Images.